Art and Enlightenment

Art and Enlightenment

*Aesthetic Theory
after Adorno*

By David Roberts

University of Nebraska Press
Lincoln and London

Copyright © 1991 by the
University of Nebraska Press
All rights reserved
Manufactured in the
United States of America
The paper in this
book meets the minimum
requirements of
American National Standard
for Information Sciences –
Permanence of Paper for
Printed Library Materials,
ANSI Z39.48–1984
Library of Congress Catalog-
ing in Publication Data
Roberts, David 1937-
Art and enlightenment:
aesthetic theory after Adorno/
David Roberts. p. cm.
(Modern German culture
and literature)
Includes bibliographical
references and index.
ISBN 0-8032-3897-5
(alk. paper)
1. Aesthetics, Modern.
I. Title. II. Series.
BH151.R58 1991
111'.85'09045 – dc20
90-35508 CIP

57502

Contents

❏

Acknowledgments

◻

In preparing this study for publication I have benefited greatly from discussions with Peter Por, Siegfried J. Schmidt, and Philip Thomson. I am grateful to them for having helped me to clarify some of the obscurities of my argument and its presentation.

The study itself is the product of an ongoing dialogue with Ferenc Feher and Agnes Heller. Without their warm encouragement and unfailing critical stimulus my venture into the terrain of aesthetic theory would have remained only a project. It is therefore a great pleasure to thank them here for their productive support.

The section "Beyond Progress: The Museum and Montage" in the last chapter appeared in an earlier version in *Theory, Culture, and Society* 5, nos. 2–3 (June 1988), 543–58.

Abbreviations

❑

AD Lyotard, "Adorno as the Devil"
AT Adorno, *Aesthetic Theory*
AV Bürger, *Theory of the Avant-garde*
BF Baudrillard, *Les Stratégies fatales*
BS Baudrillard, *Simulacres et simulation*
CL Jameson, "Postmodernism, or the Cultural Logic of Late Capitalism"
CM Eagleton, "Capitalism, Modernism and Postmodernism"
DM Bürger, "The Decline of the Modern Age"
DW Spengler, *The Decline of the West*
EM Vattimo, *The End of Modernity*
HCC Lukács, *History and Class Consciousness*
IP Wellmer, "Art and Industrial Production"
MA Meyer, *Music, the Arts, and Ideas*
MH Lambert, *Music Ho!*
MM Adorno, *Philosophy of Modern Music*
MW Malraux, *Museum without Walls*
NU Habermas, *Die neue Unübersichtlichkeit*
OR Boulez, *Orientations*
PD Danto, *The Philosophical Disenfranchisement of Art*
SO Schmidt, *Die Selbstorganisation des Sozialsystems Literatur im 18. Jahrhundert*
SS Luhmann, *Soziale Systeme*

Introduction

The dialectic of art and enlightenment has been an open question for art since the Enlightenment. The emergence of aesthetic theory in the second half of the eighteenth century signaled a new stage in the historical self-reflection of modern art. This reflection is critical in a double sense: on the one hand it registers that art itself has become theoretical; on the other, precisely this transformation of art into theory announces the crisis and end of art. This *first* critical turn of aesthetic modernity appears in the opposed versions of the enlightenment of art we find in the German romantics and Hegel.

The *second* critical turn arises from the general crisis of tradition in the first decades of the twentieth century, signaled by the collapse of perspective in painting and tonality in music and evident in the explosive ferment of the avant-garde movements. This crisis opens a new stage of modern art, which aesthetic theory is still struggling to comprehend. Here Theodor Adorno's *Philosophy of Modern Music* can be seen as playing a seminal role. The dialectic of enlightenment it unfolds renews Hegel's conclusions on the fate of art in modernity. At the same time Adorno's polemical analysis of the opposed paths of the new music anticipates in important respects the debates on postmodernism.

The critical continuity of reflection on the dialectic of art and

enlightenment from Hegel to Adorno and beyond to such contemporary theorists as Peter Bürger, Arthur C. Danto, and Jean Baudrillard is the historical frame of this book. I have focused on Adorno's philosophy of music and the question of aesthetic theory after Adorno. "After Adorno" in the sense that I approach the situation of twentieth-century art since the crisis of tradition through Adorno's dialectic of enlightenment and its consequences for "emancipated" music. And here the question is, How do we go beyond the terminus of this dialectic, which from Hegel to Baudrillard is conceived as a posthistorical, "transfinal" conclusion to art and to history.

The dialectic of enlightenment in relation to art can be formulated in various ways—as the emancipation of subjectivity, which dissolves the sensuous appearance of the idea realized in classical art (Hegel); as the domination of musical nature through a progressive rationalization, which consumes itself by consuming its object (Adorno); as the tendency to formalization, which eliminates content (Bürger). In each case, however, enlightenment can be understood as a process from the side of the subject which exhausts its object. The enlightenment of art can thus be analyzed in terms of a dialectic of the latent and the manifest, which leads to the progressive manifestation and exhaustion of the latency which constitutes both the binding force of tradition and its necessary self-blindness. Hence enlightenment can be reconstructed as the process by which art becomes conscious of itself and thus progressively conscious of its own latency, thereby setting in train the dialectic of the latent and the manifest, whose terminus is the exhaustion of latency, that is, the dissolution of the (latent) necessity of tradition into (manifest) contingency.

This abstract model must be related to what I have called the two critical turns of art and aesthetic theory in modernity. The emergence of historical-philosophical aesthetics at the end of the eighteenth century goes together with the constitution of art (the arts) as an autonomous sphere, as a separate social system of society.[1] From this point art as such (the system of arts) can be conceptualized either in the form of self-reflection (German romantic literature and theory) or in the form of philosophy of art (Hegel). This epochal threshold of the self-constitution of art brings with it a consciousness of the crisis of tradition which is

registered at this stage primarily within literature. The generalized consciousness of the crisis of tradition occurs only at the beginning of the twentieth century, and it is manifested most drastically in the specifically European arts of music and painting. Adorno's *Philosophy of Modern Music* is situated at this point of crisis, which I read as the turning point between modern and postmodern art. My thesis is that the end of tradition opens the epoch of postmodern art which is at the same time a new stage in the dialectic of art and enlightenment. And here I must stress, in order to avoid terminological confusion in relation to contemporary debates, that *modern* does not refer to modernism nor *postmodern* to postmodernism. On the contrary, modernism and postmodernism are understood here as rival positions in the debate about postmodern art, that is, art since the crisis of tradition at the beginning of the twentieth century.

MODERN AND POSTMODERN ART

The present book is a contribution—at a distance—to the postmodernism debate in the arts. I say "at a distance" because I believe that by placing the current debates in the wider context of art and aesthetic theory in this century we can see them more clearly. This wider context is of course implied by the critical revaluations of modernism and the avant-garde movements characteristic of postmodernist revisionism. Much of the present confusion, however, derives from the uncertain status and application of the key terms—not only *postmodernism* but, equally, *modernism*. The term *modernism* first appeared in Spain at the end of the nineteenth century; subsequently and independently applied in Anglo-American literary criticism to writers such as T. S. Eliot, Ezra Pound, and James Joyce, it has progressively extended its scope to embrace "modern art" since the turn of the century or 1880 or even 1848. It is thus a term which has become increasingly indeterminate, comprising both an implicit periodization, to which postmodernism would supply a correspondingly uncertain terminus post quem, and a parti pris for the modernness of "modern art," to which the critical revisions of postmodernism are directed. But here it is apparent that this revision contains an unexplicated ambivalence. Is post*modernist* art or theory also

post*modern*? This ambivalence is present in the origin of the term, which comes not from *modernism* but from Arnold Toynbee's periodization of Western history, where he distinguishes between "Western III ('Modern') 1475–1875" and "Western IV ('Post-Modern'?) 1875–?"[2] Toynbee's "Post-Modern" was taken up and applied to literature by Irving Howe and Harry Levin in the late 1950s. Subsequently theorists of postmodernism such as Ihab Hassan and Charles Jencks have acknowledged the derivation from Toynbee. Charles Olsen and François Lyotard have also proposed a similar periodization for the postmodern age.[3]

The ambivalence postmodernism-postmodern is particularly evident in Charles Jencks. On the one hand he uses both terms indifferently to register the changes in architecture since about 1960 in reaction to the purism and sterility of the International Style, while on the other he aligns his understanding of postmodernism with Toynbee, who according to Jencks used the term "to describe the pluralistic age of our civilisation, in which coexistence and cultural relativism have been inevitable outgrowths of 'modernism' (i.e., the triumph of Western civilisation) since the fifteenth century."[4] If we follow Jencks, then, postmodernist architecture (from 1960) is the reaction to the modernist school (from 1920), but both must be seen within the historical context of postmodern civilization (from 1875). If this makes Jencks a postmodernist in both the historically narrower and wider sense, it leaves the obvious question: how is modernism in the arts to be explained? Modernism is as much the inevitable outgrowth of Jencks's "modernism," the triumph of Western civilization since the fifteenth century, as the cultural relativism and pluralism of postmodern civilization. Is the modern, as Lyotard puts it, already the postmodern? Terminological clarification is called for but hardly to be attained, since the key terms have already been set by the current debates. I suggest we attempt to disentangle the confusing embrace of postmodernism and the postmodern, but also that of modernism and the modern, by returning to the genesis of the term, to Toynbee.

I propose that we cut across the division modernism-postmodernism, as an indeterminate periodization of twentieth-century art, by subordinating this division to the more fundamental periodization: modern and postmodern art. My first reason for this is

that the postmodernist debates involve less the establishment of a temporal sequence than a revision of modernism, with the result that the opposed positions emerge as competing interpretations of art in this century, thereby calling into question any implied periodization. This is not to deny the cultural and critical hegemony of modernism from the 1920s to the 1960s but to acknowledge that this revision brings back into focus the wealth and range of twentieth-century art (including modernism). Thus, my second reason for seeing modernism and postmodernism as alternative positions in relation to the art of our century is that the caesura between modern and postmodern art is of far greater significance for the understanding of twentieth-century art than the indefinite, indeed questionable, caesura between modernism and postmodernism, which is in danger of transforming the coexistence of the most divergent styles and tendencies into an illusory temporal succession.

Toynbee's tentative dating for the postmodern (1875–?) requires modification in its application to art. By *modern art* I understand the art of the European modern age since the fifteenth century, which comes to a long-prepared-for and yet explosive end in the abandonment of the frame of illusionism or representation in painting and of tonality in music in the first decade of the twentieth century. This caesura signals the end of the modern paradigm of art, which for Leonard Meyer is tied up with the idea of progress. Meyer's thesis is that "the paradigm of style history and cultural change which has dominated Western thought since the 17th century does not seem able to illuminate or make understandable the situation of the arts today." Art since the First World War has brought to an end the preceding five hundred years of ordered, sequential change. We have now entered "a period of stylistic stasis, a period characterized not by a linear, cumulative development of a single style, but the coexistence of a multiplicity of quite different styles in a fluctuating and dynamic steady state."[5]

Returning to Toynbee's term and following Meyer's characterization of the situation of the arts since the Great War, I propose to term art since the watershed of the avant-garde movements *postmodern:* historically, because twentieth-century art, most obviously music and painting, is both the product and the break

with the tradition of European modern art, and critically, because the idea of progress, implicit or explicit in the modern "paradigm of style history and cultural change," enters into crisis in aesthetic theory. Of course modern and postmodern art are both stages of Western modernity, but we must distinguish, as does Toynbee, between the European modern age and the world society of the twentieth century. Just as Europe since the Great War is no longer the center but part of the world system, so the revolutionary break in the arts in the first two decades of this century shattered the foregoing continuity of development and stylistic change. Modernism in its most radical forms—functional architecture, abstract painting, twelve-tone music—cut itself loose from the past, severing all links with history and memory to become precisely the new International Style, which asserted the technical imperatives of an emancipated material.

This caesura, this tabula rasa, helps to explain the contradictory faces of postmodern art revealed by the competing positions of modernism and postmodernism: functionalism and historicism are both responses to the revolutionary break which reduced European tradition to freely disposable material, open to recombination as rational organization or parodistic quotation. The arguments from the 1920s on between the proponents of the opposed positions of aesthetic purism and pluralism, progress and parody, are taken up again in the postmodernist debate with reversed signs. The arguments of the functional imperatives of the material, of the cutting edge of the most advanced techniques, of the shock of the new (Robert Hughes), have now lost their force and yielded to the recognition of the coexistence of the most disparate styles since the end of tradition. Before this reversal could occur, however, the radical impulse of modernism and its critical dominance had to succumb to its own contradictions. The collapse of the modernist paradigm and its consequence for aesthetic theory is the subject matter of the present book.

The consequences for aesthetic theory are indeed serious. They have been stated most succinctly by Peter Bürger in his *Theory of the Avant-garde:* if the key tenet of the modernist paradigm—the idea of aesthetic progress, predicated on the criterion of the most advanced material—no longer holds, then the multiplicity of styles and tendencies renders aesthetic theory as we know it from

Kant to Adorno no longer possible. *Theory of the Avant-garde* (1974) appeared three years after Adorno's posthumous *Aesthetic Theory*. It is symptomatic of the break between modernist and postmodernist positions, not least in the return to and critical judgment on the avant-garde's assault on the tradition of bourgeois art. This assault, which erupted from the crisis of tradition and was radicalized by the upheavals of the First World War, is for Bürger the decisive caesura for art in bourgeois society. What comes after, post–avant-garde art (in my terminology, postmodern art), defies aesthetic theory. But, as Bürger reminds us in conclusion, his diagnosis (and equally that of Meyer) of the situation of art since the collapse of the avant-garde challenge—the total availability of the materials and forms of tradition—was already the prognosis of Hegel 150 years earlier. And so if Hegel already set, as it were, the agenda for postmodernism, the path to Adorno, the most decided advocate of the modernist paradigm to which Bürger's theory responds, lies through Hegel's thesis of the end of art, which already articulated in "conclusive" fashion the consequences for the art of modernity of the process of enlightenment.

HEGEL AND THE END OF ART

Hegel's lectures on the philosophy of art, published posthumously in 1835, are at once the origin, summit, and completion of philosophical-historical aesthetics. The completion and historicity of the system go together. The Owl of Minerva flies at dusk. Hegel's philosophy of art is retrospective; its verdict and vantage point is that of the end of art. If his aesthetic theory is explicitly an immanent explanation of art, whose inner necessity is demonstrated and conceptualized by philosophy, the identity of history and system is bought at the price of the contradiction between the historicizing of art and the ahistorical concept of art itself. Art for Hegel is the manifestation of the idea, of the divine, which attained its highest realization in Greek art. His aesthetic is thus directed to the past; it recognizes but cannot accept the world of prose, the profane art of enlightenment. The art of reflection points beyond itself to its sublation in philosophy. Historical-philosophical aesthetics, the successor to the *querelle des anciens et modernes*, is thus born under the paradoxical sign of the super-

session of art, which is deemed no longer able to give form or expression to the age. Hegel's verdict of the end of art does not mean that art ceases to be produced, but that it can no longer claim or retain our highest interest: "For us art is no longer the highest form in which truth gains existence."[6]

Hegel's contradictory historicization of art, in which Greek art alone fully realizes the concept, unfolds the three stages of the rise and decline of art in relation to the progression of the spirit: symbolic (oriental), classical (Greek), and romantic (European) art. The identity of subject and object, form and content, freedom and necessity, in the sensuous appearance of the idea makes classical art the stage in which the spirit finds its fullest objectification in art. The spirit, however, moves on: European Christian art represents the emergence of the inner world of spirituality, subjectivity, and self-reflection, which strives beyond the concrete, sensuous presence of art toward the higher, abstract form of the idea in the philosophical concept. Hegel therefore characterizes romantic art as the self-transcendence of art within art. Through subjectivity freedom comes to self-consciousness, and this progressive emancipation of the spirit from the limited forms of art leads to the loss of mediation between the inner and outer worlds, that is, to the increasingly arbitrary relation between subject and object, form and content. The world of things, of mere facticity ("external objectivity in all its contingent shapes"), stands over and against the boundless inner world of subjectivity, whose infinite variety makes the artist his own content and subject matter. In Hegel's system art, religion, and philosophy are the three forms of the absolute spirit, as opposed to the objective spirit (history), but having lost its self-evidence through the spirituality of religion and the awakening of self-reflection, art must give way to philosophy as the final and highest expression of the idea. In an act of retrospection the philosophy of art completes the history of art, just as history comes to completion in the philosophy of the spirit.

Hegel offers us alternative endings to the dissolution of art through reflection, the one conciliatory—the free spirit of comedy and humor—the other destructive—the nihilistic sovereignty of irony. In comedy subjectivity raises itself through laughter above its own transient goals and purposes. Laughter is the self-

assured self-criticism of subjectivity which brings to consciousness the disjunction between subject and object in the modern world—that is, "the liberation of subjectivity, in accordance with its inner contingency, in humour." The free spirit of comedy stands at the end of Hegel's aesthetics because it announces the end of art. Comedy can present the purpose of art—the manifestation of the eternal, the divine, and the true in real appearance—only in negative form.[7] As against this farewell to art stands the theory and practice of irony of Hegel's contemporaries, the German romantics, such as Friedrich Schlegel or Ludwig Tieck. Hegel rejects the empty, formal freedom of the ironic subject, who proclaims himself the creator of all things: "What exists through me can be destroyed by me." For the artist, who sets himself up as divine ironist, the work of art has become mere appearance (*Schein*) to be played with as a self-made object. The ironist demonstrates his freedom by denying that anything is intrinsically valuable or serious. This characterless, parodistic play signifies the self-destruction of art.[8]

The principle of subjectivity, whether as humorous reconciliation or ironic annihilation, asserts the freedom and the nonidentity of the subject in relation to the object. This loss of mediation means that art can no longer concretely express the idea, that it is no longer one with the spirit of the age. The emancipation of subjectivity and the concomitant dissolution of art are for Hegel necessary. It is the sign that the spirit has moved beyond the limits of art, in other words, that art no longer retains its absolute interest because its essential content has been fully presented and exhausted. This we could term Hegel's dialectic of enlightenment, whose outcome explains why he may justly be seen as the godfather of postmodernism. Hegel's argument is this: the spirit works on objects only as long as they contain something secret and unrevealed. Such is the case as long as the subject matter of art is identical with us, that is, one with the spirit of the age. Only so long as the artist is identical with a people, a time, and the specific worldview of that time is art the expression of that worldview. The emancipation of subjectivity thus represents the loss of substantial oneness with the age, and this dissolution of the inner necessity of art sets free reflection. Bourgeois autonomous art and aesthetic theory, the art of reflection and the reflection of art, are

born under the same star of enlightenment. Both are character-ized by what we may call the freedom of retrospection. For Hegel the art of his time is no longer bound by the given contents and forms of a worldview. The artist stands above the consecrated forms of tradition because no form or content is immediately identical with his subjectivity and inwardness. Thus art has be-come a free instrument which the artist can utilize at will. The whole reservoir of forms and images of earlier art has become freely available to be selected for particular purposes. Art has reached the state of tabula rasa, in which every subject matter and its treatment is freely—that is, indifferently—available.[9] It is clear that Hegel's diagnosis of the situation of art anticipates postmodernist positions, even if the affiliation has received scant attention. Hegel's standpoint in relation to art is already that of *posthistoire* and his aesthetics in effect a postmortem, but it is a postmortem which was both internalized and deferred through the entry of history into the post-Hegelian theory of art in moder-nity.[10]

The completion of history alone ensured the identity of history and system in Hegel. Still, the entry of history into the system, the illumination of history through art and of art through history, was irreversible. The undeniable split between the boundless subjectivity of art and an alien reality, or in other words the emancipation of art from traditional religious and social bonds, meant that theory (which explains art as theoretical) takes the place of the *sensus communis* of tradition.[11] Art now finds its full comprehension and justification only in theory, and this com-prehension involves the historical judgment of the relation of art and the age. As Dieter Henrich has pointed out, Hegel's conclu-sion that art and the artist have emancipated themselves from any given worldview means that art can no longer express the totality. Its truth and content have become *partial*.[12] And yet precisely the recognition of the historicity of art demanded the linking of art and the age, and its corollary, the symbiosis of art and theory. The inescapably problematic nature of bourgeois art derives from its historical condition. If traditional art was judged by society (*sen-sus communis*), emancipated art judges society but also falls victim to this judgment. The historicity of art and society thus enters post-Hegelian aesthetics in the form of what Henrich calls

the "disastrous schema" of progressive degeneration or utopian anticipation.[13] The result is a crisis theory of the art of modernity, in which art is read either as the symptom of social decadence or as the medium of progress, that is, as the expression of social appearance or social essence.

The partial nature of art, the tabula rasa, which means that art must understand itself as self-production; the loss of the a priori of tradition, which makes the work of art its own self-reflexive theme; the indifference of all given forms and contents, which opens the *musée imaginaire* and makes the burden of memory, of historicism, the stigma of the artist's freedom—all these "postmodernist" dimensions of Hegel's theory thus had to await the exhaustion of the schema of progress and decadence.[14] In this schema the Hegelian end of art is rewritten in double and opposed fashion: as the avant-garde dream of the revolutionary overcoming of the alienation of art and life, and as the nightmare of the total self-alienation of art become the blind image of a reified world. Georg Lukács's critique of bourgeois rationalization as the process and progress of reification, which can be overcome only by the identical subject/object of history (the revolutionary proletariat), remains the classic Hegelian-Marxian text of the avant-garde project. But it is from this very analysis of reification in *History and Class Consciousness* that Adorno deduces the dialectic of enlightenment, demonstrated in the progress of music, which seals the fate of "free artistic production."

Adorno's argument in *Philosophy of Modern Music* is that the process of rationalization by which the sovereign spirit progressively asserts its domination of (musical) nature destroys all heteronomy in the name of autonomy. This loss of differentiation of the object, its reduction to indifferent—that is, neutral—disposable material, is one with the loss of differentiation (*Vergleichgültigung*) of the spirit, whose freedom reverses into a sovereignty without object, into the self-imprisonment of "means without purpose" (MM20).[15] Enlightenment, which depended for its progress on the dialectic of subject and object, ends in the destruction of the resistance (the latency) of nature. Its self-destructive terminus is the cessation of the dialectic in the indifference of subject and object. Indifference is thus the vanishing point of Adorno's dialectic of enlightenment and of the "disas-

trous schema" of progress and decadence, which underlies post-Hegelian philosophy of art and philosophy of history.

Lukács and Adorno continue Hegel in a double sense. Not only is their aesthetic theory a renewal of Hegel but historically they take up where Hegel closed his account—the bourgeois art of his time. It is not by chance that Walter Scott and Beethoven, the exact contemporaries of Hegel, are the paradigmatic reference points for Lukács's *Historical Novel* and Adorno's *Philosophy of Modern Music*. That is to say, both Lukács and Adorno take over Hegel's three stages of art for their purposes, making the art of Hegel's time, the heroic revolutionary epoch of the bourgeoisie, the modern equivalent of Greek art. Thus for Adorno baroque music is still presubjective; classical music, the fullest mediation of subject and object; and romantic music, the vehicle of a subjectivity which dissolves musical time. What lies beyond—emancipated music for Adorno or the open decadence of twentieth-century literature for Lukács—drives Lukács back to Hegel, back to a normative concept of art, and Adorno forward to the radicality of a progress, whose contradictions call forth the paradoxes of negative aesthetics. And so it is not Hegel but Adorno who completes the narrative of European art. On the one hand, it is obvious that European history did not come to rest in Hegel's system—Adorno's dialectic of enlightenment is the revenge of history both on Hegel's reconciliation of subject and object and on Lukács's attempt to "out-Hegel Hegel" in *History and Class Consciousness*. On the other hand, and just as important, music moves to the center in Adorno's narrative. The postmodernist flavor of Hegel derives from the fact the literature is his model for the end of art. Since the medium of literature, ordinary language, is at the same time its own metalanguage, its modes of irony and parody make it the art of reflection par excellence.[16] Moreover, literature has long lived with the burden of memory. But by the same token we can point to no such sharp and dramatic caesura for literature as that which befalls the language of tonality and the frame of three-dimensional representation. Atonal music and abstract painting register unmistakably the end of European tra-

dition as it is expressed in the unique development of music from ars nova to Gustav Mahler and of painting from Giotto to Cézanne (Meyer's five hundred years of ordered, sequential change). They are the specifically European arts, which have no parallel elsewhere and thus can be seen as reflecting most fully the spirit of occidental reason and science (as witnessed, for instance, in Max Weber's study of the rational foundations of music) in their quest to give shape and form to space and time.[17] We do not have to understand the historical sequence of style change in European music or painting in an evaluative sense to recognize in it an underlying process of differentiation and rationalization, that is, a process of enlightenment which finally exhausts the possibilities of the material. Music, not literature, is thus Adorno's model for the dialectic of art and enlightenment, because it is for him (as for Oswald Spengler) the European art sui generis and beyond that *the* form of bourgeois art.

Although he never publicly acknowledged it, Lukács's fusion of Hegel and Weber in *History and Class Consciousness* is the crucial text for Adorno's philosophy of music, whose focus is the new music of Arnold Schoenberg and his school.[18] The deep affinity Adorno discerned between the music of the "dialectical composer" Schoenberg and his own philosophy, born of the spirit of music, takes us to the heart of his aesthetic theory.[19] The significance of Schoenberg for Adorno is to be sought in the fact that the situation of music since the irretrievable disintegration of tonality posed in the clearest and sharpest fashion the critical state of emancipated art, but also of emancipated theory. As Susan Buck-Morss writes, "There was a parallel between his own abandonment of philosophical first principles and Schoenberg's abandonment of tonal dominance." The negation of tonality corresponded to the negation of idealism. What remained was dialectical method as the immanent logic and ferment of the disintegration of tradition. And so Schoenberg's transformation of music from within from an ideological to a critical function, as Adorno saw it, is matched by his own method of immanent critique, where the dialectical treatment of the object can be seen as modeled, as Buck-Morss persuasively argues, on Schoenberg's compositional procedures.[20] For Adorno the problems posed by the musical material are problems of society, the new atonal

music is itself social theory, just as critical theory, we might add, is also aesthetic (note the ambivalence of the title *Aesthetic Theory*). And so when Adorno writes of Schoenberg's music he writes of his own philosophy: the crisis of the new music is at the same time the crisis of theory.

Here the key text is the Schoenberg essay of 1940/41 "Schoenberg and Progress," incorporated in *Philosophy of Modern Music*. It is the first decisive formulation, derived from the progress of musical rationalization, of the dialectic of enlightenment. In it Adorno drives the autonomous logic of the emancipated musical material to the point of the simultaneous affirmation and negation of progress. This dialectic of the material is the key to Adorno's "materialist" aesthetic. The dialectic of enlightenment unfolded in the Schoenberg essay becomes, as Susan Buck-Morss writes, "an act of self-criticism, regarding 'progress' in music," which threatened his own philosophy: "The real issue is whether Adorno's attempt at a resolution within philosophy, modelled self-consciously after Schoenberg, in fact succumbed to the same fate."[21]

The simultaneous affirmation and negation of aesthetic progress in *Philosophy of Modern Music* makes it both the most radical plaidoyer for modernism and its most radical critique. As the immanent critique of modernist art it calls into question from within the possibility of aesthetic theory, and yet, bound by the very logic of disintegration, Adorno draws back from his argument by fleeing forward into the paradoxes of negative aesthetics. *Philosophy of Modern Music* spells out the inner contradiction and crisis of the modernist paradigm—how is "progress" in art to continue?—and beyond that of the whole tradition of aesthetics since Hegel, including its "materialist" turn. This impasse points forward to the *postmodernist* revisions of the modernist paradigm of aesthetic rationality but also back to the situation of *postmodern* art, the tabula rasa brought about by the end of tradition. That is to say, the dream of the revolutionary sublation (*Aufhebung*) of music (Schoenberg), of philosophy (Lukács), of art (the avant-garde movements), whose failure is articulated by Adorno, directs us back to the fundamental caesura of European tradition in the opening decades of our century.

Philosophy of Modern Music is thus the guiding thread of the

present book. On the one hand, Adorno's opposition of Schoenberg and Stravinsky, of authentic and inauthentic responses to the collapse of the binding frame of tonality, anticipates the current debates. His splitting of modernism into the alternatives of aesthetic progress and the parodistic play with the past expounds in essence if not in name the rival positions of modernism and postmodernism. On the other hand, the new music is emancipated music and in revealing in naked fashion the dialectic of enlightenment, it demonstrates the crisis of dialectical aesthetics. The progress of music from Beethoven to Schoenberg is one with the progress of philosophy from Hegel to Adorno. Just as Schoenberg's music is for Adorno the death mask of the first Viennese school, so equally the dialectic of enlightenment is the death mask of Hegel's philosophy of history, the final twist of the "cunning of reason."

Philosophy of history required a "hidden hand" to justify the ways of history to man. The prospect of unending progress which the hidden reason of history opened up dethroned, however, God, reason, man, in a dialectic of enlightenment which revealed the cunning of reason as the cunning of the Devil. Progress ends for Adorno in the "satanic parody" of nihilism. The unending progress which contracts to the vanishing point of the indifference of all values is not only a dialectic fatal to enlightenment but an "enlightenment" fatal to dialectical reason. It is this inescapable contradiction which Adorno articulates: the paradox of the simultaneous validity and invalidity of the most advanced music makes *Philosophy of Modern Music* more than just an "extended excursus" to his and Horkheimer's *Dialectic of Enlightenment*. Together they form the conclusion to the grand narrative of the European modern age, the "passage of Faust" from Christopher Marlowe to Thomas Mann.[22] Mann's *Doctor Faustus* completes the narrative by joining together Faust and music in the figure of Adrian Leverkühn and by assigning to the Devil Adorno's exposition of the tragedy of modern art.

The dialectic of enlightenment is Adorno's narrative of the *modern* age, indeed of "modernity" since Odysseus. It represents the final paradoxical affirmation and negation of the whole endeavor to grasp the movement of history, the "laws of motion" of society as an *immanent* process, as the self-unfolding of the total-

ity. That is to say, all the paradoxes of the dialectic of enlighten-
ment as the last self-contradictory assertion of the identity of
reason and history register the limits of the narrative of the
modern age. The self-understanding of the modern age as move-
ment—from the physics of the seventeenth century to the histor-
ical materialism of the nineteenth century—is driven to absurdity
by Adorno. The consequence for aesthetic theory—since for
Adorno (authentic) art is the unconscious historiography of the
age—is the crisis of the modern paradigm of aesthetic progress.
The dialectic of enlightenment leaves Adorno only the ghostly
afterimage of dialectics as negative philosophy and negative aes-
thetics. It makes him the negative executor of Hegel's positive
sublation of art in philosophy. Philosophy becomes "aesthetic
theory." Philosophy of history and philosophy of art converge in
the indifference which is the vanishing point of enlightenment. In
seeking to cross this limit—the irrational barrier of theory—
Adorno must confirm it: the new music is for him music after the
end of music, Schoenberg's progress not only destroys tradition,
it consumes itself. Art falls victim to the terminal logic of enlight-
enment.

ENLIGHTENMENT AND AESTHETIC THEORY

Leonard Meyer argues that the end of the Western paradigm of
art history, dominant since the seventeenth century, is tied up
with the demise of the idea of progress. The idea of progress is
written into the enlightenment of art, and in turn aesthetic theory
spells out the conclusions of enlightenment. That is to say, the
Hegelian and post-Hegelian thesis of the end of art is the limit of
enlightenment, and aesthetic theory is situated at this limit, the
vantage point of retrospection, from which the dialectic of en-
lightenment can be reconstructed. The terminus of this dialectic is
indifference. This is the model we find in related forms in Hegel,
Adorno, and Bürger.

Bürger's *Theory of the Avant-garde* is, as he himself observes,
a postfiguration of Hegel. In his argument art attains the stage of
self-critique in the revolt of the avant-garde movements against
bourgeois autonomous art. The stage of self-critique is reached
when the most general category of art—artistic procedures—is

recognized as such (just as in Marx the self-critique of capitalism becomes possible once labor and money are recognized as the abstract-universal categories of the system). The emancipation of artistic procedures—the enlightenment of the system of art—means in Hegelian terms the indifference of all forms and contents in relation to the freedom of the artist. Bürger's theory is retrospective, because the avant-garde is the caesura from which the differentiation (subjectification and formalization) of autonomous art is reconstructed, and because at the same time all that follows is, as it were, posthistorical. The avant-garde is an end which is no end. As the standpoint of the stage of the self-critique of art, Bürger's theory thus represents the stage of the self-critique of aesthetic theory from Kant to Adorno. He breaks with Adorno's version of the end without end—negative aesthetics—but only by historicizing the narrative of the end of art in the form of the failure of the avant-garde project to overcome the split between art and life. Adorno and Bürger both write epilogues to Lukács's classic text of the avant-garde fusion of theory and practice, inspired by the Bolshevik Revolution.

What remains is the rupture, the caesura which marks the open crisis of European tradition and brings with it the open crisis of aesthetic theory. What we might term the crisis of art in Hegel's theory becomes the crisis of theory itself in Lukács and Adorno. Through the retreat to Weimar classicism Lukács seeks to preserve the system at the expense of history, whereas Adorno's logic of disintegration dissolves the Hegelian system only to fall hostage to history.[23] But whether twentieth-century art is judged as "decadence" (Lukács) or as "progress" (Adorno), the hostile heirs of Hegel reveal the crisis of philosophical-historical aesthetics in relation to "modern art," that is, emancipated, or postmodern, art. The Western paradigm of modern art since the seventeenth century—the *querelle des anciens et modernes* and its successor the "disastrous schema" of progress and decadence, whose opposed versions of the end of art reflect the ambivalence of enlightenment—writes its own conclusion in Adorno's dialectic of enlightenment. It is a conclusion which in turn through Bürger reactualizes Hegel's conclusions for postmodernist positions.

The crisis of aesthetic theory indicates the limit of the modern paradigm, which can theorize only *negatively* what follows—the

state of emancipated art beyond the inner necessity or binding power of tradition. And yet for Hegel, Adorno, and Bürger the postmodern situation of art is the outcome of progress, of enlightenment. The emancipation of self-reflection (Hegel), of rational integration and organization (Adorno), of universal categories (Bürger), leads to the tabula rasa and impasse of indifference, the posthistorical stasis in which space (synchrony) replaces time (diachrony). The situation of stasis is the end point of the process of enlightenment, through which all that is latent—that is, secret and mysterious, blind to itself—is progressively made manifest and exhausted to give the stage of the self-critique of art. But, as we have seen, this very emancipation of art into freedom paradoxically signifies the closure of theory. Freedom without limits—the artist as divine ironist (Hegel)—defines the limit of theory. This conclusion for the art of modernity—its release into the predicament of open contingency, registered as the stasis of posthistory—clearly signals the need for a change of paradigms. The logical point and ground of paradigm change is the terminus of indifference, for it is the irrational barrier which manifests in self-destructive fashion the latency of the model of enlightenment itself: the crisis of reason. The rationality unfolded as rationalization in the separate autonomous spheres of modernity is itself irrational. Adorno's demonstration following Lukács of this "enlightenment" fatal to enlightenment, in terms of the autonomous logic of the musical material, makes "Schoenberg and Progress" the self-conscious expression of the crisis of the modern paradigm of aesthetic theory.

THE ARGUMENT

Adorno's verdict of the end of music opens up the question he closed off: can we go through and beyond the conclusions of the dialectic of enlightenment for art? To ask what the possibilities of aesthetic theory are after Adorno involves rethinking and reconstructing the process and meaning of the enlightenment of art. Since the emancipation of art is the outcome of enlightenment, it requires that we *work through*—in both senses of the term—the logic of Adorno's model of enlightenment to find in its conclusions the ground for a theory of emancipated art, of postmodern art as the consequence of modern art. It demands a close reading

of *Philosophy of Modern Music,* not only because it is the seminal work of Adorno's aesthetic theory but also because it has not been the object of sustained exegesis and analysis in the Anglo-American world. Here the problem of translating Adorno has made a difficult argument even more difficult. (I have therefore modified the translation wherever necessary.)

Philosophy of Modern Music sets up opposed models of the consequences for the new music of the exhaustion of tradition. In part 1 my focus is "Schoenberg and Progress" and its model of aesthetic rationality, based on Adorno's "materialist" logic of the "laws of motion" of the musical material. Adorno's method of immanent critique—the unfolding of the inherent consequences of an object until it is transformed into its own critique—is applied to Adorno's argument and to Lukács's reification essay in *History and Class Consciousness.* The harmonic rationalization of music (Weber), unique to European culture, serves here not only to specify the parameters of Adorno's construction of musical progress as a dialectic of enlightenment, it also defines the limits of the application of occidental reason to art and the consequences of its transgression—as progress after the end of progress—for Adorno's aesthetic theory. The irrational as opposed to the rational foundations of Adorno's argument are examined in relation to Spengler's morphology of Western music and his Alexandrian thesis of the end of art.

In part 2 my starting point is Adorno's polemical dissection of Stravinsky's music. Unlike Schoenberg and his school, Stravinsky denies the objective logic of the material. Coming from the music of prebourgeois Russia, his celebration of primitivism announces the barbarian at the gates, who, once he has gained entry to the citadel, mocks aesthetic rationality by clownishly donning the costumes of the past. This refusal of the demands of the material defines the character of his music as schizophrenic: a kaleido-scope of dissociation, an arbitrary sequence of stylistic masks, which evades the immanent logic of progress by substituting repetition for development, theatrical gesture for self-expression, the parataxis of discontinuity for the syntax of inner continuity and identity.

Adorno's splitting of the new music into the authentic and the inauthentic (Adorno's "disastrous schema" of progress and resto-

ration) has a long legacy which extends to the ongoing debates on modernism and postmodernism. The unease aroused by the specter of historicism—eclecticism, time travel, decadence, parody, pastiche—runs through the debates and is exemplified by a series of direct and indirect responses to Adorno—Boulez's reply to *Philosophy of Modern Music;* the pleas of Jürgen Habermas and Albrecht Wellmer in relation to modern architecture for an immanent critique of modernism, which is its dialectical continuation, pleas which are taken up in turn in Bürger's reflections on the "decline of modern art"; the characterization of postmodernism by Fredric Jameson and Terry Eagleton as parody and pastiche— and by a critical consideration of Bürger's *Theory of the Avantgarde,* which points the way to a change of paradigm, opened up by Lyotard's critique of *Philosophy of Modern Music* in his essay "Adorno as the Devil."

In part 3, I seek to go beyond Adorno by returning to Hegel and the Jena romantics. First, Hegel constructs the enlightenment of art from the side of *freedom,* Adorno from the side of necessity. Second, the romantic's theory of *literature* offers an alternative model to Adorno's dialectic of enlightenment in music. On the one hand, the theory of romantic irony provides the vantage point for a reconstruction of the enlightenment of literature, for which parody and irony provide the critical index. On the other hand, romantic irony's articulation of the writer's freedom, which signified for Hegel the negative dissolution of art, points beyond Hegel's and Adorno's conclusions to the situation of art after the end of tradition. The theory of romantic irony arises from the awareness that the latency of tradition has been exhausted and is at the time the response to this situation of manifest contingency. In this sense the two models of enlightenment—Adorno's rationalization of music and the romantics' ironization of literature— converge in the Hegelian tabula rasa of the self-dissolution of tradition. The difference is that what Adorno interprets as the loss of aesthetic necessity and nihilistic indifference is conceived by the Jena romantics as the absolute freedom, whose ground is the recognition of contingency which ironizes all determinations.[24]

Literature thus offers an alternative to Adorno's negative diagnosis of the fate of "emancipated" music. My reconstruction of the dialectic of enlightenment in literature in terms of a dialectic

of the latent and the manifest, which draws on Niklas Luhmann's analysis in his *Soziale Systeme* of the function of latency for social systems and the relation between loss of latency and enlightenment, has three stages: closed (parody), dynamic (irony), and open (contingency). In the third stage, which I see as applying to the arts after the crisis of tradition in this century, the freedom of emancipated or postmodern art is grounded in the critical consciousness of contingency. And here the very indetermination of the open system of emancipated art makes contingency not only the ground but also paradoxically the source of the renewed latency of the system.

The logical terminus of the enlightenment of art is the point at which art conceives of itself as its own end, however construed. From this point art becomes its own question. My third stage, prefigured in romantic literature, is thus the stage of self-critique, in which with the end of tradition art becomes self-reflection on the level of the system, that is, the critique of art qua art. The enlightenment of art means that art has become its own metatheory, whose open, experimental possibilities make the question of art itself both the center and the indeterminate limit of the system.

Aesthetic theory can no longer claim a vantage point *beyond art*. Such closure of theory confronts aesthetic theory after Adorno with a double impasse. If Schoenberg spells out the consequences of progress as aesthetic rationalization for modernism, then Adorno's rejected other of modernism—Stravinsky's parody—prefigures for Jameson the totalizing of pastiche as the cultural logic of postmodernism. Baudrillard, heir to the melancholy science of Adorno and Walter Benjamin, is the radical voice of *this* dialectic of enlightenment, whose legacy is the nihilism of a postmodernity under the sign of simulation. As against our model of the emancipation of art Baudrillard's simulacrum as the "truth" of appearance embraces the fatal logic of indifference *beyond history*. The vantage point of *posthistoire* invites, however, as we have seen, the revenge of history. The dissolution of the grand—but terminal—narrative of European art into the (postmodern) pluralism of theory and artistic practice is itself an open-ended dialectic of art and enlightenment, which theory no less than art must reflect.

Two related aspects are considered in part 3. The grounding of the emancipated system of art in contingency foregrounds the experimental nature of the work of art. Perhaps the most striking instance is the incorporation of contingency into the work through the use of chance procedures (automatic writing, aleatoric music, action painting, happenings). Such a calculus of chance acknowledges the indifference of freedom and necessity, form and content, at the same time as it *renews* the latency of the system. By the same token montage can be understood as a recurrent organizational principle of indeterminacy, an open form which both manifests and stabilizes the contingent boundaries of the work. Similarly, the emancipation of art from the confining bonds of tradition is evident in the artist's sovereignty in relation to the forms and contents of earlier art. This freedom opens the *musée imaginaire* of world art, André Malraux's museum without walls. The legacy of the Western idea of enlightenment is a universalistic historicism, which alienates the arts of the past from their defining cultural bonds to become Art for us.

This open relation to the past involves on the one hand a radical cultural hermeneutics and on the other the crucial question for Benjamin and Malraux of the mutation of art in the age of mechanical reproduction. The *secularization* of art through reproduction can be read as the destruction or as the resurrection of aura. For Malraux reproduction meant that we could now grasp in the simultaneity of retrospection the art of Europe as *one* style. This retrospection, in which the five hundred years of ordered sequential change in European art ends in the avant-garde's explosion of progress, is the version of the thesis of the "end of art" which underlies my argument. It is the point at which the emancipation of postmodern art *from* tradition brings about the emancipation *of* tradition. (A crucial date here is 1905, the year in which the art of the South Sea Islands and Africa was discovered in the Dresden Ethnological Museum by Erich Heckel and Karl Schmidt-Rottluff, and in Paris by Picasso and Matisse.)[25] Montage and the museum are interrelated aspects of this process of emancipation, in which the reproduction of art is also to be seen as a process of enlightenment.

The nineteenth-century idea of freedom as self-determination and its immanent dialectic of the latent and the manifest with all

its ironies of the cunning of (un)reason from Hegel to Marx and Freud can lead either to the closure of Adorno's dialectic of enlightenment or to the idea of freedom as indeterminate possibility. It is for this reason that I set against Adorno's construction of the implacable necessity of aesthetic progress in Schoenberg's twelve-tone method of composition an analysis of Bertolt Brecht's foregrounding of contingency as an alternative example of the dialectic of art and enlightenment. The experimental unity of theory and practice in Brecht's epic theater corresponds to the stage of the self-critique of art: the break with the tradition of European drama and change of function of the theater are for him one with the transformation of art into practical theory. His version of enlightenment as a new stage of the *secularization* of art thus stands in the other secularizing, scientific tradition of the Enlightenment as the open-ended project of modernity. The point is not to present Brecht as the authentic representative of modernism but rather to see that Brecht and Schoenberg are two examples of the possibilities set free by the end of European tradition and the emancipation of art.

The Brechtian program of the representation of representation leads on to the focus of the final chapter: the ambiguities of the "dis-appearance" of aesthetic illusion after the explosion of the traditional limits of the aesthetic in the first decades of this century. Baudrillard's and Benjamin's versions of the "death of art" in the age of the media pose the crucial question of aesthetic illusion in postmodern art. In turn the question of aesthetic theory after Adorno is considered in the light of this "dis-appearance," which manifests a new stage of the dialectic of art and enlightenment constitutive for modernity since Hegel and the German romantics.

PART ONE

Progress

Schoenberg
and Progress

◻

Philosophy of Modern Music is the most powerful and cogent of Adorno's aesthetic writings. Conceived as an excursus to *Dialectic of Enlightenment,* the central work of critical theory, it is the key to Adorno's aesthetics. But just as the fate of *Negative Dialectics* is already sealed in *Dialectic of Enlightenment,* so too the fate of *Aesthetic Theory* in *Philosophy of Modern Music.* And just as a critical theory of contemporary society must disengage itself from the fatal embrace of the dialectic of enlightenment, so equally the possibility of a theory of modern (postmodern) art must resist Adorno's siren song of the end of art.

Philosophy of Modern Music is the most cogent and compelling expression of Adorno's aesthetics because it unfolds the immanent progress of art with relentless logic. And yet this work is not a unity. It comprises two parts, the essay "Schoenberg and Progress," written in 1940/41, and the essay "Stravinsky and Restoration," written in 1948, together with an introduction intended to bring out the "unity of the whole" (MM7). This unity may indeed be granted as the premise and the problem of the investigation, the situation of art since the end of tradition, specifically the situation of music since the end of tonality, but it is in fact a unity divided against itself. What the polemics of the Stravinsky analysis reveal, *independent* of any judgment of the artistic quality of Stravinsky's music, are the limits of the Schoen-

berg analysis. It is this break in the conception, the inapplicability of Adorno's construction of the progress of art as the dialectic of enlightenment to Stravinsky's oeuvre, comprehended as the refusal of musical reason, which comprises the crucial flaw in *Philosophy of Modern Music*. In defining the immanent limit of Adorno's aesthetic theory, this break within the argument situates his theory precisely in relation to its object: the break opened up by the end of tradition (tonality). The meaning of the end of tradition is a decisive question for a theory of modern (postmodern) art. It is the decisive, the constituting, question for Adorno's aesthetic of modernism and thus my point of departure for an analysis of "Schoenberg and Progress" and for a critique of Adorno's historical-philosophical aesthetic.

The analysis of "Schoenberg and Progress" is strictly exegetical. My concern is to follow the logic of Adorno's reasoning until that reasoning turns into its own critique. This is precisely Adorno's own method:

"[Philosophical history] viewed as the science of origins is that process which, from opposing extremes, and from the apparent excesses of development, permits the emergence of [the] configuration of the idea as a totality characterized by the possibility of a meaningful juxtaposition of such antitheses inherent in these opposing extremes." This principle, adhered to by Walter Benjamin as the basis of cognitive criticism in his treatise on the German tragedy, can also serve as the basis for a philosophically oriented consideration of new music. Such an investigation, restricting itself essentially to two independent protagonists, can even be founded within the subject of music itself. For only in such extremes can the essence of this music be defined; they alone permit the perception of its content of truth. (MM3)

Benjamin's principle of the configuration of the idea, in and through which the meaningful juxtaposition of the extremes appears, is grounded by Adorno in the object. The essence of the new music is to be found precisely in the extremes of Schoenberg and Stravinsky, "because the innovators by virtue of their uncompromising consistency have driven forward to the point that the impulses present in their works have become legible as concepts of the object of investigation itself" (MM4). Benjamin's "configuration of the idea" becomes Adorno's "construction of the idea,"

by means of which the unfolding of the idea in Schoenberg's and Stravinsky's music is followed "until the inherent consequence of the objects is transformed into their own criticism" (MM27). Adorno's construction of the idea as the dialectic of progress in the Schoenberg essay, which is confirmed by Stravinsky's "restoration" as the refusal of progress, does not lead to the totality, understood by Benjamin as the meaningful juxtaposition of oppositions, but to the break in Adorno's conception, for, as he writes, "the history of modern music no longer tolerates a 'meaningful juxtaposition of antitheses'" (MM5). The "objective" impossibility of dialectically mediating the "opposing extremes" signals the logical and historical limits of Adorno's aesthetic theory.

MUSIC AND PHILOSOPHY

The introduction to *Philosophy of Modern Music* has as its epigraph a quotation from Hegel, that art is concerned with the unfolding of truth. Art is thus for Adorno an object of philosophy, an object which carries truth in itself, but this truth is historical: the unfolding of truth is a historical process, and the truth of art is at the same time one objectification of the unfolding of the social-historical totality. The truth of art is grounded in its relation to the totality, but the form this relation to the totality takes guarantees art's autonomy. The work of art is a monad which carries the history of the totality within itself in the form of its material. The monadic work of art bears witness through the organization of its material to the contradictions of the historically unfolding totality. The development of art and society presupposes parallel autonomous processes, whose correlation is not given by reflection, that is, by the method of sociological attribution, but must be deciphered by philosophy. Such a philosophy of art as a philosophy of history can no longer assume, as Hegel could, the transcendental vantage point of the identity of subject and object as the truth of the totality. For Adorno this means the necessity of an *immanent* method of analysis, which operates with the Hegelian subject/object dialectic, but whose premise and conclusion is no longer synthesis and reconciliation but determinate negation, which denies transcendence and thereby ties itself irreversibly to history. If Hegel philosophizes history, Adorno irredeemably his-

toricizes philosophy: it is reduced to unfolding the history of progress as the progress of history.

The truth which philosophy unfolds is the dialectic of enlightenment, the history set in motion by the separation of man and nature, subject and object. The totality which the dialectic of enlightenment constructs is the negation of the Hegelian rationality of the real, for the historical hour in which Adorno writes is for him the "satanic parody" of the reconciliation of subject and object. Just as the objective order liquidates the subject, so the alien totality liquidates philosophy, which lives on only in the form of determinate negation, the message cast adrift for an unknown posterity (MM133). Philosophy survives its own end as self-negation, and it is this self-negation which defines in turn the *dialectical* relation of art and society, for the self-negation of progress to which Schoenberg's music is driven is both identical and nonidentical with the progress (reification) of society. This dialectic of identity and nonidentity both confirms and negates the dialectic of enlightenment. The correlation of art and society, objectified in the most advanced state of the artistic material, is the measure of the authenticity of the work of art, which is irreversibly bound to progress.[1] But this very correlation is also to be construed dialectically as determinate negation, for the truth of art is the truth of the untruth of the totality: the greater the correlation (identity) the greater the negation of the totality (nonidentity). The price of the truth of untruth, however, is necessarily an insoluble contradiction: "The guiding category of contradiction itself is twofold in nature: that the works formulate the contradiction and, in turn, through such formulation reveal it in the markings of its imperfections; this category is the measure of its success, while at the same time the force of contradiction mocks the formulation and destroys the works" (MM27).

The philosophical construction of the idea of the work of art is thus Adorno's task, to be achieved by means of an immanent method which reads from the organization of the material the hour of the historical world clock. The (self-)destruction of the work of art is one with the (self-)destruction of philosophy: both live on in the form of the negation of the untruth of the whole. It is thus clear why modern art and negative dialectics converge for Adorno. *Philosophy of Modern Music* is indeed a *philosophy* of

art, for in writing of the progress of art philosophy writes of its own progress. But at the same time of course it is also a philosophy of *music,* for the authentic work of modern art is the concrete expression of determinate negation, of negative dialectics, which philosophy is called upon to explicate. The new music is, for Adorno, authentic philosophy; Schoenberg is, as Adorno already termed him in 1934, the dialectical composer. The analysis of Schoenberg is the key to Adorno's idea of the new art because, quite apart from his profound love and knowledge of music, *music alone* can offer him the adequate "material" for his aesthetic theory: the transformation of Benjamin's "configuration of the idea" into the strictly immanent method of the "construction of the idea," demanded by his conception of the work of art as monad.

The correlation of aesthetic and social progress in terms of rationalization can best be exemplified through the autonomous language of music. Adorno never attempted to apply the progress of rationalization systematically to literature. Moreover, music is for Adorno *the* bourgeois art, *the* artistic medium of the bourgeoisie (MM24). Although Adorno claims that *all* European music, including that of the Middle Ages, is bourgeois (*bürgerlich*), it is quite clear that music for him means central European music from Bach to Schoenberg, at its center of course the first Viennese school from Haydn to Beethoven, the period of the classical style, of the supremacy of the sonata form, which enters into crisis in the late work of Beethoven. Beethoven and Hegel, both born in 1770, are the twin stars of Adorno's firmament (just as Goethe and Hegel are for Lukács): music and dialectics belong together, indeed are one, for the music which alone counts for Adorno is dialectical. This is the reason why Adorno is indifferent, even hostile, to all earlier music with the exception of that of Bach. And because *bourgeois* music is dialectical, it is the privileged object of philosophy. If Beethoven and Hegel, music and philosophy, belong together as *the* expression of the bourgeoisie in its heroic epoch, the age of the French Revolution, then how much more is this the case when the new music needs philosophy as its advocate and philosophy needs music as its concrete object. Beethoven and Hegel stand side by side, self-sufficient, but in *Philosophy of Modern Music* philosophy and music enter into sym-

biosis: the truth of the new music becomes philosophical, art becomes knowledge and philosophy becomes aesthetics, but also "aesthetic" theory, so that Adorno's late *Aesthetic Theory* remains the tantalizing and frustrating fragment, whose form expresses what it speaks of: the destruction of the organic work of art. Schoenberg and Adorno are thus both defined by their relation to the end of tradition, for when Adorno writes of the new music that it is the dialectical consequence of the old (MMII), this applies equally to the new philosophy.

The elective affinity, even identity, of music and dialectics as the great tradition, in which music is the artistic and dialectics the philosophical medium of the bourgeoisie, unmistakably defines Adorno's "German ideology," evident above all in his pronounced antipathy to politically engaged art, most notably that of Brecht. The work as monad alone can provide the adequate model of social correlation and dialectical negation. The example of music enables Adorno to assert the autonomy of art as an immanent historical process while at the same time insisting on the profound correspondence of the monad and the social totality. That this could be carried through, that Adorno could write a philosophy of music, realized through the construction of the idea of the work of art, a philosophy which avoids the twin temptations of reduction—the idealism of Hegel's system, with its transcendental philosophical knowledge, and the materialism of Marxist totalizations, whose method of sociological attribution, for which the work of art is mere illustration, ends in the undifferentiated condemnation of modern art as decadent—is the triumph of Adorno's method, the central contribution of his aesthetics. But what his method demands—"the concept must submerge itself in the monad until the social essence of its own dynamics becomes evident" (MM26)—could be fully realized only in the analysis of music. His philosophy of art is essentially a philosophy of music and it is this constraint of his immanent method which is the source of the strength and the limits of his aesthetic theory.

The question Why music? requires a double answer, since it is not only a question of the secret identity of music and dialectical philosophy, which makes both of them the determinate negation of the reified totality. The dialectical relation of negation to the

totality can articulate itself only through immanent analysis. The dialectical concept must submerge itself in the monad in order to discover in the "laws of motion" of the musical material the dynamic of social being. The dialectic must work through the language of music, through the historical material. The demonstration of the correlation of art and society, of the correspondence of microcosm and macrocosm, must prove itself through the "self-development of the concrete object" (MM26). This demonstration is possible because bourgeois music and society are understood as developing autonomously through the same iron law of progress (rationalization). The dialectic of enlightenment is inscribed within the monad, not only in the principles of its formal organization, dictated by the historical state of the musical material, but also in the very medium itself, musical language as the product of the rationalization of nature. It is precisely this progressive rationalization which defines the cultural specificity of European music and which enabled Max Weber to write *The Rational and Social Foundations of Music*.

Weber traces the evolution of *harmonic* differentiation, *unique* to Western music, from the church modes through to the establishment of the well-tempered scale about 1700, which through its rationalization of pitch makes the twenty-four major and minor scales fully compatible (transposable), thereby providing the basis for the full elaboration of tonality in the music of the bourgeois period from the middle of the eighteenth century on. Music, no less than architecture, mathematics, bureaucratic organization, systematic theology, or economic calculation, is for Weber part of the history of occidental reason, a process of development unique to Europe, which not only defines the specificity of the most diverse social and cultural phenomena in terms of the progressive principle of rationalization, but at the same time provides the dynamic of the transition from traditional (stratified) to modern (functional) societies, from cosmologically centered worldviews to decentered or differentiated worldviews. The bourgeois epoch of modernity thus signals the emergence of autonomous value spheres, emancipated from the tutelage of external legitimization and free to unfold their inner logic of self-validation.[2] This pluralization of value spheres and the consequent multiplication of partial worldviews simultaneously ra-

tionally disenchant the world and create an irrational polytheistic universe. This "entwinement of myth and enlightenment" lies at the heart of *Dialectic of Enlightenment,* which fuses Weber and Lukács into a dialectical model of instrumental reason, whose outcome is reification: the reversal of enlightenment, grown blind to itself, into myth.[3]

It is this dialectic of rationalization which is traced in "Schoenberg and Progress," and as we have seen, it is located in the movement of the musical material. Adorno writes: "Today art in its entirety, and music in particular, feels the shattering effects of that very process of enlightenment in which it participates and upon which its own progress depends" (MM 13). The "shadow of progress" (MM 14) cannot be dispelled: it is the consequence of the total enlightenment the new music strives for. Authentic art is thus not only the dialectical antithesis of the total control for which the culture industry aims but also its objective correlative. The rationalization of the musical material demands the progressive elimination of all given, "irrational" elements (conventions) of tradition. The unrestricted autonomy released by the progressive social isolation of art reduces the musical work to the absolute monad of a polytheistic universe, whose "totalized" rationality reveals the domination of one-sided interest. The absolute monad succumbs to the paralysis of an empty higher order in which the expressive elements of tradition have been transformed into undifferentiated material (MM 19). This logic of rationalization is the logic of the dialectic of enlightenment: absolute subjectification—that is, total control over the musical material—reverses into absolute objectification (reification). The integrated "identity" of subject and object, of expression and material ends in the indifferentiation (*Vergleichgültigung*) of the spirit. The following quotation shows how Lukács's analysis of the reification of bourgeois thought is *generalized* by Adorno into the "primal guilt" of the separation of mind and body, reason and nature—the Fall, which is the genesis of the dialectic of enlightenment—and at the same time *specified* in relation to the fate of music:

Music today, like all other expression of the objective spirit, is accused of creating a schism between the intellectual and the physical, between the work of the mind and that of the hands: the guilt of privilege—Hegel's

dialectic of master and servant—is extended in the final analysis, to the sovereign spirit dominant over nature. The further this creative spirit advances towards autonomy, the more it alienates itself from a concrete relationship to everything dominated by it—human beings as well as materials. As soon as it has come to terms with the last heteronomous and material factors of its own most particular realm—that of free artistic production—it begins to circle aimlessly, imprisoned within itself, released from every element of resistance, upon whose permeation it was solely dependent for its meaning. The fulfillment of freedom of mind occurs simultaneously with the emasculation of the mind. Its fetish character, is hypostatization as that of a mere form of reflection, becomes evident when it frees itself from its last dependence upon things which are not themselves mind, but which as the implicit content of all musical form lends "mind" its substance. Non-conforming music has no defense against the [indifferentiation] of the mind, that of means without purpose. (MM20)

The fate of the self-sufficient spirit, the reason which strives to dominate nature, is written in the fate of art, because for Adorno "free artistic production" is the central and most characteristic expression of the spirit. The very autonomy of art, understood as the unfolding of self-validation and as the fateful triumph of means over ends, completes the process of emancipation which threatens the death of art. Since the middle of the nineteenth century great music has broken with all social function, opening up an even greater gulf between itself and the public. All consensus of taste has disappeared, with the result that there is a complete break between traditional music and the new music, cemented by the irreversible caesura of the end of tonality.[4] The concert repertoire, confined almost entirely to music composed before 1914, reveals a public which clings to the canon of traditional music, robbed now of all critical substance and safely neutralized into a reified cultural inheritance. The new music exists in a social vacuum. Since the end of tradition, art has split into the irreconcilable antithesis of total isolation and mass consumption, avant-garde and culture industry, between which there is no middle way. Thus for Adorno aesthetic compromise stands self-condemned, it is simply aesthetic regression in the face of the "historical force" (MM6) of an irreversible progress which has destroyed tradition. The only art which counts is that of the

avant-garde, and the only philosophy of music which is possible is the philosophy of the *new* music.

The new is defined as the most extreme, that is, as the purest, most uncompromising consequence of the immanent logic of rationalization. But equally evidently, the new can be understood only as the dialectical consequence of the old. The avant-garde is defined in terms of its relation to tradition, or rather, can be defined only through its relation to tradition in terms of a dialectic of continuity and discontinuity. What place is allotted in this dialectical model—"Schoenberg and Progress"—to the opposed extreme, Stravinsky? It is that of the negative proof that the progress of rationalization cannot be escaped or denied. The analysis of Stravinsky in *Philosophy of Modern Music* must serve to show that there can be no retreat: if the immanent logic of music leads to antinomies, nothing can be hoped from the restoration of the old, from the deliberate refusal of this logic (MMxii).

It is of interest that the first formulation of the dialectical model—the little essay "Progress and Reaction" of 1930—arrives at a justification of Stravinsky's surrealistic style. The essential element of Adorno's comprehension of aesthetic progress is already established here in terms of the historical state of the musical material: progress is realized in the work of composition through engagement with the demands of the material at the most advanced stage of the historical dialectic. The concept of progress is directed here, however, against the calls for the restitution of the "primal meaning" of past musical phenomena, which is rejected by Adorno as the vain attempt to deny their irretrievable historical constitution. The deepest justification of Stravinsky's musical surrealism, comparable to similar tendencies in literature and painting, lies in the recognition of the impossibility of such a restitution. The surrealistic technique of the montage of the cultural debris of the past speaks of the true "meaning" of contemporary phenomena.[5] Progress serves here to justify the new, whether Schoenberg or Stravinsky, against the calls for restoration. In *Philosophy of Modern Music,* however, progress no longer encompasses the opposed extremes. The defense of the new has been transformed into the critique of the new, that is, into a critique of progress. From the sharper perspective of 1940–48, Adorno grasps far more clearly—and tragically—the crucial

issue of the new as the consequence of the end of tradition. The opposition of the old and the new must go now beyond the opposition of "progress and reaction" to become the dialectic of progress itself. Now, not only is the new the critique of the old, but equally important, the old is also the critique of the new. Only thus can the dialectic of progress fully unfold its negative truth, to find its most powerful and concentrated expression in the analysis of Schoenberg's music.

The result, however, of this extremely subtle and yet relentless analysis is paradoxically the rigid reduction of the new to Schoenberg and his school as the sole exponents of authentic music. Its problematic consequence resides not in the dialectical argument that Schoenberg is the only realization of progress, the break which alone continues tradition, but in the fact that Adorno can conceive of the *new* only as the self-completing destruction of tradition. The new music is thus *not* the new but the final consequence of tradition. Paradoxically and yet necessarily, *Philosophy of Modern Music* can look only backward from the vantage point of the end of tradition and the end beyond the end in the stasis of musical time and history.

FROM TRADITIONAL TO EMANCIPATED MUSIC

"Schoenberg and Progress" precedes *Dialectic of Enlightenment*. It is the first statement of the logic of this dialectic, for enlightenment and progress are one. The purpose of my analysis is to elucidate the structure of Adorno's argument, which rests on the *mutual* critique of traditional and emancipated music—a negative dialectic, which leads to a double contradiction. This mutual critique draws its validation from the irreversibility of progress, but the progress of progress simultaneously destroys this validation, driving Adorno on to a last dialectical reversal which seeks to escape the logic of progress.

The diagnosis is simple; sickness has befallen the idea of the work of art: "The work, the age, and illusion [*Schein*] are all struck by a single blow" (MM37). The changes which have taken place in music since 1910 cannot be grasped in the conventional terms of crisis and renewal. On the contrary, "under the coercion of its own objective consequences music has critically invalidated

the idea of the organic work" (MM29). Not only is the diagnosis simple, so too is in essence the analysis: emancipated music is the objective consequence of traditional music. The motive force of this necessity springs from the "assumption of an historical tendency in the musical material" (MM32): "As a previous subjectivity—now forgetful of itself—such an objectified impulse of the material has its own kinetic laws. That which seems to be the mere self-locomotion of the material is of the same origin as is the social process, by whose traces it is continually permeated" (MM33). Thus the "laws of motion" of society are inherent in the progressive development of the material, realized through the interaction of subject and object, the composer and his or her historically given material, which defines and prescribes the historically possible and necessary.

The historically possible and necessary—the inherent historical tendency of the material—is unfolded in the progression from Beethoven to Schoenberg, from traditional to emancipated music, as the objective consequence of tradition which negates tradition, that is, the organic work and its medium tonality. How does Adorno reconstruct the historical tendency of nineteenth-century music, that is, construct the necessity of Schoenberg's twelve-tone technique? For Adorno the "natural" development of the productive forces of music has been characterized by a blindness, whose outcome is incongruities: "The various dimensions of Western tonal music—melody, harmony, counterpoint, form, and instrumentation—have for the most part developed historically apart from one another, without design, and, in that regard, according to the 'laws of nature'" (MM52). These incongruities become, however, the "historical forces of the whole" (MM53), for the very process of the development and differentiation of the individual dimensions of the musical material gives rise to the idea of the rationalization of the blind "laws of nature," to the idea, that is, of the total organization of the elements of music, whose endpoint is a common denominator which unites all the dimensions. "This is the origin of the twelve-tone technique, which finds its culmination in the will towards the suspension of that fundamental contrast upon which all Western music is built—the contrast between polyphonic fugal structure and homophonic sonata-form" (MM53). Thus the process of the dif-

ferentiation of music from Beethoven on, which blindly but at the same time ever more compellingly sets free the possibility of rationalization, leads to the idea of the totally integrated work, which is not just the sum of bourgeois music proper (homophonic sonata form) but the subsumption of the whole history of Western music. The totally integrated work suspends in the synchronic integration of the twelve tones the diachronic totality of tradition.

The integral organization of the work of art has destroyed the organic work of tradition, and yet for Adorno it is "the only possible objectivity for the work of art today" (MM54). This outcome is the consequence of classical and romantic subjectivity, more exactly, the consequence of the subject/object dialectic in classical and romantic music. Classical music (bourgeois dialectical music) is defined by the new principle of autonomous aesthetic subjectivity, "which strove to organize the work freely from within itself" (MM55) by means of dynamic thematic development. The conventional organization of the material in baroque music is replaced by the idea of inner form, the synthesis of freedom and convention, through which music gains a new relation to time. Dynamic subjectivity in its dual aspect of thematic development and variation articulates time through the generation of identity and difference in a dialectical unity, which progressively dissolves after Beethoven into "the increasing preponderance of the dynamic forces of subjective expression which destroy conventional remnants" (MM56). The elimination of conventional remnants—the formal repetitions of the "empty passage of time"—is countered by the extension of variational development to the sonata form as a whole. This for Adorno is the great achievement of Brahms, "the advocate of universal economy," which is further developed by Schoenberg, who thereby takes up the line of succession from Beethoven and Brahms—"in so doing he can lay claim to the heritage of classic bourgeois music—in a sense very similar to that in which dialectical materialism is related to Hegel" (MM57).

The classical heritage, which strove for a balance between subjective dynamics and traditional, "tonal" language, left, however, the subject and the language of music untouched. The decisive change here came from romantic subjectivity, above all from

Richard Wagner. The dissolution of thematic integration through the use of the leitmotif and of tonality through chromaticism are the programmatic-expressive constituents of what Adorno calls Wagner's "nominalism of musical language." At the same time, however, the extreme means of romantic subjectification and differentiation—dissonance—reveals its emancipatory force through its destruction of the rational, "logical" harmonic relations of tonality. The dissonant chord transforms the homogeneous (repressive) unity of tonal harmony into polyphony. "Schoenberg, finally, asserts the principle of polyphony no longer simply as a heteronomous principle of emancipated harmony, . . . he reveals it as the essence of emancipated harmony itself" (MM58).

Dissonance, whose differentiation is possible only in relation to tonality, thus becomes the ferment of emancipation which leads on to the indifference of dissonance and consonance. The most subjective, expressive element becomes "the technical organ of the objective work" (MM59). This inherent tendency of the musical material is resumed and completed in Schoenberg's development. The atonal period of Schoenberg's music, the expressionist decade (1907–17), still lives from the expressive possibilities of dissonance, as the musical correlative of the "emancipated, isolated, concrete subject of the late bourgeois phase" (MM57). But the inadequacy of the "absolute monad" of emancipated individualism drives expressionism beyond itself. The subjective autonomy of expression must reverse into the autonomous objectivity of the work, which criticizes emancipated subjectivity: "If the contingency of individuality protests against the repudiated social law which once gave rise to this individuality, then the work designs schemata intended to overcome this very contingency" (MM50). And so from the final protest of threatened subjectivity in expressionism, which destroys the organic work, there emerges for Adorno not the freedom which overcomes the distance of art from "the immediacy of life" (MM49) but the affirmation of the concept of the work of art as total rationalization. At this point we can note in passing the contrasting and complementary position of Peter Bürger in his *Theory of the Avant-garde,* in which surrealism plays the central role in this dialectic of art and life accorded to expressionism by Adorno, who correspondingly rejects surreal-

ism's reification and mortification of the organic as opposed to the "organic irrationality" of expressionism (MM51).

The expressionist decade is the watershed which divides traditional and emancipated music. Still, this world-historical moment of the crisis and agony of tradition, which brings to an end the organic work, does not open the way to the "immediacy of life." On the contrary, since the last moment for the realization of philosophy has passed, philosophy and music continue as their own negation: "Late Schoenberg shares with Jazz—and moreover with Stravinsky—the dissociation of musical time. Music formulates a design of the world, which—for better or for worse—no longer recognizes history" (MM60).

The world which no longer recognizes history negatively completes Hegel. On the one hand, Adorno confirms Hegel's analysis: the principle of modernity—subjectivity—leads to the "contingency of individuality," which spells the end of art; on the other hand, Hegel's progress of the spirit to freedom is revoked: the very attempt to overcome contingency brings about the alien order which in liquidating subjectivity announces the end of history.

THE CRITIQUE OF TWELVE-TONE TECHNIQUE

I would be doing less than justice to Adorno's dialectical method, which seeks to unfold the logic of the object until it becomes its own critique, if I did not insist on the contradiction inherent in his (use of the) concept of the musical material. The "materialism" explicit in this concept must serve on the one hand to justify the primacy of technique, which makes "the most advanced level of technical procedures" (MM34) *the* deciding criterion of the state and fate of music. The second Viennese school of Schoenberg, Alban Berg, and Anton von Webern alone "does justice to the present objective possibilities of the elements of music and stands up to the difficulties involved without compromise" (MMxii). On the other hand, this same criterion, which singles out Schoenberg's technical procedures as the authentically new, is simultaneously used to unmask twelve-tone technique as the ultimate fetishization of music. That this contradiction is inescapable lies of course in Adorno's tragic conception of the historical inescapability of progress. This contradiction is, as we have seen, the

"guiding category" of *Philosophy of Modern Music:* the very success of works of art in formulating contradiction "mocks the formulation and destroys the works" (MM27). This means that Adorno simultaneously accepts and negates musical progress through identifying with it as the decisive index of aesthetic authenticity. This permits the contemptuous dismissal of Paul Hindemith and Stravinsky as technically reactionary, or the grudging acknowledgment in passing of Leoš Janáček and Béla Bartók. Only in Schoenberg and his school does progress find authentic expression, only here in the idea of the totally organized work does the historical tendency of the musical material come to fulfillment. And so it is only with Schoenberg that Adorno's materialist method—the identification with the progress of rationalization—attains its true object, can seize the objective consequence which turns into its own critique. Because the critique unfolds from *within* the movement of musical reason its logic is *suicidal:* the verdict is the self-destruction of music. The totally organized work calls forth the total indictment of the twelve-tone method of composition. The greatest advocate of Viennese serialism, which Jacques Attali has termed "the last formalization of nineteenth-century determinism," is also its most relentless critic.[6]

The most advanced level of technical procedures is the index of progress, the moving point of "material" necessity. It makes the composer the executor of the objective tendency of the material. The *measure* of this progress lies, however, in what progress destroys. The critique of the new can be understood only in relation to the old, of which it is the consequence. All the points of Adorno's indictment depart from his conception of classical music as the dialectical mastering of time. In the new music the "continuum of subjective time-experience is no longer entrusted with the power of collecting musical events, functioning as a unity, and thereby imparting meaning to them. The resulting discontinuity destroys musical dynamics, to which it owes its very being. Once again music subdues time, but no longer by substituting music in its perfection for time, but by negating time through the inhibition of all musical moments by means of an omnipresent construction" (MM60).

The power, or rather violence, of this omnipresent construc-

tion is that of a "system by which music dominates nature" (MM64), bringing to a conclusion the bourgeois longing to "reduce the magic essence of music to human logic" (MM65). The reduction of magic to reason ends, however, in the superstition of number games and astrology: "Twelve-tone rationality approaches superstition *per se* in that it is a closed system—one which is opaque even unto itself—in which the configuration of means is directly hypostatized as goal and as law" (MM66). For Adorno it is more than chance that the mathematical techniques of composition arose in the birthplace of logical positivism. Logical positivism's dream of "controlling calculation" (MM62) is not so distant from the practice of the twelve-tone composer, in whose game of musical calculation play reverses into the blindness of mythology. "The emancipation of the human being from the musical force of nature and the subjection of nature to human purposes" (MM65) reveals its fatal consequences: the emancipation from the musical force of nature not only unbinds the violence of controlling calculation, it turns against its originator in the form of the system he or she has constructed. The omnipotent constructor becomes the object of the omnipotent system, itself the creation of "subjective autonomy and freedom": "The subject dominates music through the rationality of the system, only in order to succumb to the rational system itself" (MM68). The subjection of nature ends in the subjection of the subject to a second blind nature. "To be sure, among the rules of twelve-tone technique there is not one which does not proceed necessarily out of compositional experience—out of the progressive illumination of the natural material of music" (MM68). But this process of progressive illumination, the purification of music from its decaying organic residue, is a process of *abstraction*. The dual nature of the work of abstraction, of the *conscious* disposition over the material—illumination and blindness—is summed up in Adorno's central materialist (deterministic) formulation of the dialectic of enlightenment: "Fate and the domination of nature are not to be separated. The concept of fate might well be patterned after the experience of domination, proceeding directly from the superiority of nature over man. The concrete is stronger than the abstract. Man has thereby learned to become stronger himself and to master nature, and in the process fate has reproduced itself.

Fate develops inevitably in steps: inevitably, because the previous superiority of nature dictates every step of the way. Fate is domination reduced to its pure abstraction, and the measure of its destruction is equal to that of its domination; fate is disaster" (MM67).

Applied to music, the judgment is this: "Twelve-tone technique is truly the fate of music. It enchains music by liberating it" (MM70). Fate must reproduce itself: the reason which dominates nature reverts to nature; the technical work of art which radically destroys aesthetic illusion becomes itself blind illusion; the totally functional work becomes totally functionless: "This process is inescapable. The dissolution of the illusory features in the work of art is demanded by its very consistency. But the process of dissolution—ordained by the meaning of the totality—makes the totality meaningless. The integral work of art is absolutely paradoxical" (MM70).

The absolutely paradoxical nature of the integral work of art derives from the paradoxical telos of rationalization, the process whereby the differentiation of the elements of music ends in their reduction to indifference. The reduction of the natural material of music to purely disposable "material" forms the recurrent focus for the analysis of the technical failure of the technical work of art, which turns the question of traditional music—How can musical meaning be organized?—into the question of emancipated music: How can organization become meaningful?

The musical work, which is predetermined, preformed by the twelve-tone row, destroys difference, that is, the differentiation alone possible in relation to an articulated system of relations, whether modal or tonal. The freedom of play in traditional music depended upon the difference of the musical dimensions, the absence of subsuming preformation; the totality was thus realized, as Adorno puts it, behind the back of the individual musical events. But once this totality has become conscious—in and through the preformation of the material—the individual, concrete relationships are sacrificed to the totality. Adorno's answer to the question How can organization become meaningful? is completely negative. The outcome is not a new synthesis of organization and meaning but the complete disjunction of construction and expression, where the will to expression evokes no more

than the ghostly echo of traditional music. "Twelve-tone technique elevated the principle of variation to the level of a totality, of an absolute; in so doing it eliminated the principle in one final transformation of the concept. As soon as this principle becomes total, the possibility of musical transcendence disappears, as soon as everything is absorbed to the same degree into variation, not one theme remains behind, and all musical phenomena define themselves without distinction as permutations of the row. In the totality of transmutation there is no longer anything which undergoes change. . . . This brings the tendency of the total history of European music since Haydn—and it was very closely interrelated to German philosophy of that time—to a standstill" (MM102).

The progress which brings the history of European music since Haydn to a standstill brings at the same time, however, that history into ever-sharper focus. If the critique of twelve-tone music is strictly immanent, it gains its meaning only from the perspective of the old. The negativity of the new illuminates the classical heritage. Precisely the challenge which confronts the new music and which defines its response—"By means of organization, liberated music seeks to reconstitute the lost totality— the lost power and the responsibly binding force of Beethoven" (MM69)—reverses perspectives. The *lost totality,* which makes Schoenberg's school the death mask of Viennese classicism, transforms the philosophy of modern music into the posthumous celebration of classical music, indeed of Western music itself: for if the order of twelve-tone music signifies the virtual extinction of the subject, the inexorable coldness of late Schoenberg is equally the only fitting response left to music *after its end (nach dem Untergang;* MM69).

The paradox of music after its end is inherent in the paradoxes of Adorno's construction of progress, which flow from the end without end of his dialectic of enlightenment. The movement of history which comes to a standstill calls forth a negative dialectic which allows no resting place. From the end without end springs the restless motion of Adorno's dialectic: not the historical energy of transformation but the negativity which circles ceaselessly within the iron cage of universal reification, destroying all fixed positions, all positivities in the search for transcendence. Thus the

old and the new, traditional and emancipated music, enter into a dialectic which is their mutual critique. In order to reconstruct this dialectic we must relate twelve-tone music to that which it negates and which at the same time is its negation: bourgeois dialectical music. And in a second step we must read this dialectic from its other side: emancipated music as the truth revealed and realized through the destruction of the ideology of illusion (*Schein*) in the organic work of art.

NEGATIVE DIALECTICS: THE TRUTH OF EMANCIPATED MUSIC

In twelve-tone music the subject/object dialectic, the dynamic principle of European music since Haydn, cancels itself in a final dialectical turn. The emancipation of the material following the collapse of all "restricting principles of selection in tonality" (MM 51) appeared to open up unlimited freedom. But total freedom—the anarchy of atonality—demands order, an order which manifests itself as the totally subjective freedom of the arbitrary disposition of the emancipated material. Total freedom thereby reverses into total determinism. The very hypertrophy of subjectivity is transformed into the extinction of freedom. As Adorno puts it, twelve-tone music executes the sentence that unchained subjectivity passes on itself, for the totality which has become totally conscious of itself is struck by blindness. By contrast, as we have seen, it is the opaqueness of the object (the musical material as nature, as the Kantian thing-in-itself) which is the motor of progress (rationalization) in traditional music. It alone ensures the freedom of play, the dynamic tension of concrete relations, behind whose back the totality is realized. "Traditional music had to content itself with a highly limited number of tonal combinations, particularly with regard to their vertical applications. It had further to content itself with rendering the specific continuously by means of configurations of the general, which these configurations paradoxically present as identical with the unique. Beethoven's entire work is an exegesis of this paradox" (MM 51). This dialectic of the general and the specific is realized through the technical principle of development which entrusts organization to autonomous subjectivity. Development—that is, the sub-

jective reflection of the theme—becomes the justifying impulse and center of dynamic form, whose potentiality is unfolded in the dialectic of identity (theme) and nonidentity (variation). Through such "nonidentity of identity" (MM56) music gained a new relation to time. The synthesis of repetition (exposition and reprise) and difference (development) in the sonata form, which permits identity in variation and variation in identity, sums up for Adorno the central achievement of classical music: the mastering of time. "The concept of the classic in music is defined by this paradoxical relationship to time" (MM56).

Against this, the totally integrated work of twelve-tone technique makes "composition a parable of fatal integration" (MM74). The end of the subject/object dialectic of bourgeois music is the reflection of the end of bourgeois individualism. Just as musical meaning disappears in the indifference of integration, so the dialectic of bourgeois identity (development) is extinguished in the "totality of the social process." The decisive *technical* antagonism of music since Beethoven—"the antagonism between traditional tonality—which is in constant need of reconfirmation—and the substantiality of the individual"—is thus the mirror of the social-historical dialectic of subject and object: "If Beethoven developed a music essence out of nothingness in order to be able to define it as a process of becoming, then Schoenberg in his later works destroys it as something completed" (MM77).

And if we go back behind bourgeois dialectical music, then the most emphatic title of honor that Adorno advances for the new music—"for the first time, however, since the waning of the Middle Ages—and in an incomparably more rational disposition over the means—twelve-tone technique has crystallized into a genuine polyphonic style" (MM90)—is not spared the same verdict. The indifference of the vertical and the horizontal, which reveals polyphony as the essence of emancipated harmony, destroys by the same token the articulated system of relationships given by tonality, and thereby the possibility of counterpoint: "The old connecting means of polyphony functioned only in the harmonic realm of tonality" (MM92). Twelve-tone technique cannot, however, replace tonality. Bach's synthesis of harmony and polyphony remains incomparable. His superiority in the realm of polyphonic music lies not in the horizontal aspect as

such "but rather [in] its integration into the totality of harmony and form" (MM94). Once again the "essential" argument of difference applies. Music, whether polyphonic or homophonic, can realize itself only in the dialectical engagement with itself as its other, as musical essence per se: "In Western music, counterpoint itself could be understood as the expression of the differentiation of dimensions. Counterpoint strives to overcome this differentiation by giving it formation. . . . It [counterpoint] has its right to existence only in the overcoming of something not absorbed within it, and thus resisting it, to which it is 'added.' Where there is no longer any such priority of a musical essence *per se* by which counterpoint can be measured, it becomes a futile struggle and vanishes in an undifferentiated continuum" (MM95).

As we have seen, the progress of music to indifference is the logic of differentiation which blindly enacts the dialectic of enlightenment. This progress is nevertheless a process of enlightenment, a process of the progressive illumination of the material. On the one hand the outcome of this dialectic is the coincidence of total illumination and total blindness: in the totally rationalized system of twelve-tone technique, which has become opaque to itself, the subject/object dialectic is suspended. On the other hand by this very process, through which progress destroys itself, *progress comes to self-knowledge.* The illumination of blindness defines the paradoxical truth of the new music, which comes to self-knowledge in philosophy. Progress comes to self-knowledge in its completion and self-destruction. From the final vantage point of complete illumination aesthetic progress can be grasped as the progressive differentiation and rationalization which depended on the resistance of the material, its irreducible otherness (opaqueness). The final—blind—mastering of the material thus lays bare the *necessary* blindness of traditional music: the illusory appearance (*Schein*) of the identity of subject and object in the organic (closed) work of art. It is necessary to quote at greater length here in order to follow this crucial turn in Adorno's (negative) dialectic of the old and the new:

The hermetic work of art was not interested in [knowledge] (*Erkenntnis*), but rather allowed [knowledge] to vanish within itself. It designed itself as the object of mere "observation," obscuring every [fissure] (*Bruch*) through which thought might evade the direct actuality of the

aesthetic object. In so doing, the traditional work of art refrained from thought, renouncing its binding relationship to that which it cannot be in itself. The work of art was as "blind" as (according to Kant's doctrine) non-conceptual observation is "blind." The idea that the work of art should manifest observable clarity leads to the illusion that the dichotomy (*Bruch*) between subject and object has been overcome. [Knowledge] is based upon the articulation of this [dichotomy]: the clarity of art itself is its illusory appearance. It is only when the work of art has been thrown into confusion that it throws off the clarity of its hermetic character, discarding the illusion of appearance at the same time. It is [posited] as the object of thought and participates in thought itself: it becomes the vehicle of the subject, whose intentions it communicates and defines; whereas in the hermetic work of art, the subject—by intention—is simply submerged. The hermetic work of art upholds the identity of subject and object. In the [disintegration] (*Zerfall*) of the hermetic work this identity reveals itself as an illusion, underscoring the right of [knowledge], which contrasts subject and object with each other as the greater and moral right of the work of art. Modern music absorbs the contradiction evident in its relationship to reality into its own consciousness and form. By such action it [raises itself to knowledge]. (MM124)

The reversal carried through here contradicts Adorno's previous argument: the subject/object dialectic, which made classical music the objective expression of free autonomous subjectivity, is now grasped as the intentional submergence of the subject in the closed work, whereas the twelve-tone system, which extinguishes the subject, is grasped as the vehicle of the subject. The necessity of this turn is earlier to concede than follow, but it lies in the very nature of Adorno's negative dialectic and demands in turn that we try to reconstruct the argument from this vanishing point of negation.

In the closed work of art knowledge is both articulated and confined through the *form*. Form, as the expression of the possibility of reconciliation, is a "judgement pronounced against the negative aspects of the world" (MM125). It is a judgment, because it points to the possibility of overcoming the contradictions of reality, but in the process "the aesthetic form is also transformed into the moment in which the act of [knowledge] ceases. Art, as the realization of the possible, has always denied the

reality of the contradiction upon which it is based" (MM125). It is precisely in this sense that the traditional work of art is closed, that is, enclosed in the illusion of appearance. Nevertheless, this blindness to the world, objectified in the form, alone makes the closed work the medium of necessity, the medium of the progress which ends by no longer concealing the dichotomy of subject and object, thereby laying bare form as naked construction and releasing in the fragmentary, self-renouncing work the critical substance of the closed work of art of tradition. "For it is only in the realm of necessity—manifested monadologically by hermetic works of art—that art is able to acquire that power of objectivity which finally makes it capable of [knowledge]. The basis of such objectivity is that the discipline, imposed upon the subject by the hermetic work of art, mediates the objective demand of the entire society, about which society knows just as little as does the subject. It is critically elevated to the position of evidence in the same moment in which the subject destroys discipline" (MM126). The destruction of discipline, the disintegration of the closed work can become, however, an act of truth "only when it includes the social demand which it negates" (MM126). The *opening* of the work to the objective imperatives of society is thus the moment of its truth and simultaneously of its total alienation. The subject withdraws, abandoning the empty space of the work to the "socially possible": "The liquidation of art—of the hermetic work of art—becomes [the] aesthetic question, and the growing indifference of [the] material itself brings about the renunciation of the identity of substance and phenomenon in which the traditional idea of art terminated" (MM126). The hollow shell of the work—naked form and a naked subjectivity which withdraws— bears witness not only to the end of the subject/object dialectic but also in this liquidation of art to that which lies beyond.

By the "liquidation of art" Adorno means the destruction of the closed work of art, the end of the tradition of tonal music from Monteverdi to Mahler. What thereby comes into focus is the new music, music after the downfall of music, not only as the final consequence of the dialectic of progress but also as the hollow space of a dialectic beyond dialectic, from which springs Adorno's search for the redemption of expression. The argument is this: "All organic music proceeded out of the *stile recitativo*. From the

beginning this was patterned after speech. The emancipation of music today is tantamount to its emancipation from verbal language, and it is this emancipation which flashes [in] the destruction of 'meaning'" (MM128). If organic music is defined by its *semantics,* then the "meaninglessness" of modern music must be understood as the rebellion of music against its own meaning, whose outcome is the "dissociation of meaning and expression" (MM128), which in liberating expression from the consistency of language liberates it at the same time from subjectivity. What Adorno appears to be envisaging here is the liberation of expression which flows from the end of the confining "discipline" of traditional music, whose corollary would be the liberation of the subject from all the confining historical forms of repressive self-identity. Liberated expression would thus express the reconciliation of man and nature in a mimesis beyond the compulsions of the domination of nature. "Subjectivity—the vehicle of expression in traditional music—is by no means the last substratum thereof. It is this as little as the 'subject'—the substratum of all art down to the present day—is actually man himself. The beginning of music, in the same manner as its end, extends beyond the realm of intentions—the realm of meaning and subjectivity" (MM128). The release from the self as subject and intention sets the "arrested human being" free and opens the way to reconciliation: "The human being who surrenders himself to tears and to a music which no longer resembles him in any way permits the current of which he is not part and which lies behind the dam restraining the world of phenomena to flow back into [himself]" (MM129).

Adorno's "natural theology" of expression is the hope beyond hope of his negative dialectic, which makes the ultimate focus of his aesthetics not so much utopian as mystical: the mystery of mimesis, of identity beyond identity. Mimesis, however, emerges not only beyond meaning but also beyond historical truth. We must therefore return to the "dialectical composer" Schoenberg, and to the dual trajectory of Adorno's justification of the truth of modern music, in a final step which resumes the argument of "Schoenberg and Progress."

For Adorno, Schoenberg's whole work with all its reversals and extremes is to be understood as a dialectical tension between expression and construction. It drives him from atonal expres-

sionism to the idea of the objective work of the New Objectivity and beyond that to the search for the restitution of expression in his late compositions. The decisive moment in this process is the *break through* of trauma and shock in the prewar years, 1907–13. Schoenberg's intensification of romantic expression takes it to its "logical conclusion" (MM38), in which it turns as the objective consequence of tradition against tradition, destroying the formal mediation of expression as the representation of emotion: "Dramatic music, just as true *musica ficta,* from Monteverdi to Verdi presented expression as stylized communication—as the representation of passions" (MM38). The revolutionary change in the function of expression accomplished by Schoenberg lies in his attack on the taboo of form, which subjects unmediated expression to the censorship of rationalization (MM39). The eruption of trauma and shock shatters the self-sufficient autonomy of the closed work of art, releasing expression as knowledge—as the truth of the real, "untransfigured suffering of man." Schoenberg's radicalism denounces the reconciling subsumption of the individual under the general, which constitutes for Adorno the innermost principle of musical illusion (*Schein*). Modern music becomes knowledge through its negation of illusion and play, which are inseparable from the "domination of conventions" (MM40). Adorno leaves no doubt as to where his sympathy lies—it is with the heroic Schoenberg, who breaks through the taboo of form to untransfigured *expression,* and not with the self-reifying logic of *construction* as the dialectical response to the anarchic subjectivity of expressionism. But of course it is the logic of this dialectic, the necessity of this progression which Adorno must unfold, and it reveals the dual nature of the truth of the new music as *both* expression and construction, which is at the same time the truth of their irreconcilable opposition.

If the question which the new music posed was How could organization become meaningful? the answer of construction posed in turn the question How could organization become expressive? "The actual experiences of Schoenberg's generation had to shatter his ideal of the objective work of art—even its positivistically disenchanted form: likewise, the blatant emptiness of the integral composition could not escape his musical ingenuity. The most recent works pose the question: How is [construction] to

become expression?" (MM98). The late works pose but do not answer the question. For Adorno they stand as magnificent failures, for their renewed dynamic, expressive impulse is contradicted and neutralized by the twelve-tone technique, whose predetermination of the material resists thematic development, with the paradoxical result that "the rigid apparatus of twelve-tone technique strives for that which once arose more freely and at the same time with still greater necessity out of the [disintegration] of tonality" (MM103). The new will to expression thus presents the image of "break out" within the "iron cage" of construction as a new stage of the conflict between alienated objectivity and limited subjectivity. The truth of this conflict is its irreconcilability. The blind objectivity of the rational system drives Schoenberg on to compose twelve-tone music as though twelve-tone technique did not exist (MM110). It is this dialectic against the dialectic of enlightenment which likewise drives Adorno on to the final turn of his argument:

The possibility of music itself has become uncertain. . . . It flees forward into order. However, success is denied it. It is obedient to the historical tendency of its own material—blindly and without contradiction. To a certain degree it places itself at the disposal of the world-spirit which is, after all, not world-[reason]. In so doing its innocence accelerates the catastrophe, in the preparation of which the history of all art is engaged. Music affirms the historical process and therefore history would like to reap the benefits thereof. Music is doomed, but this historical process in turn restores it to a position of justice and paradoxically grants it a chance to continue its existence. The [end] (*Untergang*) of art in a false order is itself false. Its truth is the denial of the submissiveness into which its central principle—that of consistent correctness—has driven it. As long as an art, which is constituted according to the categories of mass production, contributes to this ideology, and as long as its artistic technique is a technique of repression, that other, functionless art has its own function. This art alone—in its most recent and most consequent works—designs a picture of total repression but, by no means, [its] ideology. By presenting the unreconciled picture of reality, it becomes incommensurable with this reality. (MM112)

This final turn transforms the false into the true, identity into nonidentity, the untruth of construction into the protest against

total integration: "The inhumanity of art must outdo the inhumanity of the world for the sake of the humane" (MM132). "The shocks of incomprehension, emitted by artistic technique in the age of its meaninglessness, undergo a sudden change. They illuminate the meaningless world. Modern music sacrifices itself to this effort" (MM133).

This "sudden change" transmutes the dialectic of enlightenment into negative dialectics. And so the illumination of the meaningless world emitted by the totally integrated work simultaneously casts its light over the history of the dialectic of necessity—progress—which has now come to an end, and which art in fulfilling always sought to resist: "The intense desire of the work of art to withdraw itself from the dialectic which it obeys might well be viewed as its central concern. The works react to the [affliction of dialectical compulsion]. For art, this represents the incurable [sickness] caused by necessity. At the same time, however, the formal [laws] of the work, which arise from the [dialectic of the material, cut this dialectic off]. The dialectic is interrupted—interrupted, however, by no force other than the reality to which it is related—that is to say, [by] society itself" (MM132). But this very cessation of the dialectic, which freezes the work into the image of blind necessity become total construction, also reveals the truth of *expression*. For Schoenberg's resistance to the "affliction of dialectical compulsion" through the impulse to restitute expression points to the one hope for doomed music—the freedom beyond the compulsion of the system announced by his refusal of aesthetic necessity. Again, the dialectical reversal is summoned against the dialectic of enlightenment: the "dialectical composer" brings the dialectic to a halt (MM124). The dialectic of the musical material—the process whereby differentiation ends in indifference—is once more recalled to win from indifference its paradoxical truth as the coming to self-knowledge of progress.

As we have seen, the terminus of the domination of musical nature is the indifference which marks the suspension of the subject/object dialectic, the end, that is, of musical history. But this history was always a history of dialectical compulsion, of the "incurable sickness caused by necessity" (MM132), which the work of art, in obeying, always desired to escape, for this compul-

sion springs from the inextricable entanglement of the subject in the material, in the double sense of the entrapment in "natural matter" (*Naturstoff*) and of the domination of nature (*Naturbeherrschung*). And so the indifference of the material can now be posited as the point at which the composer is released from the domination of nature which constituted musical history (MM118). The destruction of the work of art as *aesthetic totality*, whether the organic work of traditional music or the vain attempt at its reconstruction through twelve-tone technique, is thus the (necessary) goal of progress which releases music from necessity. What is left is the *fragmentary work*: "Musical language dissociates itself into fragments. In these fragments, however, the subject is able to appear—[indirectly] 'in its significance,' as Goethe might have said—[whereas the bonds] of the material totality [held] it in their spell. The subject—trembling before the alienated language of music which is no longer its own language—regains its self-determination, not organic self-determination but that of superimposed intentions. Music becomes conscious of itself as the [knowledge], which great music has always been" (MM118).

The dialectic of the old and the new is thus finally reversed and completed. The new music is the self-consciousness of the aesthetic totality of tradition, which it has destroyed. In destroying tradition emancipated music has been released from necessity to become *knowledge*. It is no longer ideology, for it lies beyond the illusion of aesthetic necessity.

ADORNO'S PROGRESS

The Schoenberg essay unfolds the logic of progress. From it can be read the trajectory of Adorno's philosophy. Its origin is the lost totality of Hegel's system, which is transformed by means of its Marxian materialist inversion into the "satanic parody" of the blind totality. If philosophy is the truth of history, it is because history dictates its truth to philosophy, and this truth is that of the end of history. The full time of history—the time of music—has become the empty time of repetition: the eternal return of the same in the twelve-tone row is the microcosm of the reified social totality which no longer knows history. The dialectic of enlight-

enment reverses the Hegelian progression to freedom into the inescapable progression to unfreedom: the liquidation of the subject and the organic work of art. The dialectic of enlightenment thus drives Adorno on to negation as the sole expression of freedom. The negativity of the authentic work of art beyond progress and history leaves it suspended as "determinate negation" between the blind totality of second nature (construction) and the true mimesis of first nature (expression). The end of musical history is to be read in two ways: as the self-destructive hypertrophy of the domination of nature but also as opening up through the disintegration of the aesthetic totality a space for liberated expression beyond "the realm of meaning and subjectivity."

Adorno's trajectory from the dialectic of enlightenment to negative dialectics is accomplished in a double movement. The construction of the idea of the modern work of art, defined by the dissociation of construction and expression, involves a dialectical critique of the old and the new. Simplifying, we can say that the construction of progress as "material reason," unfolded by the dialectic of enlightenment, is the critique of the new by the old. If Schoenberg's music is the objective consequence of tradition, his tragic fate is the faithfulness to tradition which destroys it. Against this, the negative dialectic opened up by the end of tradition—the totality *within* which progress brings to completion the domination of musical nature—permits the critical revision of tradition, that is, the critique of the organic, the closed, work as ideology. This double movement of Adorno's dialectic is paradoxical. The medium and motor of progress is the subject/object dialectic, which unfolds as the history of freedom within the objectivity of the aesthetic totality (individually, the work of art; collectively, tradition). Closure—the aesthetic totality—is the condition of the freedom of the subject, progress, and thus history. The end of aesthetic necessity brings the end of freedom. Beyond freedom lies the *negative* freedom of total negation, that is, the negation of the alien social totality, which has invaded and alienated the work from itself. The iron cage of reified rationality dispossesses the subject and releases him or her into the truth of negation: suffering.

Underlying Adorno's *construction* of progress is the *expres-*

sion of his longing to escape the self-alienating compulsions of necessity and identity in the redemptive reconciliation of reason and nature, the longing to escape the separation of spirit and matter, to escape the Fall, which chained the spirit to material necessity. In this sense the resistance of Odysseus, chained to the mast, to the siren song of nature, is the moment of the birth of music, which always carries within itself, even in its most trivial manifestations, this *promesse de bonheur,* whose authentic expression now is the untransfigured suffering of humankind. But the end of music *also* releases the song of the sirens, no longer imprisoned, objectified, and alienated in form. It is the dream of mimesis. Adorno's philosophy of the end of music is thus deeply ambivalent, for it is both the affirmation and negation of progress in a double sense. First, from the side of objectivity (necessity) it traces the progress of musical rationalization as a dialectic of enlightenment whose terminus is the stasis of indifference. Second, from the side of subjectivity (freedom) the self-negation of progress is finally affirmed as the possibility of liberation from the domination of nature which always constituted musical history.

Nevertheless, total negation offers no issue within the realm of history frozen into stasis. The end of history and the end of music may metamorphose the historical dialectic into negative dialectics, but such negative transcendence cannot revoke the conclusions of progress: that the antipodes Schoenberg and Stravinsky belong together.

The common view projects Schoenberg and Stravinsky as being diametrically opposed. Stravinsky's masks and Schoenberg's constructions actually present [at first sight] slight similarity. Yet it can very well be imagined that some day Stravinsky's unrelated juxtaposed chords and the succession of twelve-tone sounds—the connecting threads of which are severed, as it were, by the command of his system—will some day no longer strike the ear as so distinct from one another as they do today. It is rather that they designate different levels of consequence within the same realm. Common to both, by virtue of their command over [the atomized elements], is their claim to [binding force] and necessity. The aporia of impotent subjectivity becomes apparent to both and assumes the form of an unconfirmed norm which is nonetheless dominant. In the works of both objectivity is [posited] subjectively—though to be sure, on totally

different levels of formulation and with unequal powers of realization. In the works of both, music threatens to [freeze] in space. (MM71)

Progress and reaction converge in the indifference of time and space. This convergence is the limit of progress which signifies the limit of Adorno's aesthetics.

Dialectics
Finale

⌐

ADORNO'S CONSTRUCTION OF MODERN ART

Adorno's aesthetic of modern art stands and falls with his dialectic of progress. Its central statement is the Schoenberg essay. The elaborations of the late *Aesthetic Theory* add nothing essentially new; rather they confirm the impasse of "Schoenberg and Progress." Not only is *Aesthetic Theory* incapable of going beyond the limits of the earlier construction, it even retreats from its logic to circle endlessly, inconclusively, in the empty space of a modernism which has lost all historical contours, has been evacuated of all historical events and figures merely as the backdrop to the invocation of the exclusive pantheon of authenticity—Schoenberg, Marcel Proust, Paul Klee, Pablo Picasso, Franz Kafka, Samuel Beckett. *Aesthetic Theory* is Adorno's *Endgame* and this is hardly surprising, since nothing can happen anymore. That, after all, is the logic of the end of progress and history. *Aesthetic Theory* is therefore repetition, but a repetition which is made inconclusive by the very compulsion to repeat: its appropriate image is that of Clov reiterating his intention to make his final exit on the threshold he cannot cross. The end which is no end is the equivalent of the progress which cannot come to rest. It is only appropriate that the reflections on progress in art and the relation between aesthetic progress and artistic technique in *Aesthetic Theory* end with Beckett:

Unconcerned with development in its commonly understood form, Beck-ett views his task as moving in an infinitely small space, ultimately a one-dimensional point. This is a trans-static principle of construction, truly a principle of *il faut continuer*. It is also trans-dynamic in that it "marks time," shuffling its feet and thereby confessing to the uselessness of dynamics. The only *telos* towards which the dynamic of the immutable moves is perennial disaster. Beckett's writings face this unpleasant truth squarely. Consciousness exposes the infinity of self-congratulatory prog-ress as an illusion dished up by the absolute subject. Social labour defies aesthetically the bourgeois pathos of subjectivity, because the abolition of labor is within reach of being realized. What puts a stop to dynamics in art works is both the prospect of the abolition of labour and the threat of death by freezing. Both tendencies well up objectively in art; art cannot choose between them. Since the potential of freedom is scuttled by social conditions, it cannot come to the fore in art either. This accounts for the ambivalence of aesthetic construction. Construction is able to do two things: it can codify the resignation of the emaciated subject, and promote absolute estrangement by incorporating it in art; or it can project the image of a reconciled future situated beyond statics and dynamics. There are many linkages between the principle of construction and technocracy, linkages that reinforce the suspicion that construction belongs inevitably to the administered, bureaucratized world. Yet it may also terminate in an as yet unknown aesthetic form, the rational organi-zation of which might point to the abolition of all notions of administra-tive control and their reflexes in art. (AT319)

Progress dissolves into the ambivalence of the indifference of the dynamic and the static, to be construed as both the "one-dimensional point" of entropy and the image of reconciliation beyond the confines of the administered world. Such a final per-spective finds its appropriate formulation in Beckett's ironic "il faut continuer." It leads Adorno to assert in response to Hegel's "prognostication of the end of art": "The reason why there is still art and progress in art is that there has been no progress in the real world. *Il faut continuer*" (AT297). That Adorno's aesthetic the-ory remains predicated on the most advanced consciousness re-veals the consequence and inconsequence of his position:

The truth content of works of art, which ultimately determines their rank, is historical through and through. . . . history inheres in works of

art. It is not some extraneous fate or a change in evaluation. Truth content becomes historical when true consciousness is not a vaguely conceived *kairos* or timeliness. If it were, it would merely sanction the temporal course of a world that is anything but the unfolding of truth. Correctly understood—and speaking from the perspective of possible freedom—true consciousness refers to the most progressive consciousness, which is one that is aware of contradictions within the horizon of possible reconciliation. What determines whether a consciousness is advanced or not is the development of the artistic forces of production in the work, and that includes—at least in an age where reflectiveness is constitutive of art—the position it takes socially and politically. Truth content in art works is the materialization of the most advanced consciousness, including the productive critique of the status quo in art and outside of it. (AT273–74)

The essential elements of Adorno's theory of modern art are contained in this passage. Here it is not a question of explicating philosophy's role in disclosing the truth content of the work of art as "unconscious historiography" but of drawing out the implications of the materialist metaphor, the development of the artistic forces of production. By binding the work of art to the objectivity of the unfolding of the forces of production (cf. AT275), aesthetic production acquires an objective criterion, which is all the more value laden because it is apparently value free. The demands of the material are deemed self-legitimating: their realization defines the line of aesthetic progress—to refuse the demands of the material is reactionary, that is to say, irrational. Thus Adorno claims to speak in the name of aesthetic necessity. If progress has reduced the artist to the executor of the demands of the material, by the very same token it elevates the philosopher to the executive voice of progress, that is, to the role of pitiless executioner: "Nowhere can the historical essence of art be seen more clearly than in the qualitative irresistibility of modern art; the thought of inventions in the field of material production is no mere association. Important works of art tend to destroy everything that is contemporaneous but fails to live up to the standard of modernity. One reason why so many of the well educated close themselves off from radically modern art is their angry displeasure at having to witness the decomposition of traditional artistic values brought

on by the murderous historical force of modernity" (AT50). The legitimation of the new derives from the "murderous historical force of modernity." The technical standard of the authentic modern work annihilates its competitors. The deciding criterion of radicality is "artistic technology" (AT51). Progress therefore is the key to Adorno's "material concept of modern art" (AT50), which categorically distinguishes the new from the old, the "materially modern" from traditionalism's illusion of the organic nature of art. Material and artistic production converge in the rationality of the functional work of art, which is the only possible form today of aesthetic rationality. Construction is termed the representative of logic and causality in the monadic work of art (AT84).

Aesthetic Theory does not lead us out of the paradoxes of "Schoenberg and Progress," the power of whose argument lies in the dialectic of a progress which destroys itself. The dissolution of the organic work of tradition comes to its culmination and conclusion in the material rationality of the work of integral construction. And yet, thirty years later the most advanced techniques are resurrected as the still-decisive criterion of modern art. Progress has ceased and yet it continues: the outcome is the *timeless* epoch of modernism, whose determining feature is supposedly the "murderous historical force of modernity." Since the modernity of art is defined as the response to, and thus the product of, industrialization (AT50), we must assume a continuity from Baudelaire to Beckett and beyond, an apparently endless continuum of indifference, for the progress which has frozen time into space can know only the eternal return of the same, as indeed might well be argued of the age of mass culture as an age of repetition under the domination of the commodity. Adorno, however, cannot register the end of progress, while simultaneously retaining the concept as the authentic stamp of the new. We are left with the contradiction that the new, that modern art, whose legitimation can be given only by progress, *lies at the limit* of progress. The new can be defined only by the paradox that it marks the endpoint of progress. This limit reveals Adorno's understanding of the new as a closed dialectical construction: the new is the negation of the old, which yet cannot die. Beckett's *Endgame* is necessarily the perspectival vanishing point of the

timeless space of Adorno's *Aesthetic Theory*. And yet *Aesthetic Theory* takes its stand on the equation of the new, the authentically modern, with the progress of artistic technology.

The contradictions of progress in *Aesthetic Theory*, which bespeak the contradictions of aesthetic theory itself, symbolize the dilemma which Adorno could not escape. The contradiction of his position is expressed in a double paradox. Because progress has come to its conclusion, Adorno must go on—"il faut continuer." Adorno cannot go on, however, because he cannot abandon the (reified) concept of progress. The reification of theory is, we might say, a necessary consequence of the dialectic of enlightenment. Theory is not left untouched by its own conclusion, the coming to self-knowledge of progress is not spared the fate of Oedipus—the invocation of Oedipus at the end of the Schoenberg essay is indeed prophetic. Reification expresses itself, however, also in a more indirect form. The progress of music is such a perfect illustration of the dialectic of enlightenment that one is tempted to conclude that the dialectic of enlightenment has been won from the immersion in the history of music rather than the other way round. It certainly led Adorno to extend the model of aesthetic rationalization from music to all art in *Aesthetic Theory*, an extension, which is in fact a singular, indeed fateful, restriction. On the one hand the yardstick of technical construction results in an excessively formalistic *and* materialistic reduction of the work of art. On the other hand, the annihilating "technical standard" Adorno blindly vaunts manages to ban practically all of twentieth-century art from the empty space of his *Aesthetic Theory*. Adorno's "progress" excludes the new beyond the limit of his dialectic construction. The nihilism of progress is denounced and at the same time used to annihilate the new behind the mask of its aggressively polemical defense.

Adorno's "satanic parody" of progress expresses the fatalism of his dialectic of enlightenment. That this fatalism has its irrefutable evidence in Auschwitz—and the Gulag Archipelago and the massed atrocities of history—cannot and must not be denied. Nevertheless, Horkheimer and Adorno's *Dialectic of Enlightenment* is fatally flawed by its totalizing construction of mankind's history as domination. The very totalizing of the dialectic robs it of all concrete historical specification. All history becomes the

history of the Fall. As against this, the dialectic of enlightenment in *Philosophy of Modern Music* is that of the bourgeois age, demonstrated with all desirable clarity in the progress of music. We must regard the history of bourgeois music as the most satisfactory, indeed, as *the* model of the dialectic of enlightenment, for the very simple reason that it constructs a totality and is neither a totalizing construction (*Dialectic of Enlightenment*) nor a totalizing deconstruction (*Negative Dialectics*). Moreover, it is only in relation to the historically specified—music as *the* bourgeois art—that we can specify Adorno's historical position. It is that of the articulation of the self-knowledge of progress, whose historical dialectic has brought about the crisis of German music and of German philosophy. We must therefore return to the *limits* of the dialectic in the Schoenberg essay in order to defend Adorno against himself. Let us accept the logic of his argument. The dialectic of enlightenment unfolded by the history of bourgeois music is the *history of progress in the age of progress*. Progress is the decisive, because self-specifying category of music of the epoch of tonality: in the wider sense, musical history from Monteverdi to Mahler; in the narrower, more explicitly relevant sense, bourgeois music from the middle of the eighteenth century to the First World War. Progress is the concept which expresses the self-understanding of the bourgeois age.[7] It enabled Hegel to philosophize history as the progress to freedom. The end of progress by contrast forced Adorno to historicize philosophy. That is to say, if progress brings history to a standstill, all that is left for philosophy is to write the history of progress as the dialectic of enlightenment.

"Schoenberg and Progress" thus demonstrates necessarily and paradoxically that the answer to the question What constitutes musical progress? must be sought in the old, not the new. The great achievement of the philosophy of the *new* music is its reconstruction of the history of *traditional* music in terms of the unfolding of the logic of rationalization. The very process by which the objective demands of the material end by destroying the composer's language, however, reveals that the necessity immanent in the material cannot be separated from the encompassing frame of the language of Western music. Adorno's demonstration that the organization of the material by means of the twelve-tone tech-

nique cannot replace the system of tonality confirms this. The divorce of meaning and material in twelve-tone music manifests the collapse of the aesthetic necessity of tradition within which the domination of musical nature can proceed. This dialectic interests Adorno only from the moment that free aesthetic subjectivity appears, that is, from the moment when, with the constitution of a self-validating aesthetic sphere, progress reaches the epochal threshold of self-consciousness to give Adorno's "great tradition": its apex Beethoven and Hegel, its epilogue Schoenberg and Adorno. Adorno's model thus presupposes on the one hand the whole lengthy period of development as the prehistory of progress, a prehistory largely ignored by Adorno because music has not yet achieved autonomy. Up to this point, subjectivity remains narrowly confined by the rule-governed rhetoric of conventions, the reflection of music's subordination to the dictates of social representation of church and court. In turn, the self-completion and destruction of tradition indicates the limits of the model: the break, accomplished by Schoenberg, which transforms the organic work of art into the "material concept of modern art" (AT50).

The end of tradition is thus the pivot of Adorno's aesthetic theory and at the same time the boundary which he could cross only negatively. Beyond lies the tragedy of modern art for Adorno no less than for Lukács. The conclusions they draw are directly opposed, but they hide a deeper affinity. If Adorno saw himself as the champion of the new art, which Lukács unequivocally condemned, neither in reality crossed the divide of the First World War. For both, all that follows stands under the sign of reification; for both, *there can be nothing new in the West*. For both, the art of capitalist modernity (the postmodern) lies beyond progress, reason, and history. That is to say, both are bound within the self-understanding of the history of the bourgeois epoch—the history of the unfolding and destruction of reason which they cannot transcend.

It is appropriate that the enemies Lukács and Adorno found common ground in Thomas Mann's *Doctor Faustus*, the novel of the end of European culture, of the "passage of Faust," which spans and circumscribes the modern age from Marlowe to Mann as the history of Faustian progress. A decisive inspiration for the

novel was "Schoenberg and Progress"; its complement is Lukács's essay "The Tragedy of Modern Art," written in response to the novel. The tragedy of modern art, which they both write, could be written only against the shared background of their admiration for and identification with the great epoch of bourgeois culture. It is their admiration for the "golden age of art," which reveals, as Ferenc Feher puts it, the "profound relationship" of the two antagonists: "In their analyses, both are drawn to the great achievement of modern history, the birth of the autonomous freeborn subject, the free bourgeois individual. To be sure, at a later point they both 'revoke' this achievement by exposing the subsequent reification and alienation of this free individual. Nevertheless, during this *intermundium* of a century or a century and a half the free individual was to obtain unsurpassed heights of art. Thus both thinkers emphasize their unqualified admiration for the artistic microcosm *created by the autonomous subject.*"[8] The supreme expression of this self-realizing activity is the "world of the birth of dialectics" in Goethe, Hegel, and Beethoven. At the center of the aesthetic systems of Lukács and Adorno stands the work of art raised to the level of totality through the dialectical synthesis of the universal and the particular. It is the *normative* basis of Lukács's theory of realism and what Feher calls Adorno's semantics of music: *"the first genuine and profound outline of the semantics of music* which has withstood all later correction."

First of all, *for Adorno, musical organization is not simply an order but a totality,* at least in the case of matured and emancipated Western European music. For a detailed explanation of the difference between these two concepts, the reader is advised to consult Lukács' essays in *History and Class Consciousness* from which Adorno took the distinction. It is not to his credit that he carefully avoided mentioning the source of his youthful inspiration. Schematically, the essential difference is as follows: order is the absolute inter-connection of objects, and totality is their entirety consciously realized as being-for-us. This explains why, in Lukács' conception, bourgeois society, based on goal-rationalism and an attempt to change futile heterogeneity into a rationalistic homogeneity, is the first historical formation of totality *sui genesis*. In accordance with this conception Adorno maintains that Renaissance and late Renaissance music is merely order-formation (and thus judged inferior), whereas the music of the initial bourgeois period (whether called baroque or preclassical) is

a *rationally organized totality*. His occasional reproaches of Bach's music as "mathematical over-organization" (kept to a whisper before the great authority of Bach) are made in the spirit of purposeful rationality which in fact organizes order into totality. Even in its suspicions and absurdities, Adorno's animosity is derived from the ideal of an unsurpassable world historical epoch.[9]

This "unsurpassable world historical epoch" is that of Adorno's model of musical progress. At the beginning stands the *rational* music of Bach, in which the subject/object dialectic is held latent within the bounds of *order;* at the center stands *dialectical* music, in which the dialectic of freedom and necessity realizes the artistic *totality sui genesis,* whose crisis and disintegration is heralded in Beethoven's late work; at the end stands the *rationalized* music of Schoenberg, the manifest crisis of the hypertrophy of musical reason, in which the subjectification (rationalization) of the musical language reverses into the blind totality of a mute and alien order. The immanent bounds of the model describe what we might paradoxically call the *organic* parabola of progress, organic in a double sense, for not only does the unsurpassable accomplishment of bourgeois culture lie in the creation of the organic work of art (the organic totality, in which the sum is more than the parts, as opposed to the rationalist, mechanical ordering of the parts), which is the fullest expression of musical time, but also because, as Feher stresses, Adorno's model of progress holds concealed within it, although explicitly rejected, a theory of *decadence*. In a later article Feher observes "not without glee . . . how Adorno, who had embarked on such a savage criticism of Lukács' theory of decadence, has one of his own which places the deadline, from which *les capacités de la bourgeoisie s'en vont,* at exactly the same time as Marx and Lukács did, namely after the defeat of the June 1848 Paris proletarian revolution."[10]

The historical and the normative together describe the parabola of progress. Adorno's model thus possesses a double perspective. On the one hand we have the *linear logic* of rationalization, objectified in the musical material in analogy to the progress of the material forces of production. This unending line of progress produces, however, the *organic curve* of the elaboration and exhaustion of the language of tonality. The disjunction of lan-

guage and material, which registers the end of tradition, leads, as we have seen, to the crisis of value rationality in the new music and to the antinomies of Adorno's aesthetic theory. *Within* Adorno's model the dialectic of unbounded progress (the logic of rationalization) and bounded progress (the organic curve) exactly corresponds to the dialectic of the growth of the material forces of production and the cultural decadence of bourgeois society. Adorno's very insistence on the immanent logic unfolded by the musical material is meant to demonstrate the autonomy, the self-grounding, of his philosophical aesthetics, but only the better to demonstrate the dialectical relation of the artistic monad and the social whole. He writes:

It is tempting to deduce all of this [the situation of music] in social terms directly out of the decline of the bourgeoisie, whose most unique artistic medium has always been music. Such an approach, however, is compromised by the inclination to throw an all-too rapid glance at the total picture, thereby overlooking and devaluating the individual moment present in this totality of social forces, which is determined by it and, in turn, resolved by it. This view becomes entangled with the inclination to take sides with the totality, or the mainstream, and to condemn anything which does not fit into the overall picture. In this way, art becomes the mere exponent of society, rather than a catalyst for change in society. . . . Furthermore, the reduction of advanced music to its social origins and its social function hardly ever rises above the hostilely uncritical designation that it is bourgeois, decadent, and a luxury. (MM24–25)

Although we can agree with Adorno's strictures against a crude sociological reductionism, especially as regards "advanced music," it is nevertheless clear that music and the bourgeoisie belong together for Adorno and that the polemic against the cry of decadence only masks Adorno's own theory of decadence. In this respect Lukács and Adorno cannot be separated: Lukács's concept of realism and Adorno's musical semantics are both defined by—that is, confined within—the bourgeois age. The limit is given by their theory of reification, which leads to Lukács's absolutization of decadence and Adorno's ambivalent espousal of "material" progress.[11] The *indifference* of decadence and progress signals the limiting value of their aesthetic theories, which arose from the bourgeois epoch and are tied to it. Lukács's theory of

reification, situated precisely at the limit of bourgeois society and thought, marks the turning point which reverses dialectical reason back into myth. It is from this point of reversal that Lukács and Adorno can be seen as standing together as the great theorists of bourgeois culture, whose expressive essence is concentrated for both in the lost organic totality of the artistic microcosm.

LIVING AND DEAD NATURE

The young Lukács registered the widespread sense of the crisis and tragedy of culture prior to 1914 in a double form, as György Markus has shown. The crisis was diagnosed both metaphysically and historically. The ontological gulf between the soul and life, the organic and the mechanical, the authentic and the reified, manifests the metaphysical tragedy of human existence, of which the crisis of culture is one expression. At the same time, Lukács also sought to grasp this metaphysical dualism in sociohistorical terms as a determining characteristic of bourgeois society. Thus in Lukács's *History of the Development of Modern Drama* and *Theory of the Novel* the historical diagnosis is underpinned by the familiar contrast between *Gemeinschaft* and *Gesellschaft,* the closed totality of organic communities as against open, emancipated, abstract, and alienated bourgeois society. "The crisis of culture is the inevitable product of this historically determined state of affairs in the world. Within the bourgeois world, culture in the true sense of the word is impossible. It is objectively impossible: no general goal, no meaning can be discerned in the abstract and irrational necessity of the conditions created by the 'anarchy of production.' Its objective laws, alien to man, can no longer be related to the individual in a unified view of the world."[12]

Lukács's metaphysical-historical ambivalence is in many ways typical for the time. It led to a privileging of cultural analysis (in an atmosphere of cultural pessimism also to be found in Wilhelm Dilthey and Weber), in which cultural objectifications were perceived in the oscillating light of essence and historical determination. Thus for Lukács form possesses a "redeeming power" and is at the same time the only category of literature which is both social and aesthetic. The concept of realism in the later Lukács and Adorno's semantics of music both arise from this urge to

grasp the social and the aesthetic in systems which unite the normative and the historical. The result could not be other than the verdict of decadence. Both arrive at a similar construction of the disintegration of bourgeois culture, whose rational, historical foundation derives from Marx's analysis of commodity fetishization and Weber's logic of rationalization. Nevertheless, the "tyranny of reason" in the later Lukács, to which we may well compare the tyranny of progress in Adorno's *Aesthetic Theory,* should not blind us to the irrational roots of their analysis of the tragedy of modern art.[13] In the young Lukács the metaphysical tragedy of human existence takes the form of a radical version of *Lebensphilosophie* (vitalism) and romantic anticapitalism, through which the longing for authentic culture and redemption finds expression. Adorno's *utopia* of reconciliation in turn may be seen as the rational veneer for a profoundly arational *mysticism* of redemptive mimesis beyond and behind all civilization—"the echo of the primeval" invoked at the very end of *Philosophy of Modern Music.* Axel Honneth has drawn attention to the connection between basic theses of *Dialectic of Enlightenment* and the major work of Ludwig Klages's *Lebensphilosophie, Der Geist als Widersacher der Seele,* whose title echoes the opposition of life and soul in the young Lukács. It is this dual foundation—rational and irrational—which Albrecht Wellmer sees as the key to *Dialectic of Enlightenment:*

The extraordinary character of *Dialectic of Enlightenment* resides not only in its literary density—prose illuminated by flashes of lightning, as it were—but even more in the extreme daring of the authors' attempt to fuse two disparate philosophical traditions; one which leads from Schopenhauer via Nietzsche to Klages, and another which leads from Hegel via Marx and Weber to the early Lukács. Lukács had already integrated Weber's theory of rationalization into a critique of political economy; *Dialectic of Enlightenment* may be understood as an attempt to appropriate in addition Klages' radical critique of civilization and reason for Marxist theory. The stages of emancipation from the spell of nature and the corresponding stages of class domination (Marx) are therefore understood simultaneously as stages in the dialectic of subjectification and reification (Klages). For this, the epistemological triad of subject, object and concept has to be reinterpreted as a relationship of repression and domination, where the instance of repression—the subject—at the same

time becomes the overpowered victim. The repression of inner nature, with its anarchic desire for happiness, is the price paid for the formation of a unified self; this in turn being necessary for the sake of self-*preservation* and for the mastery of external nature. . . . Mind, bent on objectifying and system-constructing, and operating according to the law of non-contradiction, becomes in its very origins—by virtues of the "splitting of life into mind and its object"—instrumental reason. This instrumental spirit, itself part of living nature, can in the end understand itself only in the categories of a *dead* nature.[14]

Wellmer, unfortunately, does not develop this crucial insight into the fusion of the two opposed nineteenth-century German philosophical traditions in *Dialectic of Enlightenment*. It is clear, however, that the whole ambivalence of the dialectic of enlightenment springs from the ambivalence of a progress which comes to reflect on itself at the epochal threshold to modernity. Anne-Robert Turgot's lectures on universal history and progress (1750) and Rousseau's Second Discourse (1755) mark this threshold with their complementary interpretations of the "progress" of civilization. Whether positively or negatively conceived, progress (the idea of progress) and the concept of history (philosophy of history) are integral to the self-understanding of European society in the age of progress. The *fusion* of the two philosophical traditions in Horkheimer and Adorno signifies the conclusion of the dialectic of enlightenment. The progress which leads via Hegel, Marx, Weber, and the young Lukács to *reification,* and the decadence which leads via Schopenhauer, Nietzsche, and Klages to *nihilism,* meet and fuse in the end of history. The dialectic of the rational and the irrational ends in the indifference of Adorno's and Horkheimer's "universal system of delusion," in which it is no longer possible to distinguish between reason and myth. But behind this "rational" demonstration of the self-destruction of reason the unacknowledged "soul" of *Lebensphilosophie* asserts itself: in Wellmer's words, "This instrumental spirit, itself part of living nature, can in the end understand itself only in the categories of a *dead* nature." For what is the process of rationalization other than the mortification of nature? What is the logic of Schoenberg's progress but the destruction of the organic? The final product of musical reason is lifeless material, no longer the thing-in-itself (nature) but a mere thing in the hands of the sov-

ereign spirit. The tragedy of modern art thus enacts the murder of the living, the final disenchantment of nature, the extirpation of the song of the sirens which enslaves the master to a conquered and lifeless material. This is the myth behind Adorno's rational construction of aesthetic modernity: the "material concept" of modern art as the dialectical consequence of the dissolution of the organic work of tradition.

If Odysseus is the self-preserving "hero" of *Dialectic of Enlightenment*, its tragic figure is Oedipus. "Schoenberg and Progress" ends with the invocation of Oedipus: "Works of art attempt to solve the riddles designed by the world to devour man. The world is a sphinx, the artist is blinded Oedipus, and it is works of art of the type resembling his wise answer which plunged the sphinx into the abyss. Thus all art stands in opposition to mythology. In the elemental 'material' of art, the 'answer'—the only possible and correct answer—is ever present, but not yet defined. To give this answer, to express what is there, and to fulfill the commandment of ambiguity through a singularity which has always been present in the commandment, is at the same time the new which extends beyond the old, precisely by virtue of being sufficient to it" (MM 132). The artist is Oedipus, but the wisdom of his answers to the riddles presupposes his blindness, which alone sets art in opposition to mythology.

That is to say, only as long as the elemental material of art itself partakes of myth, is itself the riddle of the Kantian "thing-in-itself," can the blind process of enlightenment continue. The Oedipus who finally sees, who finally comprehends and "masters" the necessity which drives his blind freedom, destroys himself through the recognition of his act—the act of patricide. Adorno turns to Oedipus at the end of the Schoenberg essay to assert against better knowledge, against the whole logic of his argument, the possibility of the new, the possibility of the continuation of the old beyond the death of tradition. Schoenberg and Adorno are thus the enlighteners, driven blindly by the movement of the material to the all-seeing vision of the destruction of all they sought to continue—the tradition of dialectical reason and dialectical music. The progress which leads to total enlightenment ends in total blindness. What remains is the self-enlightenment of progress which is the truth of the fatal domina-

tion of nature. As we have seen, the dialectic of the old and the new music, the critique of aesthetic illusion (*Schein*) reveals Adorno's deep ambivalence to tradition, his Schopenhauerian longing to escape the "affliction of dialectical compulsion."

This mythical element underlying and overwhelming the dialectic of enlightenment can be seen as the sign of the fusion of the two philosophical traditions, which defines at the same time their limit. Adorno's history of musical progress unfolds not only the logic of rationalization—whose categories of logic and causality are those of dead nature—it also describes the organic parabola of growth and decay, categories of living nature. Whereas the logic of rationalization points forward to its "material" extrapolation in *Aesthetic Theory*, the exhaustion of the language of European music points back to the organic curve of progress, the completed totality of bourgeois culture. The paradigm of music in the age of progress can thus be read in two ways, reflecting the fusion of the two traditions: it is both a history of progress and of decadence. It is here that we can see why the radical critiques of bourgeois civilization from the left and the right converged in a similar diagnosis. Common to both perspectives is the deep sense of the hostility of industrial society to culture.

Honneth and Wellmer have drawn attention to the parallels with Klages in *Dialectic of Enlightenment*. A comparison with Spengler is in turn relevant for the *Philosophy of Modern Music*.[15] Adorno's lecture on Spengler of 1938, revised for publication in German in 1950, gives no clues to possible parallels because the lecture is restricted to the second volume of *The Decline of the West* and ignores the morphology of Western music and painting presented in the first volume. Nevertheless, there are important points of contact which help to clarify Adorno's position. In his lecture Adorno rejects, not Spengler's historical fatalism, but its explanation in terms of the metaphysics of the unfolding and dying of a collective soul rather than in terms of the "tendency of the domination of nature." To Spengler's triumphant identification with the brute power of history Adorno can oppose only the forces set free by decay. In a world of violence and oppression *decadence* is proclaimed the only refuge left. As the negative expression of the negativity of culture, it alone incorporates the hope of the end of domination: "Against the decline of

the West stands not a resurrected culture but the utopia which lies enclosed as a worldless question in the image of the dying culture."[16] Again in his 1962 lecture, entitled "Progress," Adorno invokes decadence as a concept which contains encoded within itself the true image of progress, that of the progress which brings progress to an end and breaks its spell, the compulsion of the domination of nature.[17]

There is, however, a reference to Spengler in *Philosophy of Modern Music* which directly relates the musical domination of nature realized in the twelve-tone technique to Spengler's philosophy of history: "The conscious disposition over the material of nature is two-sided: the emancipation of the human being from the musical force of nature and the subjection of nature to human purposes. In Spengler's philosophy of history the principle of blatant domination breaks through at the end of the bourgeois era. This principle was inaugurated by the bourgeoisie itself. Spengler has an affinitive feeling for the terror of domination and for the relationship between its dispositional rights in both the aesthetic and political fields" (MM65). Here, despite the disclaimer of the 1938 essay, Adorno recognizes that Spengler also traces in the Faustian dynamic of the West a dialectic of enlightenment. Faust the scientist, the inventor, the discoverer, is the symbol of the will to master and enslave nature which culminates in the unbounded growth of the machine age (DW2:501, 502). According to Spengler, "It is a triumph, so far as we can see unparalleled. Only this our Culture has achieved it, and perhaps only for a few centuries. But for this very reason Faustian man has become *the slave of his creation*" (DW2:504). The dominance of the machine and the dictatorship of money are the characteristic "form-worlds" (Spengler) of civilization. They signify the inner exhaustion of the Faustian potential: dynamics must end in entropy.

The ethos of the word Time, as we alone feel it, as instrumental music alone and no statue can carry it, is directed upon an *aim*. This aim has been figured in every life-image that the West has conceived. . . . And it is figured, as the destined end-state of all Faustian "Nature," in Entropy [DW1:422] . . . the passionate thrust into distance is Faustian. Force, Will, has an aim, and where there is an aim there is for the inquiring eye an end. That which the perspective of oil-painting expressed by means of

the vanishing point, the Baroque park by its *point de vue*, and analysis by the *n*th term of an infinite series—the conclusion, that is, of a willed directedness—assumes here the form of the concept. The Faust of the Second Part is dying, for he has reached his goal. What the myth of Götterdämmerung signified of old, the irreligious form of it, the theory of Entropy, signifies today—*world's end as completion of an inwardly necessary evolution.* (DWI:425)

Spengler's "inwardly necessary evolution" thus provides the organic version of Adorno's progress—opposed but complementary models of the same historical process, which for each unfolds the same fatality, whether it be termed irrational destiny or rational progress. *The Decline of the West,* conceived in the years immediately preceding the First World War, is—for all the predetermined schematism of its cultural cycles with their inevitable progression from spring to winter—a direct expression of the crisis of European culture and society, situated precisely at the point of the break, the end of the European totality. It looks back at the unique historical drama of Faustian culture, viewed organically as an expressive totality.

Spengler's Faustian perspective throws into relief the elements of German ideology in Adorno's privileging of music as *the* medium of the bourgeoisie. Like Spengler, Adorno too stands in the tradition of Schopenhauer and Nietzsche, a tradition which appropriately found its conclusion in Thomas Mann's *Doctor Faustus.* The bounded time of European culture as conceived by Mann is simultaneously the time of progress and of mythical recurrence. Adorno's dialectic of enlightenment in "Schoenberg and Progress" as the Faustian time of the progression to self-destruction is bound by Thomas Mann into Spengler's cyclical model of the end of European time. For Spengler no less than Adorno the expressive essence of European time is music, that is, German music. When Spengler writes, "The ethos of the word Time, as we alone feel it, as instrumental music alone and no statue can carry it," this time is for him Faustian (Dionysian), as opposed to the plastic, classically Apollonian order of antiquity and of Renaissance art, and its summit is the instrumental music of Beethoven. If for Adorno all music is bourgeois, he makes no effort to hide his conviction that the only music which counts is German. Thus behind the immanent construction of the dialectic of enlighten-

ment in *Philosophy of Modern Music* we can discern its unspoken German ideology, which is brought into the open in Thomas Mann's linking of *Faust and music,* Adorno and Spengler, just as Schoenberg and Nietzsche merge in the figure of Adrian Leverkühn.

Music stands at the center for Spengler and Adorno, for both it is the expression of the uniqueness of Western culture, and as such the paradigmatic focus for the fusion of the two traditions of which Wellmer speaks, for it can be viewed either through the Weberian optic of occidental reason or through the Spenglerian optic of Faustian culture.

The genesis and heartland of Western culture lies for Spengler in the area bounded by Amsterdam, Paris, and Cologne, the birthplace of the Gothic cathedral, of counterpoint, and of oil painting. The Apollonian reaction of the Renaissance against Germanic Gothic art is for Spengler but an interlude: the moment of the apparent expulsion of music from European art, when sculpture became the dominant art and impressed itself on painting, freezing Gothic dynamics into the dream of plastic presence. Flemish painting and music reemerge, however, in Venice. The threshold of the modern age is announced by the new dynamic forms of opera (Monteverdi), oratorio (Carissimi), and cantata. We can add to these drama (Elizabethan, Spanish, and French) and the novel (Cervantes), although Spengler confines himself to the two specifically European arts of music and painting, excluding literature from his morphology. The new science of harmony (Gioseffo Zerlino's treatise of 1558) introduces perspective and depth (general bass) into the pure space of tones, just as Venetian painting from Titian on with its play of light and shade brings true depth to painting. The baroque period inaugurates the completion of Faustian style with the transition from impersonal form to the personal expression of the great masters. In this organic development from the Gothic to the baroque, in which the plastic art of the Renaissance is but an interlude, painting and music represent the highest expression of the Faustian arts. They alone unfold a history, whereas sculpture becomes completely insignificant after the Renaissance. The climax, and limit, of oil painting is reached with the deaths of Velázquez, Poussin, Hals, Rembrandt, Vermeer, and Lorrain between 1660 and 1682. The

Faustian will to the transcendence of space transforms their "painterly" art into music. In the horizon as the symbol of infinite space, which dissolves Dutch landscapes into atmosphere, the "infinitesimal" spirit of music triumphs, to become in German instrumental, absolute music the dominant art of the eighteenth century. The first stage is the development in Italy of the sonata-like forms of the suite, symphony, and concerto grosso:

The inner structure and sequence of movements, the thematic working-out and modulation became more and more firmly established. And thus was reached the great, immensely dynamic, form in which music—now completely bodiless—was raised by Corelli and Handel and Bach to be the ruling art of the West. When Newton and Leibniz, about 1670, discovered the infinitesimal calculus, the fugal style was fulfilled. And when, about 1740, Euler began the definitive formulation of functional Analysis, Stamitz and his generation were discovering the last and ripest form of musical ornamentation, the four-part movement as vehicle of pure and unlimited motion. For, at that time, there was still this one step to be taken. The theme of the fugue "is," that of the new Sonata-movement "becomes," and the issue of its working out is in the one case a picture, in the other a drama. Instead of a series of pictures we get a cyclic succession, and the real source of this tone-language was in the possibilities, realized at last, of our deepest and most intimate kind of music of the strings. . . . Here, in *chamber-music, Western art as a whole reaches its highest point.* (DWI:231)

All this is for Spengler—no less than for Hegel—the expression of the deep necessity of history: "We have learned to understand arts as prime phenomena. We no longer look to the operations of cause and effect to give unity to the story of development. Instead, we have set up the idea of the *Destiny* of an art, and admitted arts to be *organisms* of the Culture, organisms which are born, ripen, age and *for ever* die" (DWI:281). "At the culmination of every Culture we have the spectacle of a splendid *group of great arts,* well ordered and linked as a unity by the unity of the prime symbol underlying them all. . . . The *Faustian group* forms itself around the ideal of pure spatial infinity and its centre of gravity is instrumental music. From this centre, fine threads radiate out into all spiritual form-language and weave our infinitesimal mathematics, our dynamic physics, the propaganda of the

Jesuits and the power of our famous slogan of 'progress,' the modern machine-technology, credit economics and the dynamic-dynastic State—all into one immense totality of spiritual expression" (DW1:282). And so the *organic expressive totality* of the bound time of European culture is Spengler's vision, at its heart instrumental music, the expression and mastering of infinite space and dynamic time from Bach to Beethoven. The limit of the epoch of great style is reached with the Congress of Vienna—which coincides exactly with the beginning of Beethoven's last period, we may add. The transition to the nineteenth century is thus for Spengler the transition from the summer of culture to the autumn of civilization. Music, the last of the Faustian arts, dies with Wagner's *Tristan*. Wagner, like Monet, already announces the art of decadence: "the beginning of dissolution sensibly manifested in a mixture of brutality and refinement. . . . And the bitter conclusion is that it is all irretrievably over with the arts of form of the West. The crisis of the 19th century was the death-struggle. Like the Apollonian, the Egyptian and every other, the Faustian art dies of senility, having actualised its inward possibilities and fulfilled its mission with the course of its Culture" (DW1:293). All that remains is the empty eclecticism of Alexandrian decadence, the "art-clamour" of the megalopolis and its cult of fashion.

In Spengler and Adorno we observe essentially the same morphology of music, derived, however, from opposed constructions of its telos. Spengler's telos, like Hegel's spirit of a people, is that of the entelechy, of the organism, rejected by Adorno as a metaphysical principle, close to the *Lebensphilosophie* of Nietzsche and Simmel, which reduces world history to a history of styles by excluding the real basis of the dynamic of history.[18] Nevertheless, Spengler's organicism arrives at the same conception of the teleological work of art as we find in Adorno or Lukács: the mastering of space in the frame of the painting and the mastering of time in the sonata form. Although musical dynamics are related to mathematics for Spengler and philosophy for Adorno, "the ethos of the word Time" defines their common pathos: the time of music. And this time runs out in twelve-tone music, just as the three-dimensional space of painting contracts to the two dimensions of cubism. Adorno's decisive value criterion is the articula-

tion of time in music. This is a criterion based on dialectical *development* (becoming), realized in the teleological work of art, and not on *progress* (rationalization), which dissolves the organic work of tradition. It is for this reason, as we have seen, that Adorno possesses no less than Lukács—or Spengler—a theory of decadence. Indeed, we can even argue that Adorno's *Aesthetic Theory* must be seen as a "progressive" formulation of the "decadence" of modern art.

In this sense, comparison with Spengler serves to bring out the "decadent" dimensions of Adorno's model of progress. More important, Spengler's morphology of the completion and exhaustion of the expressive totality of European culture underlines and confirms the limits of Adorno's model. Precisely the fusion of the two philosophical traditions in *Dialectic of Enlightenment* registers the boundary of the totality in which the logics of progress and decadence unfold their complementary versions of the self-destruction of the totality in the forms of reification and nihilism. The end of the time of music is the crux of Adorno's judgment on the new music: the organic time of tradition freezes into totalizing construction (Schoenberg) or into the mechanical march of the totalitarian collective (Stravinsky). Each signals the return of differentiated time (of the subject, of expression and development) to the undifferentiated time of an alien collective order beyond progress and history—Spengler's entropy.

The distinction Lukács draws between order and totality (cf. Feher's distinction above) corresponds to the distinction between the mechanical and the organic concepts of form. The understanding of form as an inner-directed, self-evolving system, "one in which each part is reciprocally means and ends," "purposefulness without purpose" (Kant), the expression of "inner truth and necessity" (Goethe), underlies Adorno's and Lukács's concept of the teleological work of art.[19] The totality of the organic work of art is thus for both the highest realization of the expressive totality of European culture. Although the objective consequence of the dissolution of the organic work of tradition is the material concept of posttraditional art, Adorno has no place for the new form of "mechanical" order—the aggregations of *montage,* in which the organizing primacy of the whole is surrendered to the parts (cf. AT232). In *Doctor Faustus* the integral rationalization

of Adrian Leverkühn's music is prefigured in the physical and chemical experiments of Adrian's father, which mimic organic form through inert, mechanical duplication. The fate of the organic is reification. Susan McClary has aptly characterized Adorno's relation to music as "first that of a Cassandra and then that of a coroner performing an autopsy."[20]

Adorno's *anatomy* of the new and Spengler's *morphology* of the old, progress as Adorno's logic of time as against Spengler's destiny as the logic of time (DW I:7) arrive, as we see, at the same morphology of music. The merit of Spengler's irrational model over Adorno's rational model lies in the fact that it spells out more clearly Adorno's conclusions: the irretrievable end of Western music. Spengler's philosophy of history as the demonstration of the inescapable fate of European culture is expressly conceived against the idea of progress. It stands in explicit opposition to the Enlightenment idea of universal history as the progressive self-understanding of the modern age. Horkheimer and Adorno's *Dialectic of Enlightenment* holds fast to the idea of universal history but in the form of its negation. For Adorno also progress has become destiny. The fate of culture announces for him no less than for Spengler the winter of despair. Behind them lies the great age of European art, the great tradition, which is one with the great transformation, which defines the uniqueness of the modern age, whose privileged index is music. The opposing constructions—the organically bound totality of Faustian culture and the telos of occidental reason—together reflect the uniqueness of the modern age, whose dynamic of transformation unfolds the dialectic of the organic and the rational, tradition and progress. This dialectic appears in Adorno as that of nature and domination, specified in the history of Western music. The complete rationalization of musical "nature" completes the dialectic of progress. In this sense Adorno's model is no less "natural" and organic than Spengler's, that is, Spengler makes explicit the presupposition of Adorno's *Philosophy of New Music,* the comprehension of the completed totality of European culture, within and against which alone the history of progress can be written.

Adorno's very method of immanent analysis presupposes the expressive totality of tradition: to Spengler's macrocosm of a culture corresponds Adorno's microcosm of the work of art. Each

is a windowless monad. Each is a closed organic form, which contains its telos within itself. The disintegration of the closed work of tradition releases the alien telos of progress—artistic technology—in emancipated music, which has severed its roots in "nature." If the basic opposition of *Lebensphilosophie*—life and death—underlies for Lukács Spengler's opposition of morphology and causality, the logic of time versus the logic of space, then the dialectic of enlightenment which freezes musical time into space and transforms the organic into the inorganic is to be read as a "progressive" version of *Lebensphilosophie*.[21] The fusion of Marx and Klages in *Dialectic of Enlightenment* is foreshadowed in the conjunction of Spengler and Weber in *Philosophy of New Music*. In *The Destruction of Reason*, which Adorno declared to be the destruction of Lukács's reason, Lukács singles out Spengler and Klages as the culmination of the irrationalism of *Lebensphilosophie:* the moment of its reversal into open myth.[22] We have now reached the point in our argument at which we can turn to Lukács and the entwinement of reason and myth in the founding essay of Western Marxism, "Reification and the Consciousness of the Proletariat."

THE REVENGE OF HISTORY

After the detour via Spengler we have finally reached the single most significant source of Adorno's *Philosophy of New Music*, Lukács's Hegelian fusion of Marx and Weber in his theory of reification in *History and Class Consciousness*. The recourse to Spengler not only served to oppose the two models of organic morphology and rational progress, it also reinforced Wellmer's thesis of the combination of the two philosophical traditions in *Dialectic of Enlightenment*. Approached from such a perspective, "Reification and the Consciousness of the Proletariat" reveals not only the decisive break with Lukács's earlier work but also, behind the Marxian opposition of living and dead labor, the ongoing influence of *Lebensphilosophie*.[23] "Schoenberg and Progress" is the continuation of Lukács's analysis of reification, a continuation, however, which involves the negation of its central concept of totality by turning the logic of Lukács's argument against him. In the process Adorno defines his own position against that of

Lukács. But what Adorno does to Lukács rebounds on him. Or rather, we should say, the fatal flaw in Adorno's logic is already contained in and taken over from Lukács. If "Reification and the Consciousness of the Proletariat" is the seminal essay of Western Hegelian Marxism, "Schoenberg and Progress" is the seminal essay of Western Marxist aesthetics. Together they circumscribe the genesis and fate of the German line of Western Marxism, not only in the reduction of philosophy of history and social theory to the realm of aesthetics but also in the philosophical construction and deconstruction of the ideal of totality. Here it is sufficient to refer to Martin Jay's admirable survey of the vicissitudes of the concept of totality in Western Marxism from Lukács to Habermas.[24] My interest here is confined to the *logic* of Lukács and Adorno's model of dialectical reason. This *logic* offers the "immanent" key, I suggest, to the foregoing argument, which has revolved around the end of the European modern age, whose limit and conclusion finds its "logical" reflection in the fusion of the two disparate philosophical traditions of which Wellmer speaks in the indifference of progress and decadence, reification and nihilism. The following analysis of "Reification and the Consciousness of the Proletariat" is thus directed to the entwinement of reason and myth.

Lukács writes: "The commodity can only be understood in its undistorted essence when it becomes the universal category of society as a whole" (HCC86). We find the same structure of argument in *Philosophy of Modern Music*—the emancipation of the twelve tones as the universal category of emancipated music—and in Bürger's *Theory of the Avant-garde*, where the avant-garde revolts of this century signal the emancipation of technical procedures as the universal category of art. The emergence of universal categories—the index of formalization in the various logics of the autonomous, self-validating spheres of differentiated society—is conceived by Lukács as a process of abstraction, whose medium and abstract symbol is the universal equivalent—money, which transforms use value into exchange value. The specialized rational systems of bourgeois society are the outcome of a continuous trend to rationalization, which brings with it the end of organic production (HCC88), of the "empirical, the concrete and the traditional" (HCC97). In short, the reduction of

quality to quantity produces the phenomenon of reification, the transformation of the living into the dead. As a result relations between people are perceived as relations between things, as the "immediate commodity relation" (HCC93). "Just as the capitalist system continuously produces and reproduces itself economically on higher and higher levels, the structure of reification progressively sinks more deeply, more fatefully and more definitively into the consciousness of man" (HCC93). This "potentiation of reification" is exemplified for Marx in the relation money bears to itself. Interest-bearing capital is *form without content* (HCC94), whose corollary Lukács sees in the progressive separation of form and content in bourgeois thought. Following Weber, Lukács defines rationalization as the striving to make the world predictable. The calculation of contingency objectifies itself, however, in the laws of the market, which confront the capitalist as a blind second nature, as irrational content: "men constantly destroy 'natural,' irrational bonds and create in their 'made' reality a second nature which evolves with the same necessity as was the case with irrational forces of nature" (HCC128). The formally closed systems of partial laws—whether in the sphere of economics or the sciences, the law, the state, the bureaucracy— cannot grasp their social and material base, which they are forced to irrationalize. The structure of reification is thus revealed in the coexistence of partial rationalities which together constitute the relative irrationality of the whole (HCC102): the totality governed by chance. Bourgeois rationalism cannot advance beyond the antinomies of system and contingency, since the dualism of form and formed content (that is, "intelligible contingency" [HCC138]) only produces and reproduces the irrationality of the whole.

Thus, Lukács argues, each rational system must come up against a barrier of irrationality (HCC114). Only a philosophy which has attained to the standpoint of the concrete material totality can break through the limits of formalism. Only an inwardly synthesizing philosophical method can fill "the purely formal determinants of freedom with truly living life" (HCC134). This was the great achievement of classical German philosophy which was "able—in thought—to complete the evolution of class" (HCC121), that is, *think* through to the very end the funda-

mental problems of the development of bourgeois society by raising the problem of form and content, the question of totality, to the level of consciousness. Lukács's focus here is Schiller's and Hegel's response to Kant's dualism, the dualism of appearance and the thing-in-itself. For Schiller the task of art is to make man, who has been "socially destroyed, fragmented and divided between different partial systems," whole again (HCC139). Art can lead the way because its principle is the "creation of a concrete totality that springs from a conception of form oriented towards the concrete content of its material substratum" (HCC137). It thus seeks to overcome the contingent relation of the parts to the whole, the opposition of freedom and necessity. The concrete totality of the work of art—in Jay's terminology an expressive totality—is a created whole, whose artist-creator points beyond the realm of art to the decisive question of the subject, of reconstituted man.[25] "The genesis, the creation of the creator of knowledge, the dissolution of the irrationality of the thing-in-itself, the resurrection of man from his grave, all these issues become concentrated henceforth on the question of *dialectical method*. For in this method the call for an intuitive understanding (for method to supersede the rationalistic principle of knowledge) is clearly, objectively and scientifically stated" (HCC141).

Here we must pause for a moment to underline the fundamental structure of Lukács's argument: the opposition of bourgeois rationalism—the dualism of form and *formed* content—and dialectical method—the dialectic of form and *concrete* content. The one conceives totality as the abstract goal of the infinite process of scientific approximation. The other intuitively grasps the concrete material totality as self-realization, which contains the infinite (the absolute) within, not beyond, itself and is prefigured in the principle of art. This opposition of quantity and quality, of rationalism and dialectics contrasts mechanical order—the realm of causality given by the invariant laws of nature—with the dynamic, organic totality, as the living process from which the qualitatively new emerges. We recognize in it Spengler's opposition of causality and morphology, the logic of *space* and the logic of *time*. For Lukács reification leads to the degradation of time to space. Through the subordination of man to the machine "time sheds its qualitative, variable, flowing na-

ture; it freezes into an exactly delimited, quantifiable continuum filled with quantifiable 'things' . . . in short, it becomes space" (HCC90). It is hardly necessary to recall that we have here the essence of Adorno's judgment on modern music.

If the principle of art and dialectical method break through the barriers of formalism in thought, it is only to come up against the insuperable barrier of the real subject of the historical process. This is the limit classical German philosophy could not transcend. It marks the point at which *reason reverts to myth*. Just as the opposition of rational and dialectical thought defines the *structure*, so this irrational limit is the key to the *logic* of Lukács's argument. If Hegel is the pinnacle of classical philosophy, who unites genesis and history, subject and substance, in his system, this synthesis is possible only in the mystified form of the world spirit. "At this point Hegel's philosophy is driven inexorably into the arms of mythology," since history itself is unable to form "the living body of the total system" (HCC147). This has three consequences: (1) the relation of history and reason remains contingent, (2) it forces Hegel to the assumption that history has an end, (3) the actual separation of genesis and history delivers the logical categories over to the revenge of history: "And since the method, having become abstract and contemplative, now as a result falsifies and does violence to history, it follows that history will gain its revenge and violate the method which has failed to integrate it, tearing it to pieces" (HCC148).

Now it is precisely *at this point*—the conclusion of the section "Antinomies of Bourgeois Thought" and the beginning of the final section, "The Standpoint of the Proletariat"—that Lukács's own argument is "driven inexorably into the arms of mythology": that is, the discovery of the identical subject/object of history in the proletariat, which transcends through praxis the limits of bourgeois thought. Lukács's verdict on Hegel turns against him, tearing his own method—Hegel out-Hegeled (HCCxxii)—to pieces. Our starting point was Adorno's method, the unfolding of the idea "until the inherent consequences of the objects is transformed into their own critique" (MM27), and the aim was to show how Adorno's method turns against itself: that the contradictions grasped as the inherent consequences of the object are the inherent contradictions of Adorno's logic. This reversion of reason into

myth joins Adorno and Lukács. It is on the turning point of their argument that my argument rests, the point from which we can draw together the conclusions of part 1.

"Schoenberg and Progress" is the continuation and *negation* of Lukács's method, that is to say, Adorno unfolds the same logic of history: the dialectic of form and content, subject and object, which drives on to the objective understanding of the historical process. The ongoing rationalization of the musical material leads to the cancellation of the subject/object dialectic in twelve-tone music, an outcome, parallel and *opposed* to the ongoing process of rationalization under capitalism, which leads to the overcoming of reification in the self-constituting praxis of the proletariat. Just as history comes to self-knowledge in the proletariat, so musical history in twelve-tone music. My incongruous equation between the proletariat and twelve-tone music can be justified because both constitute new totalities. As Markus has observed, Lukács's concept of praxis must be interpreted in analogy with artistic creation.[26] Of course, the outcome of the historical dialectic is diametrically opposed in Adorno and Lukács. If Lukács seeks to out-Hegel Hegel, Adorno out-Lukácses Lukács. Lukács resurrects the Hegelian totality against the world of bourgeois reification. Adorno, by driving Lukács's dialectic of reification to its extreme, makes Lukács's "totally closed, petrified world of reification" the satanic parody of the Hegelian fulfillment of history.[27] And so, just as Lukács's Hegelian logic becomes its own critique—the reversal into the myth of the proletariat, which is to be the genesis of a new history, so equally Adorno's Lukácsian logic becomes its own critique—the reversal of musical reason into total reification, in which the new music as the objective consequence of the old announces the end of history. Adorno thus completes in the name of progress the history of the Hegelian idea of totality, just as Schoenberg completes the history of German music since Beethoven. Adorno's negation of Lukács is, however, a Pyrrhic victory, for in revoking Lukács he destroys dialectical reason. Dialectical method, for Lukács the legacy of classical German philosophy, must demonstrate the irreversible severance of reason and history.

For Martin Jay the Lukácsian problematic of the totality, central to Western Marxism, spans the half-century from *History*

and Class Consciousness to *Negative Dialectics*. It is clear, how-
ever, that the Schoenberg essay already unmistakably delineates
Adorno's relation to Lukács. Moreover, Adorno's identifica-
tion of philosophy and music—mediated through the figure of
Schoenberg, the "dialectical composer"—points to the common
time and place of origin of Western Marxism and twelve-tone
music. It is not by chance—to use a favorite phrase of Lukács—
that Lukács's reification essay and Schoenberg's first twelve-tone
piece were written in 1922 in Vienna, or that the elaboration and
exhaustion of their respective problematics occupy roughly the
same time span. If Vienna is their common origin then Paris could
well be seen as the site of their common fate in the hypertrophy of
Boulez's integral serialism and the structuralist critique of Hegel-
ian Marxism.[28] Adorno, the pupil of Alban Berg and in important
respects the pupil of Lukács, who stands like Lukács at the meet-
ing of the two traditions—Hegel, Marx, and Weber and *Lebens-
philosophie*—is the relentless critic of Lukács and Schoenberg's
comparable drive to the revolutionary transcendence of the bour-
geois inheritance. In tracing the fate of German music and philos-
ophy Adorno gives voice to the revenge of history, which tears the
closed systems of Lukács and Schoenberg to pieces, but at a fatal
price: negative dialectics detaches itself completely from history
to circle endlessly in the iron cage of timeless modernity. In
Adorno's negative dialectics abstract form confronts totally
opaque content. Moreover, we observe the same response to
Lukács and Schoenberg. Adorno retreats from the blind logic of
twelve-tone construction to Schoenberg's heroic phase of atonal-
ity of the prewar and war years, just as he retreats from the
identical subject/object of Lukács's "proletarian" totality (ne-
gated and parodied in the indifference of subject and object,
freedom and necessity of twelve-tone music, the mirror of the
blind social totality) to the heroic phase of despair of Lukács's
prewar years, which culminated in the fragmentary *Theory of the
Novel*, written in the winter of 1914/15. Just as Schoenberg's
liberation of expression prefigures the mystery of mimesis, so
Lukács's mysticism of irony in the face of a God-forsaken world
of absolute sinfulness prefigures the negative dialectics which is
the last word of "Schoenberg and Progress."

The failure of Lukács's *Aufhebung* of the bourgeois legacy—

the limit which drives him *forward* into the arms of mythology—drives Adorno *back* into the arms of negative mysticism, that is, back to the point of the break, of the crisis of tradition. This is the *historical-logical* limit (the asymptotic barrier) which cannot be crossed. On the one side we have Adorno's negative mysticism (close to *Theory of the Novel*); on the other side we have Lukács's leap of faith, the mysticism of the *coincidentia oppositorum:* the identical subject/object of history, the union of form and content, word and flesh, spirit and matter, the infinite and the finite. It is clear that the eschatological thinking called forth by the total crisis of the war, whether despair or chiliastic hope, articulates what Lukács calls "the aspiration to wholeness." This longing for wholeness, for totality, manifests itself in the structural identity of the Lukácsian Hidden God of the prewar world and the Revealed God of the postwar one. They stand on either side of the asymptotic barrier which separates the finite and the infinite. Lukács's *salto vitale* (whose parallel is Adorno's *salto mortale* into negative dialectics) is thus the infinite leap of faith, which accomplishes here and now what the "infinite progression" of bourgeois science and thought can never attain: the dialectical identity of form and content, the immanence of the absolute in the concrete totality. The organic work of art, in which the symbol functions as the manifestation of the real presence, remained for Lukács the representative on earth of the expressive totality, whose destined subject-creator is the proletariat. The allegory espoused by Benjamin as the signature of modernity thus defines itself negatively in relation to the Hegelian-Lukácsian symbol: it is the manifestation not of presence but of absence, whose form is the nonidentity of sign and signified, the conventional—that is, arbitrary—relation of form and content. Exactly contemporary with the unfinished *Theory of the Novel* is the fragmentary work which may be seen as completing it—Kafka's *Trial*. The advocacy of Kafka by Adorno and Benjamin thus finds its structural inversion in Lukács's singling out of Kafka as the representative figure of decadent modern art.[29]

Theory of the Novel marks the parting of the ways between Lukács and Adorno. And yet for all that they were politically and geographically worlds apart the two follow complementary paths: the positive negation of the negation in *History and Class*

Consciousness is answered and "taken back" by Adorno's dialectic of enlightenment. Adorno's fatalism is the revenge of history on Lukács's revolutionary idealism. The collapse of the grandiose conception of *History and Class Consciousness* led Lukács to the restoration of classical aesthetics as the vehicle of philosophy of history. In his late *Aesthetics* art becomes the consciousness of the ongoing emancipation of mankind, whereas Adorno's dissolving of aesthetic theory into negative dialectics shrinks history to the rarefied sphere of authentic modernism, to the last threatened elite of a disappearing European culture. The irrational barrier which transforms the rational form of twelve-tone music into opaque content can be read as the symbolic moment of the end of aesthetics for Adorno. Like *Doctor Faustus,* Adorno's philosophy and aesthetic theory are the farewell to and the revocation of the "great tradition"—the progress of aesthetic rationalization, which ends in simultaneous affirmation and negation, leaving beyond it only negative dialectics as the other of reification, turns his "construction" of authentic modern art into negative theology. The inherent limit of his model of progress closes off new perspectives. Its achievement is not the construction of the new but the reconstruction of the old: the new perspective he opens up on the *completed totality* of European music. Despite the critique of illusion in the closed work of art, Adorno, no less than Lukács, is tied to the golden age of German culture. All his work is thus a reflection on decadence, a tracing of the progressive "logic of disintegration" against the lost historical-normative synthesis of German idealism.

In insisting on the reversion of reason into myth, that is, on the theological configurations which arise at the limit (the irrational barrier), I am only following Lukács, who writes: "from the standpoint of both logic and method, the 'systematic location' of the absolute is to be found just where its apparent movement stops. The absolute is nothing but the fixation of thought, it is the projection into myth of the intellectual failure to understand reality concretely as a historical process" (HCC187). If mythology "inevitably adopts the structure of the problem whose opacity has been the cause of its own birth" (HCC194), then Lukács perfectly characterizes the entwinement of reason and myth in his own system, just as Adorno's dialectic of enlighten-

ment not only diagnoses but exemplifies the self-destruction of reason. This ironic combination of prescience and blindness derives precisely from the dialectical reason by which Lukács seeks to transcend the antinomies of bourgeois rationalism. The identification of logic and history (form and content), whereby the absolute becomes part of the historical process itself, means that his system (and Adorno's) contains its fate in itself, that its structural limit is indeed absolute. It is not only that the system is delivered over to the revenge of history, that "irrational" history destroys the "rational" construction, that is, history as reason, the identity of subject and substance—this is the revenge spelled out by Adorno's progress—but that the dialectical constructions of Lukács and Adorno necessarily reproduce the Hegelian end of history. "The 'systematic location' of the absolute is to be found just where the apparent movement stops": in Lukács it is the absolute identity of subject and object; in Adorno it is the absolute indifference of subject and object.

What this "absolute" structural limit tells us is the fate of dialectical reason: "When Marx makes dialectics the essence of history, the movement of thought also becomes just a part of the overall movement of history" (HCC188). The fate of dialectical reason is sealed by history—the Western Marxism inaugurated by Lukács is its epilogue, just as the twelve-tone music inaugurated by Schoenberg is the epilogue to European music. We can now recapitulate why Adorno's Schoenberg essay occupies such a strategic place in this whole problematic. The *philosophy* of *music* is related not only to Schoenberg's *Aufhebung* of German music but equally to Lukács's *Aufhebung* of German philosophy. Adorno's critique of Schoenberg's system is simultaneously directed to the liquidation of Lukács's renewal of Hegel. Schoenberg becomes thereby the tragic self-portrait of Adorno: the composer who in seeking to continue tradition is forced to destroy it. Adorno negatively ratifies and prolongs the Hegelian end of art and history in the form of negative dialectics.

Progress is Adorno's immanent absolute, the logic of historical necessity which completes and destroys history. It is thus a retrospective category. The limit (twelve-tone music) brings, as I have argued, the history of musical progress (the dialectic of form and formed content) into sharper focus, enabling us to grasp the more

clearly through the prism of occidental reason the historical uniqueness of Western music as Adorno's paradigm of the progress and the end of tradition. The expressive totality comes to self-knowledge at its limit. The unfolding of the immanent telos of progress can only be thought within the totality: progress and history, dialectical reason and the historical totality, are mutual presuppositions. The *time of music* is coterminous with the history of progress. It is for this reason that the *soul* of the expressive totality—whether it be that of Lukács, Adorno, or Spengler—is organic form, "the good infinity" of Hegel, the "closed yet dynamic totality," which contains time within itself.[30] And it is for this reason that we must distinguish between the teleological work of art and the telos of progress, because this telos cannot transcend the limits of the teleological model, it can only destroy it. The "irrational" structural limit is thus the boundary of the space-time of the European totality within which the forms of dialectical reason—history, progress, the subject, tradition, the organic work, aesthetics—move and have their being. The telos which *does* "transcend" the bounds of the totality is the "logic" of European society which drives it on to catastrophe in 1914.

THE END OF TRADITION

Adorno's model of progress is tied to the end of tradition. The exhaustion of the aesthetic rationality of the language of music (and of painting) is the index of the (self-destructive) completion of the European cultural totality. His history of musical progress as rationalization is that of the modern age, in which the progressive emancipation from traditional constraints leads to the emergence of the autonomous sphere of art. The progress of musical reason is thus one with the great transformation of the modern age, the process of modernization, which defines the uniqueness of the transition from traditional to functional society, whose outcome is the world history to which the European modern age gave birth.[31] Weber's occidental reason, of which Western music is an aspect, bursts the bonds of Western culture to become the functional reason of world society, whose contours are emerging ever more clearly from the ruins of two world wars. In the process, as "Schoenberg and Progress" and the late *Aesthetic*

Theory testify, the "organic" link between progress and culture is destroyed. The destruction of this organic link (the unique characteristic of European art) makes Adorno the voice of the revenge of history, which tears to pieces dialectical reason in its twin forms of the philosophy of art and of history. Adorno's negative dialectics is the ghostly afterimage of the lost totality, just as his prolongation (extrapolation) of reified aesthetic progress beyond its organic limit demonstrates his inability to advance beyond the "affliction of dialectical compulsion" (MM132).

Progress and decadence (negative progress), inseparable since Rousseau, are rival accounts of the process of modernization, of the progressive emancipation from and exhaustion of tradition in the modern age. They are intrinsic categories of the self-understanding of the bourgeois epoch up to the First World War. By the same token neither concept can be applied to art since the end of tradition. Thus Adorno's simultaneous deconstruction of dialectical reason—the legacy of bourgeois thought—and application of the criterion of the most advanced state of the material to the new—that is, post-traditional—art, is simply illogical. The end of tradition is transformed into the endless crisis of tradition. The exhaustion of Adorno's "material" concept of modern art points to the need for a paradigm change, which accepts Adorno's model of the end of tradition and progress as the point of departure for the new time of postmodern art.

This point of departure appears in Adorno's polemic against Stravinsky. Stravinsky represents the other side of the new, of the situation of music after the end of tradition. His radical break with "musical reason," as opposed to Schoenberg's dialectical continuation of tradition, openly proclaims the end of the teleological model of music. What Adorno denounces as technical and political reaction can also be understood as located *beyond progress*. Like Picasso, Stravinsky is a crucial figure for understanding the modernism split by Adorno into the opposing lines of "progress" and "decadence," tragic authenticity and cynical inauthenticity in *Philosophy of Modern Music*. The different logics of Schoenberg and Stravinsky are both attempts to come to terms with the crisis of tradition, that is, with the exhaustion of the pregiven material. Their "music after the end of music" demonstrates in the purest form the situation of emancipated music:

the logic of disintegration issues into the consciousness of *contingency*. Schoenberg's construction and Stravinsky's masks—the flight forward into a self-imposed order or the parodistic play with the conventions of tradition—equally register the fact that tradition has become mere material, which no longer carries any binding force, any necessity in itself.

But it is through Stravinsky's play with contingency, rather than through the vanishing point of Schoenberg's (and Adorno's) "progress," that we come closer to comprehending the situation of postmodern art, obscured by the debates of modernism in the period of transition between the two world wars and beyond. The *querelle des anciens et modernes,* the struggle of progress and reaction was once more fought out in the name of a political-aesthetic progress which had become incoherent. Both "modernism" and "postmodernism" must be seen as belonging to the history of art since the crisis of tradition, most drastically revealed in the avant-garde revolts in the decade of the Great War. That the avant-garde revolts failed—Bürger's thesis—is a verdict from the perspective of progress. Their explosion of tradition announces rather the new situation of art—the setting free of the fragments of tradition, the emancipation of "material" as the universal category of the age of contingency, for which the tradition of European art no less than any other has entered the museum and become part of the horizon of world culture. I am arguing here primarily from the example of music and painting, since the semantic content of literature allows no such clear break. Still, it is obvious that literature is no less affected and defined by the broken relation of the new to "tradition." We need think only of those key documents of modernism *Ulysses* and *The Waste Land,* both published in 1922, the year of Lukács's reification essay and Schoenberg's first twelve-tone compositions.

PART TWO

Parody

Stravinsky
and Restoration

❑

European progress ended in world war. The progress of the modern age produced however, not only world history but also the idea of world culture. The ever-expanding frontiers of Europe's conquest of time and space necessarily involved the progressive discovery of the past. But as long as the idea of progress held, the past it created was subordinated to the future. Only when the idea of progress entered into crisis could the past be emancipated in its own right to become the horizon of world culture. The end of tradition thus has a double meaning: the very entry of European art into the museum not only closes tradition, it opens up and transforms the museum. European art takes its place alongside the art of all cultures. The legacy of progress is the inescapable presence of the past. The shadow of the past rather than the shadow of progress (Adorno) lies over postmodern art and poses the problem of parody, eclecticism and historicism as a recurrent thread of the modernism-postmodernism debate, which I trace in a series of direct and indirect responses to *Philosophy of Modern Music*. My starting point is "Stravinsky and Restoration."

If the immanent critique of Schoenberg's music reveals the internal limit of Adorno's dialectic of progress, the dissection of Stravinsky's music indicates the limit from without of Adorno's argument. Just as dialectical music and philosophy mirror each other as the enlightenment of art, so by contrast Stravinsky's

refusal of musical reason is mirrored in the breaking apart of Adorno's dialectical construction. In this construction the situation of the new music is deduced from the consequence of the split between subject and object, a consequence which governs the contrary paths of Schoenberg and Stravinsky. In "Stravinsky and Restoration," however, the dialectical argument dissolves into an unmediated typology of progressive and regressive music. This schizophrenia as method underlies the denunciation of Stravinsky's music as the method of schizophrenia, a method whose mask is parody. Here Constant Lambert's attack of 1934 in *Music Ho!* on Stravinsky as the representative figure of the postwar period serves to reinforce the thrust of Adorno's polemic: that Stravinsky is the target for all he rejects in twentieth-century art. If Schoenberg is the authentic isolated figure of art become knowledge, then Stravinsky is the other extreme of modernism precisely not as individual but as the type of dissociation, the prototype of an aesthetic of nonidentity.

SCHIZOPHRENIA AS METHOD

The new music is confronted by the problem How is it to escape contingency and regain authenticity? The premise of *Philosophy of Modern Music* springs from the situation and challenge defined by the dissociation of subject and object, form and content, intention and material. From it Adorno derives the construction which allows him simultaneously to unite and to separate the authentic and the inauthentic. Underlying the opposition of Schoenberg and Stravinsky is the schema by which Schoenberg is identified with the subject side and Stravinsky with the object side of the subject/object dialectic of traditional music. This division is of course schematic—Adorno speaks only on Stravinsky's objectivism and not correspondingly of Schoenberg's subjectivism—but it does serve to bring out the essential thrust of the argument. The untruth of *both* composers lies in the sundering of subject and object, in the cessation of the dialectic in a polarization which reveals the identity of the extremes. At the same time, however, only Schoenberg's subjectivism—despite and because it leads to the blind objectivity of the twelve-tone system—is the bearer of a dialectical relation to tradition. It carries its fate—the fate of music, of expression, of the subject—within itself, whereas Stra-

vinsky's objectivism substitutes for self-realization the mask of authenticity. Subject and object thus stand opposed as the split halves of the lost totality, both driven to the reconstruction, the recreation of order which will overcome contingency. As the split halves, both must fail, but in so doing their music traces the contrary paths of essence and appearance:

Their intention is emphatically to reconstruct the authenticity of music—to impose upon it the character of [the eternally confirmed], to fortify it with the power of being-so-and-not-being-able-to-be-otherwise. The music of the new Viennese school would hope to partake of the same power by means of infinite submersion within itself—by means of total organization: such force, however, is missing in its jagged physiognomy. Consummate unto itself, its intention is that the listener should share in the experience of this consummation, not simply reactively re-experience it. Since this music does not engage the listener, Stravinsky's consciousness denounces it as impotent and [contingent]. He renounces the strict self-development of essence in favor of the strict contour of the phenomenon. (MM136)

We thus have the basic outline of the *deduction* of the new music. The polarized extremes are both defined by the situation of contingency, but the one—the subject side—unfolds an inner logic (essence), whereas the other—the object side—refuses musical reason. This construction reveals the break in Adorno's argument: instead of taking his own premise seriously, which would require the recognition of the different logics of Schoenberg and Stravinsky in response to the end of tradition, Adorno splits modernism apart. The attempt to encompass dialectically the end of tradition does not and cannot work, because Adorno can arrive at no dialectical formulation of the relation between Stravinsky's music and tradition. Stravinsky's break with the teleological model of music may be the cause of Adorno's indictment, but it also demonstrates the limits of his argument, emphasized by the telling reversal of categories. Schoenberg's (dialectical) continuation of tradition is justified as progress, whereas Stravinsky's (undialectical) break is declared restoration. It is not only that these "progressive" categories seek to relate what Adorno has divorced, the division is reflected in a dubious division of labor. All that Schoenberg's progress has "authentically" destroyed—the integral subject, expression, the unfolding of mu-

sic as time, the organic work—is restored in order to unmask the inauthenticity of a music which has also drawn conclusions from the end of tradition. The methodological consequence is this: the dialectical model disintegrates into an antithetical typology. The schema already contains a judgment. This can be seen particularly clearly in Adorno's *equation* of his typology of listening types—the expressive-dynamic and the rhythmic-spatial modes of listening (MM197)—with the subject and object sides of the dialectic. Not only is this an extremely dubious equation, Adorno substitutes by a sleight of hand production for reception: the two modes of listening are immediately metamorphosed into opposed types of music. The opposition of the two types of music, effected by means of the abstract (analytic) separation of two types of reception which are no longer dialectically related, has the function of making Schoenberg the legitimate heir to the expressive-dynamic legacy of tradition and Stravinsky the regressive appropriator of its mechanically rhythmic and spatial elements. This separation, as the consequence of the dissolution of the binding subject/object dialectic of tradition, exemplifies the collapse of Adorno's dialectical method into an openly biased typology.

On the one hand we have the dialectical treatment of the two types within and beyond tradition:

The two types are separated by force of that social alienation which [tears] subject and object [apart]. Musically, everything subjective is threatened by [contingency], everything which appears as collective objectivity is under the threat of externalization, of the repressive hardness of mere existence. The idea of great music lay in a penetration of both modes of listening and by the categories of composition suited to each. It might be felt that the history of music after Beethoven—Romantic music as well as that which is actually modern—indicates a decline parallel to that of the bourgeois class. . . . If this is in any way true, then this decline is conditioned by the impossibility of resolving the conflict between the categories. The two types of musical experience, torn from each other, have today diverged without mediation and must pay with untruth. (MM198)

This loss of mediation is already prefigured, however, in the equation of subject and object with the two types, to emerge in its own "nakedly eloquent" form in the characterization of the two

types (of production *not* reception), the expressive-dynamic and the rhythmic-spatial: "The former has its origin in singing: it is directed towards the fulfilling [mastering] of time and, in its highest manifestations, transforms the heterogeneous course of time into the force of the musical process. The latter obeys the beat of the drum. It is intent upon the articulation of time through the division into equal measures which [virtually abrogate and spatialize time]" (MM197).

The prejudice of this contrast is so obvious—behind it lies, in the sphere of reception, the psychological opposition between the free and the authoritarian character type (MM200–201)—that it reveals in the most direct manner the basic flaw in the whole argument of *Philosophy of Modern Music*. Adorno confirms this when he declares that the distinction between his two types approximates closely Ernst Bloch's "distinction between the dialectical and mathematical essence within music" (MM198).[1] Adorno's typology is meant to reflect the tearing apart of the "musical subject-object," that is, the *end* of the subject/object dialectic, but in fact it smuggles the dialectic back in as the defining characteristic of the expressive-dynamic type. The crucial distinction between traditional and emancipated music—the "fulfilling mastering of time" and the freezing of time into space—is now used to distinguish between authentic and inauthentic music *after* the end of tradition. Such an inconsistency allows Adorno to argue on two levels. On the one level the separated halves—Schoenberg and Stravinsky—are defined by the crisis of tradition. Their music, however opposed, expresses the reduction of time to space. On a second level, the separated halves of the dialectical construction are transformed into a typology of the authentic and the inauthentic. The internal contradiction of the Schoenberg essay—the progress which destroys and yet continues tradition—breaks into the open in the Stravinsky essay. That is to say, the real line of break in *Philosophy of Modern Music* lies *not* between traditional and emancipated music but between Schoenberg and Stravinsky.

SCHIZOPHRENIC MUSIC

The two main charges in the case against Stravinsky are regression and restoration. They are linked together by the accusation

of schizophrenia. Stravinsky's explosive amalgam of the archaic and the modern—the revolt of primitivism against civilization—is accomplished by the ritual sacrifice of the subject, which prepares the way for the ironic restoration of "authenticity," purged of all suspect romantic remnants of expressive intention. The two related charges thus correspond to the two main phases of Stravinsky's work. First is the phase of the shattering of tradition, which parallels Schoenberg's atonal period, the music of the heroic decade from *Petrushka* to *The Soldier's Tale,* the work which Adorno considers central to Stravinsky's whole oeuvre. Second is the neoclassical phase inaugurated by *Pulcinella,* somewhat anticipated by Picasso's neoclassical reaction to cubism (Picasso designed the sets for *Pulcinella*), in which the "classical" composer now plays with the shattered fragments of tradition. This second phase in the wake of the Great War is also paralleled by Schoenberg's drive to reconstitute authenticity through the development of the twelve-tone method of composition. Adorno himself draws attention to this parallelism: "It would be a simple matter to compare the transition to neo-classicism to that from free atonality to twelve-tone technique, which Schoenberg completed at the same time: both developments have in common the transformation of highly specifically designed and employed means into as it were, disqualified, neutral material, severed from the original intention of its appearance" (MM206).

Although Adorno is utterly dismissive of the musical substance of Stravinsky's work from *Pulcinella* on, it is also the case that his real sympathies are confined to the atonal period of Schoenberg's music. What comes after the explosion of tradition is subject to the verdict of the dialectic of enlightenment—reification. Schoenberg's progression to the total integration of the material and Stravinsky's regression to its "schizophrenic" disintegration can be grasped as complementary forms of alienation, which in seeking to master contingency lay themselves equally open to the charge of the arbitrary. Schoenberg's *construction* and Stravinsky's *masks* thus both register the liquidation of the subject. Adorno's roots in expressionism—this last agonized and heroic outburst of bourgeois subjectivity—color his judgment on all that follows, as for instance in his rejection of both New Objectivity and surrealism, regarded as complementary versions of

reification. Schoenberg's "authentic" reification alone sets him and his pupils apart from the nihilism of aesthetic modernity, for he alone, as we have seen, by following the inner logic of the material executes the fate of music. Stravinsky's self-sacrifice in the name of self-preservation is that fate imposed from without in the name of objectivism. For a brief moment their paths meet, but only the more surely to indicate the parting of the ways. It is the moment of *Pierrot Lunaire* and *Petrushka,* the clowns who survive their own demise.

But in the treatment of the tragic clown, the historical lines of modern music separate. In Schoenberg, everything is based on that lonely subjectivity which withdraws into itself. The entire third part of *Pierrot* designs a "voyage home" to a vitreous no-man's land in whose crystalline-lifeless air the seemingly transcendent subject—liberated from the entanglements of the empirical—finds itself again on an imaginary plane.[2] . . . The texture of the composition designs the image of hope beyond hopelessness with [its expression of an utterly precarious security]. Such pathos is totally alien to Stravinsky's *Petrouchka*. . . . In Stravinsky's case, subjectivity assumes the character of sacrifice, but—and this is where he sneers at the tradition of humanistic art—the music does not identify with the victim, but rather with the destructive element. Through the liquidation of the victim it rids itself of all intentions—that is, of its own subjectivity. (MM 142–43)

Sacrifice and *mimesis* are the poles of the dialectic of enlightenment: the one, the "rational" propitiation of the split between man and nature, which the process of civilization progressively internalizes; the other, the "mythical" reconciliation of man and nature, which releases reason from the bondage of mythical blindness. The idea of sacrifice is antagonistically contrasted in the music of Schoenberg and Stravinsky. As Lyotard observes, Schoenberg becomes for Adorno the Christ who takes the sins of the world upon himself: "The shocks of incomprehension, emitted by artistic technique in the age of its meaninglessness, undergo a sudden change. They illuminate the meaningless world. Modern music sacrifices itself to this effort. It has taken upon itself all the darkness and guilt of the world" (MM 133).[3] Stravinsky's music, however, is denounced as the sacrifice of the individual to the collective, as prophetic complicity with the horrors of

twentieth-century totalitarianism, manifest in the eruption of the archaic and the barbaric in *The Rite of Spring* or the cynical demontage of the subject—the naked survivor of the Great War—in *The Soldier's Tale*. Thus on the one hand Stravinsky's music is seen as proto-fascist in its surrender to and celebration of the collective and its mechanical nature, while on the other the catalog of invective hurled against the cynical games, the inauthentic masks of this rootless, cosmopolitan intellectual recall not only Spengler's contemptuous dismissal of the sterile culture of the megalopolis but disturbingly echo the fascist denunciations of "degenerate art" (Schoenberg and Stravinsky were prime targets of the Düsseldorf Exhibition of Decadent Music, 1938).[4] This unpleasant and disturbing proximity is eloquent testimony to the infection of the time, so disastrously engaged in proclaiming rival political versions of authentic art. Adorno does not escape the dangers of this poisoned atmosphere. The Jew who defends authentic German culture (even if Jewish and in exile) from the inauthentic modernism of the Parisian avant-garde shows himself not so much acutely sensitive to the reactionary political implications of Stravinsky's music as appallingly insensitive to the political overtones of his own polemic. That this polemic is paradoxically formulated in terms of "progress" against "restoration" in no way disguises Adorno's deep resentment and antipathy toward the aesthetic modernity represented by Stravinsky. Behind the identification with Schoenberg lies the parti pris for German and Austrian expressionism; behind the anathema pronounced on Stravinsky lies the rejection of dada, of French surrealism, cubism, and the Russian film, and Brecht's epic theater.

The antipsychological Stravinsky sums up for Adorno all the tendencies of post-traditional (postmodern) art which have broken with expression, and with the bourgeois expressive subject whose medium is music. Whereas Schoenberg's sacrifice of music releases expression as suffering beyond subjectivity, Stravinsky's liquidation of expression is the sacrifice to a subjectivity which must deny itself to preserve itself. This sacrifice makes Stravinsky the puppet master, whose creations live from the separation of body and soul. To this animation from without—the wordless gestures of ballet—corresponds the brutal and yet detached celebration of animism in *The Rite of Spring*. The music, which

accompanies the self-annihilating dance of the sacrificial victim, states only "it was so and the music is as far removed from assuming a position as was Flaubert in Madame Bovary" (MM146). Such a dissociation, which refuses identification, is for Adorno the key to Stravinsky's animistic magic: the propitiating sacrifice of the self which preserves the self. The surrender to the magic power of the collective must leave the artist's sovereignty untouched. "*Le Sacré du printemps*—as the virtuoso composition of regression—is an attempt to gain control over regression [through its image]; the composition by no means intends to abandon itself to regression. . . . This was accomplished by making such a threatened [liquidation of the subject] its own concern, or at least by registering it artistically from the vantage point of an impartial observer. The imitation of the primitive [is to] serve as a miraculous, yet objective, magic means to avoid falling [victim to] the feared forces" (MM148).

Magic imitation replaces mimesis. Regression, however, demands permanent renunciation. The anxiety, called forth by the return of the repressed, can be mastered only at the price of crippling neurosis: the impotence, henceforth raised to a principle, to redeem or fulfill what "appears in the immanent dynamics of the musical material, as an expectation, or a demand" (MM149). Self-sacrifice is not only the subject matter of the ballet, it is the objective content of the music, which eliminates all that distinguishes the individualized from the collective (MM157). In short, what Stravinsky's music assaults is the bourgeois principle of individuation (MM152), that is, in terms of Adorno's typology, the destruction of the expressive-dynamic mode by the rhythmic-spatial.

Behind the typology stands not only the opposition of the dialectical and the mechanical-mathematical, the living and the dead, but also the psychoanalytic categories of sublimation and regression. The critique of the entwinement of subjectivity and domination, central to the analysis of Schoenberg's music, is subordinated now to the affirmation of the bourgeois principle of individuation (sublimation as the source of the expressive dynamic) against the dangers of regression. The *délire de toucher* produced by the incest taboo, attributed to Stravinsky (MM150), suggests equally, however, Adorno's own permanently deferred

longing to regress to mother nature, which is the key to the final page of *Philosophy of Modern Music,* where he opposes to Stravinsky's mythology authentic myth "the echo of the primeval— the recollection of the pre-historical world" (MM216). If Adorno's horror of regression reflects in the first instance revulsion against the violence of the totalitarian collective, it also involves an evident antipathy to the bodily, presubjective art of the dance. Stravinsky's "regression" to the dance is thus symptomatic of the retreat from musical individuation. His aversion to the whole syntax of music reduces dynamic development to motor repetition, shot through with irregular, convulsive rhythmic accents. The syncopated shocks of *The Rite of Spring* fall like blows from outside which compel music into submission and reduce the "resisting ego" to a traumatized bundle of reflexes: "The sadomasochistic element accompanies Stravinsky's music through all its phases" (MM159).

Adorno's defense here of the bourgeois principle of individuation, in which psychoanalysis is turned not against the suspect identity principle of the ego's domination of nature but against the decomposition of identity, forces him into a position in which he is compelled to condemn, with few exceptions, modern art. Indeed he seems to equate the avant-garde's revolt against tradition with regression, a regression, however, which is all the more reprehensible because it is merely simulated (MM168). In other words, Stravinsky's music cannot *express* schizophrenia, it merely imitates it. And yet Adorno does not hesitate to apply psychoanalytic categories to this form of dissociation. *The Soldier's Tale,* which is seen as taking Stravinsky's experiments in controlled regression furthest, is termed infantilistic, because it strikes at the very core of music—its expressive-dynamic impulse—by refusing *identity.* The compulsion to repetition means that his music has cut itself off from memory and from continuity in time. This suspension of identity is compared to children's dissimulation in play where they slip in and out of masks. *The Soldier's Tale* anticipates in fact two of the most important tendencies of the avant-garde's break with the bourgeois principle of identity: surrealism's montage of the fragmented images of modernity (MM161) and the technique of estrangement in Brecht's epic theater. Needless to say, they find no mercy in Adorno's eyes. The

detailing of the schizophrenic elements in *The Soldier's Tale* (to which temporally and thematically Brecht's *A Man's a Man* is very close) is also to be read as a description of Brecht's dramaturgy: "*L'Histoire du Soldat* ruthlessly weaves psychotic attitudes and behavior into musical configurations. The organic-aesthetic unity is dissociated. The narrator, the events on stage, and the visible chamber orchestra are juxtaposed; this challenges the identity of the supporting aesthetic subject itself. The anorganic aspects block [all] empathy and identification" (MM174).

Adorno leaves us in no doubt that Brecht is intended when he calls Stravinsky "the yea-sayer of music" (MM170) and chooses the Brechtian term *Einverständnis* (consent) to underscore once more Stravinsky's perverse pleasure in the death instinct: the proud declaration of the negation of "the concept of the human being through consent to the dehumanized system" (MM170). The references to the yea-sayer and to *Einverständnis* are clearly aimed at Brecht's didactic plays of the late twenties, which culminate in the sacrifice of the individual to the collective in *The Measures Taken*. Brecht serves to reinforce the political indictment of Stravinsky: the dissociation of the organic-aesthetic unity of the work goes hand in hand with the surrender to the dehumanized system.[5] It is for this reason that Stravinsky's musical techniques of dissociation are regarded as a ritual exorcism of the soul, and that his break with the expressive-dynamic inheritance is labeled psychotic, schizophrenic, the depersonalizing compulsion to repetition of the death instinct. The "psychoanalysis" of Stravinsky's music—and here we must remember that his work is representative of modernism in a way that Schoenberg's is not, as all the barbs directed in passing at the avant-garde indicate—can deliver only a *pathology* of post-traditional art. It is not by chance that the Viennese Freud (the unwitting father figure of surrealism) is called upon as the ally of Schoenberg.

It is indeed ironic that the very pessimism of the dialectic of enlightenment, which unfolds the objective necessity of the fate of the bourgeois subject and tradition, turns into aggression against the aesthetic manifestations of that fate. On the one level, Schoenberg and Stravinsky belong together; on the other, Adorno vents through Stravinsky his spleen at the avant-garde's destruction of tradition. At the heart of Adorno's theory of modern art is thus

the fate of the aesthetic *principium individuationis*. It is the basis for his genealogy of "Western" (that is, French) decadence, which makes Stravinsky the successor to the line which runs from Baudelaire to Debussy: "a type of Western art the highest summit of which lies in the work of Baudelaire, in which the individual—through the force of emotional sensation—enjoys his own annihilation" (MM166). In turn, Debussy's functionless harmony, which produces a "juxtaposition of colors and surfaces such as are to be found in a painting" (MM188), prepares the ground for the "eradication of time." The undynamic nature of French music negatively reflects the empty dynamics of Wagner, but where Wagner's renunciation of development was sustained by Schopenhauer's negation of the will to life, French music renounces even the metaphysics of pessimism for the resignation which is tied to the absolutely transitory: "Such steps of resignation are the pre-form for the liquidation of the individual that are celebrated by Stravinsky's music" (MM190).

In Spengler's morphology the climax of Faustian culture—eighteenth-century German music—is preceded by the dynamization of seventeenth-century painting and its transformation into music. Adorno arrives at a complementary formulation for decadence: the eradication of time and the spatialization of music represent the triumph of painting over music. This is the significance of the parallel between what Adorno calls the *transition* from Debussy to Stravinsky and the *development* from impressionism to cubism (MM191), although of course this "transition" and "development" accomplish the radical break which brings about the end of the European tradition in music and painting. The spatial dimension, which becomes absolute in Stravinsky, testifies to "the abdication of music" (MM191). The end of subjective, dynamic time and thus of the possibility of experience achieves not the desired objectification but the extirpation of life. It is the revenge of the regression which degrades "music to the status of a parasite of painting" (MM196), a regression which musically speaking is signified by the retreat from the sonata form to the movement without progression of the dance, the art of static time. "Music for the dance lies on this side of—and not beyond—subjective dynamics; to this extent, it contains an anachronistic element, which in Stravinsky stands in highly peculiar

contrast to the literary-modish success of his hostility towards expression. The past is foisted upon the future as a changeling" (MM196).

All Adorno's charges of regression against Stravinsky (and the French avant-garde) revolve around the disintegration of the bourgeois subject. The outcome is aesthetic, psychological, and political surrender, judged as self-sacrificial complicity with the tendencies of the age. The loss of memory, continuity, and identity results in a fundamentally schizophrenic opportunism which substitutes appearance for essence. The would-be sovereignty of artistic detachment is the symptom of Stravinsky's impotence in relation to the material. The work of art, which is no longer organized from within itself, is driven to proclaiming the extreme dissociation of subject and object as the form of their association (MM174). Adorno regards *The Soldier's Tale* as the *non plus ultra* of Stravinsky's archaic modernism, which derives its surrealistic impetus from the decomposed fragments of subjectivity. Regression can go no further, the disintegration of musical identity (expression) calls forth the counter gesture of restoration. The place vacated by the liquidated subject is filled by the masks of *parody,* which openly acknowledge the contingent relationship of subject and object, form and content. Here Stravinsky is seen as carrying to its conclusion the logic of Nietzsche's aesthetic. "Even Nietzsche in one of his occasional remarks has pointed out that the essence of the great work of art lies in the fact that it [could be other] in any of its given moments. The definition of the work of art in terms of its freedom assumes that conventions are binding. Only at the outset where such conventions guarantee totality beyond all question could everything [in fact] be different: precisely because nothing would be different. Most compositions by Mozart would offer the composer far-reaching alternatives without forfeiting anything. [Consequently Nietzsche adopted a positive attitude] towards aesthetic conventions and his [*ultima ratio* was] the ironic play with forms whose substantiality has [disappeared]" (MM40).

If freedom within the totality once meant the possibility of difference within identity, the definition of the emancipated work of art in terms of its freedom is to be found in the sentence of Brecht quoted by Adorno in another context: "It can be done

otherwise, but it can be done this way too" (MM170). It is a freedom which replaces Adorno's defense of aesthetic identity—the dialectic of thematic-variational development (whether in drama or music)—by an aesthetic of nonidentity. The alternative between Adorno's construction and Nietzsche's masks is the choice offered the composer Leverkühn by the Devil in Mann's *Doctor Faustus*. It is the choice between *necessity* and *freedom* as the only possibilities open to the artist after the end of tradition. Each is a response to contingency which reflects the dissociation of the subject/object dialectic. The subject side in Adorno's schema follows the path of necessity because the restitution of authenticity is to be accomplished through the radical reintegration of identity—the work organized solely from within itself. The object side follows the path of freedom because it formalizes and radicalizes the logic of the disintegration of identity—the work of art which is no longer organized from within is free to play with the masks of authenticity. Integration is opposed to dissociation, essence to appearance. Where there is no identity there can only be parody.

PARODY AND PASTICHE

From the two phases of Stravinsky's work—explosive regression followed by ironic restoration—there emerge the "ferments of dehumanization": the mimicry which exorcises mimesis, while mocking itself at the same time.

Unlike the numerous composers who thought to benefit their own "vitality" . . . through tactless familiarity with jazz, Stravinsky reveals, by means of distortion, the shabby and worn-out aspects of a dance music which has held sway for thirty years and has now [surrendered] completely to the demands of the market. He forces [as it were] the flaws of this music to speak, and transforms the standardized elements into stylized ciphers of decay. In so doing he eliminates all traits of false individuality and sentimental expression, which irrevocably belong to naive jazz, and converts such traces of the human—insofar as they might survive in the artful fragmentation of the formulae which he has put together—into ferments of dehumanization, with glaring mockery. His compositions are pieced together out of a montage of scraps of [com-

modities] just as many pictures or sculptures of the same time were composed of hair, razor blades, and tinfoil. This defines its difference in *niveau* from commercial [kitsch]. At the same time, his jazz pastiches appear to absorb the threatening attraction of [self-abandonment to mass art. The danger is averted] by giving in to it. Compared to these practices, every other interest of composers in jazz was a [simpleminded] effort to gain an audience—a [straightforward] matter of selling-out. [Stravinsky, however, has ritualized selling-out itself, the very relationship to the commodity. He dances the dance of death] around its fetish character. (MM171)

The death dance of nonidentity wears the mask of parody. Through parody Stravinsky reveals the "rattling skeleton" of the commodity, the degraded music of the market, which has become the material of his models. But behind the mask of parody grins the death mask of expression: "universal necrophilia is the last perversity of style" (MM204). It is the "final trick" of a procedure which makes disorganization its organizing principle and whose impotence lays bare the decisive anthropological condition of the age: the impossibility of experience.

The impossibility of experience is for Adorno not merely reflected in the disintegration of the work, it is at the same time the accusation of this disintegration. He thus rejects, like Lukács, montage, but not in the name of the lost aesthetic totality of the organic work. He accepts, like Benjamin, the fragmentation of experience and the work but opposes to the assembly of fragments in montage the idea of the fragmentary work. That is to say, the fragmentary work of Schoenberg is seen as expressing the truth of the age, whereas Stravinsky's fragmentation of expression mimics the untruth of the age.[6] Adorno dismisses as superficial the Spenglerian verdict on the decadent eclecticism of Alexandrian civilization. It ignores its technical cause, the exhaustion of the finite harmonic-melodic resources of tonality, which led composers to the hypertrophy of forced "inspiration" and drove them to the stratagem of the quotation of used material—a procedure which becomes absolute in Stravinsky.

The "second language of dream-like regression" in *The Soldier's Tale,* which anticipates the dream montages the surrealists assembled from the residues of waking consciousness, is con-

structed from the ruined fragments of traditional music. The result is that the "immanent formal validity" (MM183) of the work is replaced by a consciousness external to it, which takes the pregiven material as its "literary" object and feeds on the difference realized through distortion. Parody's dependence on pregiven material destroys not only the spontaneity of life but also of course identity. The duplication of disintegration produces the absolute indirectness of music about music, which treats its models like a child taking a toy to pieces. Needless to say, the reassembly of the broken pieces is not for Adorno the expression of "loving imitation" (MM187). The evil eye of parody is the enemy of expression, and since Stravinsky stands as the representative figure of inauthentic modernism, his practice also serves to disqualify montage: "The remnants of memory are joined together; direct musical material is not developed out of its own driving force. The composition is realized not through development, but through the faults which permeate its structure. These assume the role which earlier was the province of expression; this recalls the statement which Eisenstein once made about film montage; he explained that the 'general concept'—the meaning, that is, or the synthesis of partial elements of the theme—proceeded precisely out of their juxtaposition as separated, isolated elements" (MM187).

The counterpart to Stravinsky's aesthetic of nonidentity, the refusal of the immanent logic of the material in favor of dissociation and estrangement, is Adorno's treatment of Stravinsky as type, as the representative of the tendencies of the age. We find the same impulse in Constant Lambert's acidly witty Stravinsky polemic in *Music Ho!*, in which Stravinsky is regarded as the expression of the "group soul or Zeitgeist."[7] Looking back in 1948, Lambert saw his book as a period piece, "essentially a history of the troubled 'twenties' " (MH8), but in fact it is more than that. Like Adorno, Lambert sets out to present the position music finds itself in *after* the revolutionary explosion of the prewar years. "The landmarks of pre-war music, such as *Le Sacré du Printemps, Pierrot Lunaire* and Debussy's *Iberia,* are all definitely antitraditional; but they are curiously linked to tradition by the continuous curve of their break-away, comparable to the parabola traced in the air by a shell. But this shell has reached no

objective; like a rocket in mid air it has exploded into a thousand multicoloured stars, scattering in as many different directions, and sharing only a common brilliance and evanescence" (MH14).

The explosion of tradition was prepared by Debussy's dissection of harmony, Stravinsky's dissection of rhythm, and Schoenberg's dissection of counterpoint. The two great revolutionaries are Stravinsky and Schoenberg, the revolt from without and the revolt from within tradition. If Stravinsky is the barbarian at the gates—the immense prestige that *The Rite of Spring* enjoys "with a certain type of intellectual is due to the fact that it is barbaric music for the super-civilised" (MH30)—Schoenberg is the civil war within the citadel: "Schönberg is that anomalous figure, an anarchist with blue blood in his veins. He is historically and racially attached to those he seeks to destroy, and the spiritual conflict in his works is obvious" (MH30). Common to Debussy, Stravinsky, and Schoenberg, however, is the neurasthenia of the fin de siècle: the masochism of *Le Martyre de San Sebastian,* the sadism of *The Rite of Spring,* the hysteria of *Erwartung,* or the sinister morbidity of *Pierrot Lunaire,* in which "the ghost of the German *Lied* meets the ghost of French decadence" (MH37). But where, Lambert asks, can music go after the destruction of tradition released a new world of sound and a new world of sensation (MH41)? "Unlike the experimental period of the seventeenth century the pre-war period has led to a psychological cul-de-sac. There are many explanations of this, of which the most convincing is a simple and practical one. By 1913 music had already reached the absolute limit of complication allowed by the capacity of composers, players, listeners and instrument makers" (MH46).

Stravinsky's answer to this question—what happens after the revolutionary break—makes him for Lambert the key figure of the postwar situation. Since there is nowhere to go he takes to time traveling. *Pastiche*—"the synthetic creation of music by a rearrangement of previously existing formulas" (MH78)—becomes his chosen means of self-expression. "Stravinsky, at one time the globe-trotter par excellence, can no longer thrill us with his traveller's tales of the primitive steppe and has, quite logically, taken to time travelling instead" (MH47). Here he followed the master impresario Diaghilev (for whom Constant Lambert wrote

the music for a ballet in the 1920s). Cut off by the war and the Bolshevik Revolution from Eastern exotica, Diaghilev allied himself with the dernier cri from Paris, choosing as his collaborators Jean Cocteau, Erik Satie, Picasso, and Léonide Massine and developing for the ballet "the most typical artistic device of the present age" (MH50)—time travel. Diaghilev's scrapbook method made his ballets since *Parade* the antithesis to Wagner's ideal of the union of the arts in the *Gesamtkunstwerk*. In Stravinsky, his fellow exile, he found the ideal partner, since music can be dissociated far more easily than the other arts into its various elements and reassembled in a montage of disparate times and styles. That is to say, a composer can, if he so wishes, "take medieval words, set them in the style of Bellini, add twentieth century harmony, develop both in the sequential and formal manner of the eighteenth century, and finally score the whole thing for jazz-band" (MH50). In *Pulcinella,* the founding work of neoclassicism, Stravinsky rearranges scraps from Pergolesi: the trick consists of treating the expressive element mechanically while giving purely conventional formulas of the eighteenth-century pride of place: "like a savage standing in delighted awe before those twin symbols of an alien civilisation, the top hat and the *pot de chambre,* he is apt to confuse their functions" (MH52). It is relevant to recall here that the reversal of expression and convention—convention as expression—is taken by Benjamin as a defining characteristic of baroque allegory. Allegory's anatomy of melancholy, its mortification of the living into a constellation of inorganic emblematic fragments, serves Benjamin as the premodern prefiguration of the postmodern break with the expressive organic totality.

For Lambert the significance of Stravinsky's and Diaghilev's scrapbook method of the parodistic synchrony of styles lies in the fact that it is more representative of modern taste than the contrary direction of the austerity of Le Corbusier's designs—or the program of the Bauhaus or Schoenberg's twelve-tone constructions, we may add. "Modern taste is to be found far more in the typical post-war room, in which an Adam mantelpiece is covered with negro masks while Victorian wool-pictures jostle the minor Cubists on the walls. . . . To the post-war intellectual all periods are equally *vieux jeux,* including his own" (MH53). Neoclassi-

cism and surrealism are thus complementary aspects of the arbitrary association of the incongruous, of the travel in space and time which destroys all sense of life and identity. They are both for Lambert as for Adorno essentially *literary* in their treatment of content; that is, unlike any previous school of music or painting, they are defined not by style but by the alienation of content (the pregiven model or materials): "The cadences in the chorale of *L'Histoire du Soldat* give one the same shock as the combination of classical statues with balloon ascents in Max Ernst's *La Femme—Cent Têtes*" (MH59).

We can only note in passing the close agreement between Lambert's and Adorno's evaluation of Stravinsky's oeuvre—the rejection of the sadism and barbarism of *The Rite of Spring;* the admiration for *Les Noces;* the recognition of *The Soldier's Tale* as the most important of his "nursery-rhyme works" (the group of wartime works Adorno calls infantilistic): "Harmony, melody, all that could give the least emotional significance to his music, has been banished in the interests of abstraction, and musical purity has been achieved by a species of musical castration . . . there is no further progress possible on these lines" (MH68). Stravinsky's turn to music about music since *Pulcinella* represents for Lambert as for Adorno a complete impoverishment: "Stravinsky is essentially a decorator, not an architect, and he must always find new shapes to decorate. *Oedipus Rex, Apollon Musagète, Le Baiser de la Fée,* may differ in outward shape, but the mentality behind their fabrication remains the same. They are not so much music as renowned impersonations of music" (MH75).

In short, Stravinsky is the representative figure of the postwar period because he plays out the melancholy logic of dissociation—impersonation, schizophrenia, pastiche, and parody. "Like Diaghileff, Stravinsky stands for more than he himself has achieved, and it is as a group soul or *Zeitgeist* that he is a figure of weight" (MH78).

Writing in 1934, Lambert is no less than Adorno a partisan in the struggle to determine what is authentic in modern music. The polemic against Stravinsky is counterbalanced, however, not by the turn to Schoenberg but by the turn, or rather return, to Sibelius's "integration of form" in his symphonies as a possible escape route from the decline of music. The belief that Sibelius

could be seen as the symphonic successor to Beethoven was hardly more persuasive then than it is now. The evaluation of Schoenberg, while sympathetic, remains distanced, because Lambert regards the twelve-tone system as a radical and intellectual revolution which has no instinctive musical basis (MH209). Thus Lambert can already articulate the crux of Adorno's dialectic of enlightenment: Schoenberg "has escaped from an academic set of rules only to be shackled by his own set of rules, and this self-imposed tyranny is taken over *en bloc* by his pupils" (MH208). From this follows his own "theological" version of Adorno's negative dialectics. Atonal or twelve-tone music requires, like blasphemy, a background of belief for its full effect. "There is a strong flavour of the Black Mass about Schönberg. He has the complete lack of humour of the diabolist, while a glance at his earlier work indicates how devout a believer he once was" (MH211).

Adorno can hardly be exempted from Lambert's judgment. The diabolic nihilism of progress is the message of the Schoenberg essay, which is taken up by Thomas Mann and Lyotard. Stravinsky's irreverence leads to the anathema pronounced with complete lack of humor on his parodistic play with the fragments of tradition. Adorno's splitting of modernism into the opposed extremes of "progress" and "restoration" sets the scene for the opposed positions of the modernists and postmodernists.

After Adorno:
Modernism and Postmodernism

◻

In 1946 Schoenberg wrote a little essay, "New Music, Outmoded Music, Style and Idea," in which we recognize the same basic argument as that of *Philosophy of Modern Music:* Adorno's opposition of the authentic and the inauthentic, of essence and appearance, is presented as the contrast between idea and style.[8] According to Schoenberg the "new music" since the 1920s reveals a preoccupation with the search for new styles at the expense of new ideas. Schoenberg's target is primarily neoclassicism, the attempt, as he calls it, to compose in ancient styles. Already in 1926 he had dubbed Stravinsky "the restorer"—a title deliberately taken up in turn by Adorno—and dismissed him as a purveyor of fashionable goods, a mere window dresser, a jibe which also finds a direct echo in Adorno's contemptuous reference to a "tailor's dummy" (MM172).[9] Compared with this music of the day, the music of the future appears as "outmoded" idea, defined not by its relation to fashion but by its inner logic: "An idea is born, it must be moulded, formulated, developed, elaborated, carried through and pursued to its very end."[10] We are already fully aware of the contradictions inherent in the determination to pursue an idea to its very end. Let us examine first three more recent versions of the opposition of style and idea, which are indebted to Adorno and which do not escape the problematic of "progress": Pierre Boulez's essay "Style or Idea?" written in 1971 and intended as a direct response to *Philosophy of Modern Mu-*

sic; Jürgen Habermas's speech "Modern and Postmodern Architecture," given in 1981; and Albrecht Wellmer's speech of 1983, "Art and Industrial Production."

Like Schoenberg, Adorno, or Constant Lambert, Pierre Boulez is a partisan in the debate on twentieth-century music. He too writes in the name of the idea against the temptations of style. The decisive difference, however, is that he belongs to a later generation. For him, the alternative Schoenberg or Stravinsky has become relativized by the passage of time. The twenty-five years which separate his essay from *Philosophy of Modern Music* have drastically altered the perspective: Adorno's Manichaean splitting of modernism into progress and restoration, which completely split the musical world of the time into hostile camps and demanded, as Boulez writes, that we take sides, has given way to the perception of the historical unity of the epoch.[11] Boulez's historical perspective is one that Stravinsky had already articulated in 1959:

> Every age is a historical unity. It may never appear as anything but either/or to its partisan contemporaries, of course, but semblance is gradual, and in time either and or come to be components of the same thing. For instance, "neo-classic" now begins to apply to all the between-the-war composers (not that notion of the neo-classic composer as someone who rifles his predecessors and each other and then arranges the "theft" in a new "style"). The music of Schönberg, Berg and Weber in the twenties was considered extremely iconoclastic at that time but these composers now appear to have used musical form as I did, "historically." My use of it was overt, however, and theirs elaborately disguised. . . . We all explored and discovered new music in the twenties, of course, but we attached it to the very tradition we were so busily outgrowing a decade before.[12]

The sequence sketched out by Stravinsky—the explosion of tradition in the prewar and war years, the recoil of the 1920s in search of a new style, a new order after the revolutionary chaos, which would reestablish links with tradition—can be followed through Constant Lambert, Adorno, and Boulez. It takes us from Stravin-

sky's time travel (Lambert) and restoration of the old (Adorno) to Boulez's application of the phenomenon of *historicism* to Stravinsky's and Schoenberg's generation as a whole. The guiding interest of Boulez's essay is the implication of historicism for the concept of style.

Boulez sees the revolutionary period in literature, music, and painting of the first quarter of the century as characterized by two reactions to the exhaustion of tradition: exaggeration or simplification. He also speaks of the two ideas—sublimation or destruction—which leave no room for considerations of "style." On the one side is the intensification which drives the legacy of decadence to crisis through excess—here the exemplary work is Schoenberg's *Erwartung*—on the other is the barbarian plundering of Rome, the burning of Alexandria, for which *The Rite of Spring* is the example. The representatives of *exaggeration* are Schoenberg, Alban Berg, Wassily Kandinsky, Paul Klee, and James Joyce; of *simplification*, Stravinsky and Picasso (OR350–51). (It is interesting to note that if Stravinsky epitomizes for Adorno the abdication of music to painting, Kandinsky by contrast was strongly inspired by Schoenberg and thought of painting as music.)

The two sides of Stravinsky's simplifications are vehemence and irony. Irony led him to the use of parody and like Picasso to the objet trouvé. Instead of stylistic integration Stravinsky sharpens discrepancies and plays with the contradictory nature of the musical language with the result that his writing in quotation marks paves the way for the appropriation of preformed elements from the past, the turn to tradition as the repository of "style." Like Schoenberg he too is in search of order, that is, a style of binding generality which would again make composition possible after the heroic years of chaos. This dream of a style which would determine the idea is for Boulez the sign of a new phenomenon, the penetration of contemporary consciousness by historicism. The ever-greater intrusion of the past now emerges as a serious obstacle to invention. The composers and painters of this generation surrendered to the security of the monuments of culture, because unlike literature, where the consciousness of the legacy of the past was always present, painting and music could no longer escape the burden of memory (OR352).

For Boulez, however, it is not the rebel Stravinsky but Schoenberg, the man of tradition, who most fully exemplifies the retreat to a classicist idealization of style. His self-understanding as the continuation—however radical—of tradition meant that history could not become a problem for him. And so he pulled back from the anarchy which threatened musical evolution and in the name of evolution (progress) created a *new* order, but one which is to be guaranteed, "authenticated" by the old order. The incompatible forms of tradition are grafted onto the new language. The contradiction of new wine in old bottles—in Stravinsky's terms, the "historical" use of form—signifies for Boulez the break with the direct, living relation to tradition which informed and inspired the revolutionary phase of atonality. Tradition is now transformed into the image of a golden age of invention, the utopian projection of Schoenberg's longing for the security of a perfect model. As a consequence the relation between style and idea is reversed: "*Ideas* no longer generate style—style imposes the *idea*" (OR354). And so ironically Schoenberg's "classical" ideal is in reality a *mask*.

And the *terrible simplificateur* Stravinsky? Since he is not tied to the classical-romantic inheritance in the same way as Schoenberg, he does not succumb to the same degree to the neoclassicist idea: "Far from taking up his inheritance, he simply destroys it and hence there arose that series of works that still fill us with astonishment" (OR355). This series, from *Petrushka* to *The Soldier's Tale,* accomplishes the break with tradition—for Adorno the extirpation of memory and identity—by a "masterly *reduction* of the musical vocabulary" (OR355), which permits cultural reference only in the form of caricature and the objet trouvé. But could the confrontation with the past be evaded in the longer term, Boulez asks, in an epoch which continually compels us to remembrance?

Stravinsky's "discovery" of tradition and history with *Pulcinella* is likened by Boulez to that of the visitor to the museum. The mixture of amusement and fascination, which derived from the Parisian intellectual milieu of the time (Cocteau and Paul Valéry), is not in Stravinsky, however, an intellectual-speculative attitude but the basic impulse of childish curiosity to take the toy to pieces and reassemble it (the image is familiar). Style for Stra-

vinsky was a game by which he sought to come to terms with the accumulation of culture, the burden of the past under which we are constrained to compose: "playing with this culture means trying to abolish its influence by making it quite clear that one has mastered all its mechanisms—from outside—even the most perverse" (OR356). But finally the result of this play with the past adds up to no more than a gigantic quotation. We are once more back in Alexandria. In the end the time traveler cannot escape the necessity of forgetting the past, removing the mask, and revealing his true face.

Because they were faced with the compelling task of creating the new, Stravinsky and Schoenberg made history in their revolutionary period without thinking about history. Since the 1920s, however, history has claimed its revenge. For all their differences both composers called a halt to progress and sought to reestablish an absolute continuity by combining memory and invention. The very attempt, however, to reattach the new to the old marked the capitulation to "an obsessive desire for order and classification based on absolute models," the freezing of the historical dynamic of musical innovation. From this point on they no longer belonged to the future but only to the present.

Boulez answers *Philosophy of Modern Music* by locating Adorno's historical alternative of progress or restoration within the unifying framework of the phenomenon of historicism, the return to the past after the revolutionary break. Here it is not just a question of the *composer* Boulez seeking to make room for himself by relativizing the dominant influence of the masters of modernism; his concern is rather the underlying problem of the power of the past over the present. Boulez would like to explain the fascination that the "world of quotation" exerted over the most brilliant minds of the twentieth century. Does it lie in the character of invention in our epoch or in our civilization itself? The whole encyclopedia of culture, the whole memory of the world, lies at our disposal. Time and space have been canceled. It has become practically impossible to ignore history, not only our own but that of the most remote civilizations. Perhaps only *architecture* has escaped the compulsion of imitation (OR358).

And so when Boulez concludes by praising the loss of memory, it is a demand made in commitment to the *idea,* since it involves

the very question of the possibility of composition of music now. Although he emphatically relativizes Adorno's partisan position, as composer and theorist Boulez stands in the line of succession from Schoenberg and Adorno. The progress of the idea remains paramount. It is expressed in his definition of the idea as the inescapable consequence of a language which unifies all its elements. Indeed, Boulez's compositions represent the ultimate consequence of the idea of serialism as the total rationalization and integration of all the elements of music. In 1963 he wrote of the "absolute necessity for a logically organized *consciousness*" which can be achieved only systematically: "It is now essential to forge ahead with this coherent system: it will give impetus to the future development of musical thought. . . . The weakness of certain recent tendencies of thought is exactly this, that partial speculations have never been fully evolved, hence certain hesitant and invalidating constructions. These must be overcome in order to put contemporary musical thought on a completely and infallibly valid basis."[13]

Boulez's scientistic faith in an infallible system (the axiomatic method), comparable to Louis Althusser's contemporary version of "scientific" Marxism, appears in retrospect as a last logic of totalization, intended to hold the specter of contingency at bay. The flight forward into order is fatally reminiscent of the dialectic of enlightenment.

<center>HABERMAS:</center>
<center>MODERN AND POSTMODERN ARCHITECTURE</center>

Boulez suggests that architecture has escaped the temptations of historicism. At the time of writing the "world of quotation" in "postmodernist" architecture had only begun to call into question the functional idea of international modernism. Although hardly consciously intended, Habermas's defense of modern architecture in "Moderne und Postmoderne Architektur" reads as a replay of *Philosophy of Modern Music*. His speech is the attempt to grapple with the "reactionary" spirit of a "period of transition," in which post–avant-garde movements, infected by the conservative atmosphere of the 1970s, have arrived at an intellectually playful but provocative rejection of the *moral* principles of modern architecture (NU9, 11, 12).

Habermas proposes a dual reconstruction of nineteenth-century architecture as the prehistory of the classical modern in terms—*historicism* and *reason*—which renew the opposition of style and idea, nonidentity and identity. Historicism is seen by Habermas as the Janus-faced legacy of the Enlightenment: on the one hand it is the confirmation and radicalization of the Enlightenment, which defines, as Nietzsche recognized, ever more sharply and inexorably the conditions of modern identity; on the other hand, by making historical traditions available in ideal synchrony, it permits the flight from the present into the costumes of borrowed identities. Modern architecture is the still-valid answer to this situation, which points back to the other tradition, the "hidden reason," of nineteenth-century architecture (NU13–14). The work of Adolf Loos, Frank Lloyd Wright, Walter Gropius, Mies van der Rohe, Le Corbusier, constitutes the one and only binding style since classicism: "This architecture alone has sprung from the spirit of the avant-garde, is of equal rank with the avant-garde painting, music, and literature of our century. It continued the line of tradition of occidental reason and was itself powerful enough to create models, that is, to become classical and to found a tradition, which from the beginning crossed national frontiers" (NU15, my translation). And yet its opponents, whatever their persuasion, are united in their critique of its consequences since the Second World War: the brutal and soulless landscape of the city today. Confronted by this unanimity Habermas seeks to disentangle the spectrum of positions by distinguishing in a further step between style and idea in this criticism: whereas *immanent critique* is directed to the critical continuation of an irreplaceable tradition, the *opponents of the modern* hasten to proclaim the age of postmodernism. Here Habermas discerns two main tendencies, the conservatively minded who, like Robert Venturi, treat the spirit of the modern movement as quotation, and the radical antimodernists, whose goal is the de-differentiation of architecture (NU14–15).

For Habermas the problem is this: Is the tradition of the modern to be critically continued or do we surrender to the escapism dominant today? In other words, does the contemporary city reveal the true face of modernism or is it the falsification of its true spirit? Since modern architecture continues the line of

tradition of occidental reason, clearly for Habermas its true spirit has been falsified. How could this have occurred? The answer essentially is that its autonomous logic was subordinated to the systemic imperatives of capitalist modernization. The functional logic of modern architecture was falsified precisely by the anonymous functionalist demands of the economy and administration (NU23–24).

While it is undoubtedly the case that architecture is an applied rather than a pure art and as such necessarily subject to what Habermas calls systemic imperatives and in this sense very different from the "autonomy" of twentieth-century painting, music, and poetry, does it follow that the "true spirit" of modern architecture can be separated so neatly from its social consequences? Here Habermas's turn to Adorno is particularly instructive. The functionalism of modern architecture reveals, he argues, the consistent pursuit of an immanent aesthetic logic, a constructivism parallel to the experiments of avant-garde painting. Although modern architecture is always tied to external functions, it is nevertheless governed by the laws of cultural modernity: the compulsion to radical autonomy, to the complete differentiation of a sphere of genuine aesthetic experience. Adorno's characterization of avant-garde art, which has emancipated itself from perspective in painting and tonality in music, by the key terms *construction* and *experiment* defines the authentic functional work of art as self-referential: its immanent teleology is to be distinguished from the external determinants of functional objects such as bridges or factories. Habermas disputes Adorno's dichotomy and insists that the functionalism of modern architecture does not stand apart from but coincides with the inner logic of the development of modern art (NU21). In his separation of occidental reason into inner aesthetic logic and outer systemic imperatives in order to defend the true spirit of modern architecture, Habermas forgets that for Adorno the autonomous "functional" work of modern art carries within itself the logic of capitalist modernization. The distinction between the true spirit of modern architecture and its system-dictated deformation evades Adorno's dialectic of rationalization but must in fact bear witness to it, as we shall see. Habermas's commitment to "the line of tradition of occidental reason" in the sphere of art compels him

to repeat the self-defeating impasse unfolded in *Philosophy of Modern Music.*

This compulsion to repetition is symptomatic of a problem which cannot be solved. Its recurrent emblem—from Schoenberg and Adorno to Boulez and Habermas, the advocates of progressive aesthetic rationality as against "historicism" in post-traditional art—is the opposition of style and idea. In order to demonstrate the parallels between Habermas's argument and that of *Philosophy of New Music* we need only substitute for the "true spirit" of the international school of modern architecture the idea of the school of twelve-tone music, which likewise attained international recognition only after the Second World War, and for the disappearance of the *European* town, the frame which gave meaning to traditional architecture, the dissolution and destruction of tonality. The town, the bourgeoisie, and music belong together for Adorno. For Habermas, it is the "occidental town, as Max Weber described it, the town of the European bourgeoisie [*Bürgertum*] of the late Middle Ages, the urban aristocracy of upper Italy in the Renaissance, the residences renewed by the baroque architects of the princes" (NU24). Habermas knows that there is no way back to the "old European town." Like tonality, the concept of the town is irretrievable. What the town once offered, the architectural representation of a visible life world, the translation of social function into formed shape, is no longer possible.

Since the nineteenth century the city has become the locus of abstract systems, which can no longer be given concrete aesthetic presence. The functional networks of the system have become invisible behind the faceless facades of the public and private bureaucracies. The *differentiation,* which the form language of architecture can no longer realize, is delegated to the medium of the sign (NU25–26). Even if we agree that modern architecture cannot be blamed for the destruction of the town by the modern conurbation, it is nevertheless the case that the anonymous, purely "functional" office blocks, banks, or ministries cannot be separated from the true spirit of modern architecture. The *idea* of the perfect congruence of form, function, and material ends like the twelve-tone technique of composition in the fatal indifference of form and function. (And here one is tempted to compare their

common adherence to *serial* techniques: to the preformed row of twelve-tone technique corresponds the montage of prefabricated parts, integral to Le Corbusier's idea of a "unité d'habitation.") Habermas can defend the idea of modern architecture only by separating inner and outer imperatives, abandoning in the process Adorno's demand for immanent critique.

Habermas admits that the outcome of instrumentalized architecture is a disaster which calls for new solutions, but he makes it clear that the only new solution he can envisage is the return to the old: the self-critical continuation of the *idea* as opposed to the postmodernist reactions which reduce the problem to a question of *style* (NU26). Thus, although he concedes that Venturi's aggressive mixture of styles, which recall surrealist stage sets, seeks to express in chiffers the abstraction of a world which defies architectural shaping, he appears unable to relate what he acknowledges as the common denominator of the diverse tendencies of postmodernism—the programmatic separation of form and function (NU26)—to the self-destructive logic of functional rationalization in modern architecture.

We find the same inconsistency in Albrecht Wellmer's "Art and Industrial Production," in which he searches for an *immanent* continuation of the tradition of modern architecture through a differentiation of Charles Jencks's "rehabilitation of eclecticism" in *The Language of Postmodern Architecture*. Jencks defends eclecticism as the inescapable linguistic plurality of post-traditional society which no longer possesses a generally binding system of signification. Architecture must therefore draw, in full consciousness of historical distance, on the semantic potentials of the past which the loss of a general system of significance makes freely available. As such, this defense of eclecticism represents for Wellmer the confession that postmodern architecture is incapable of creating its own language (IP57). The differentiation which Wellmer proposes is familiar: the distinction between idea and style, progress and regression, authentic and inauthentic. Applied to postmodern architecture it allows the line to be drawn between the immanent critique which is the continuation of modern architecture and "the arbitrary or frivolous game with the language forms of the past" (IP57). The result, however, underlines the problematic of the defense of the progress of the idea: what

Wellmer's application of the distinction achieves is the incongruity of a distinction between authentic and inauthentic eclecticism!

The rejection of a one-sided technocratic modernism by postmodernist architecture *must*, obviously, not be understood as a turning away from modernity and the enlightenment; it can also be understood as an immanent criticism of a concept of the modern which has fallen behind its own goals: the rediscovery of the articulate dimension of architecture, the contextuality, participatory planning models, the emphasis of the city "fabric" in place of contextless structural monuments, historicism and eclecticism themselves [understood] in the sense of a re-discovery of the historical-social dimension of architecture as well as the cultural tradition as a reservoir of semantic potentials—in short, much of that which distinguishes the so-called postmodernist architecture from the technocratic-utopian biases of the modern can be understood as progress in architectural awareness and as a corrective *within* the modernist tradition. But against this, eclecticism and historicism also have the potential meaning of a renunciation of the constitutive features of modernity: from enlightenment, universality, and rationality. (IP59)

Idea and style, progress and regression, have now become the Janus face of *eclecticism*. The ambivalence Wellmer discerns in postmodernism reveals also the ambivalence of his position, which leads to a "progressive" defense of eclecticism.

This is *not* to say that I disagree with Wellmer's understanding of Jencks's postulate of an eclecticism which is qualitatively different from that of the nineteenth century. Indeed, Jencks's "new, authentic eclecticism" (IP58) presupposes in our terms the end of tradition and with it the end of the idea of progress; that is, in Wellmer's terms it is the outcome of a pluralism of values, meanings, and forms of life intrinsic to post-traditional society and a universalistically understood democracy, which can no longer prescribe a system of objectively binding meanings (IP58). And so when Wellmer speaks of the productive possibilities given by the new degree of freedom of modern consciousness in relation to tradition, he points back not so much to Adorno as to Benjamin. Such an "eclecticism of *contemporising*"—"the possibility of striking sparks from the petrified texts of the past, while adapting their signs into new configurations of an altered legibility" (IP59)—will occupy us in conclusion in the context of the new

historicism beyond progress in its dual aspect of the Museum and montage.

Boulez ends in praise of the loss of memory, Habermas and Wellmer with the praise of the tradition of modern art. They speak in the name of the critical continuation of the idea, but what they demonstrate is the aging of the *idea* of modern art.

THE AGING OF MODERN ART

Peter Bürger draws many of the issues of the debate together in a paper entitled "The Decline of the Modern Age," first delivered at the 1983 Adorno conference in Frankfurt. It presents a decided if respectful critique of Adorno's splitting of modernism, for which *Philosophy of Modern Music* remains the paradigmatic expression. In line with the argument of his earlier *Theory of the Avant-garde* (1974), Bürger rejects the central category of Adorno's aesthetics of modernism, the concept of the historically most advanced material, but pleads at the same time for a theory of contemporary art capable of conceptualizing postmodernism as a dialectical continuation of modernism. As the title of his paper, derived from Adorno's 1954 essay "The Decline of Modern Music," indicates, Bürger has not altogether abandoned the perspective of decadence and progress. Bürger poses the question of the decline of modernism by highlighting the turn to neoclassicism by Picasso, Stravinsky, and Valéry about 1920. That such significant figures in the development of modern art oriented themselves on classical models "makes the problem of neo-classicism a touchstone for every interpretation of artistic modernity" (DM118). Adorno cannot answer this problem. As Bürger observes, Adorno's comparison of Stravinsky's music with the techniques of the surrealists is not intended positively; on the contrary, it means that he excludes neoclassicism and surrealism from his canon of the authentically modern. Their "quite avant-gardistic treatment of the pre-given, which does not settle just for a parody of these forms (as Adorno suggests in one passage: *Philosophy of Modern Music*, 186), but through it aims at a questioning of art, resists Adorno's concept of art" (DM120). Adorno's aesthetic theory, predicated on the recognition of only *one* material in a given epoch, is antagonistic to the avant-garde's principle of montage.

This splitting of modernism Bürger calls Adorno's anti–avant-gardism (DM120). He draws two consequences from the abandonment of Adorno's thesis of the most advanced historical material. It "does not merely allow the juxtaposition of different stocks of material to come into view (e.g., the painting of 'new objectivity,' along with Picasso's or that of the surrealists), whereby theory no longer presumes to explain *one* material as the indicator of the historical moment. It also facilitates the insight that the later development of an artistic material can run into internal limits." The example which Bürger takes is that of Picasso's sudden break with cubism, that is, his "broken" relationship to it from 1917 on. It suggests that a consistent continuation of "the Cubist material" would have led to exhaustion (DM121).

The impasse of Adorno's aesthetic theory is summed up for Bürger by Adorno's inability to draw conclusions from the internal limits of an artistic material. Adorno's recognition in his 1954 essay that the tendency to total rationalization is the cause of the decline of modern art remained without consequences: "the expectation that Adorno would draw the consequences from this radical critique of modernism, more precisely from his concept of modernity, is frustrated" (DM123). That this absence of revision is in fact a necessary "logical" consequence of Adorno's method of immanent critique, which permits in the name of progress only the dialectical negation which is simultaneously affirmation, is not fully grasped by Bürger. It is, however, the "logic," of the Schoenberg essay. Similarly, Habermas's position of immanent critique—the critical continuation of the idea—stands in the way of the consequences of his argument. He remains trapped in a too narrow concept of modern architecture. In turn, Bürger's search for a dialectical continuation of modernism leads him to draw back from the logic of his argument in *Theory of the Avant-garde*. The specter of progress has not been completely exorcised. Bürger explains what he calls Adorno's "undeniable aesthetic decisionism" by his desire "to banish the danger of historicism" (DM124): "Fear of regression remains the central motif for Adorno's aesthetic decisionism. It determines both his rejection of the avant-gardist Stravinsky as well as of neo-classicism. This fear, understandable because of the experience of fascism . . . however, strips modernism of one of its essential modes of ex-

pression. . . . The longing for regression is an eminently modern phenomenon, a reaction to the advancing rationalization process. It should not be tabooed, but worked out" (DM125).

Apart from the fact that historicism and regression cannot be equated, what sense does it make to speak of regression in modern music or painting once the criterion of the most advanced material has been abandoned? Adorno's aesthetic theory stands and falls by its central category of the material. Bürger's break with Adorno makes sense only if he means by "the decline of the modern age" the collapse of Adorno's "construction of the development of art in bourgeois society based on the Weberian concept of rationality" (DM123) *in its application to postmodern art*, that is, Adorno's application of the opposition of progress (idea) and decadence (style) to art *after* the historical avant-garde's assault on tradition, which set free the material of tradition. This, after all, is the thesis of Bürger's *Theory of the Avant-garde*, for which by definition neoclassicism, or more generally historicism, cannot be a problem.

The problem appears to lie in the lingering bad conscience engendered by the equation of modern art with progress (the avant-garde), a link severed in Bürger's construction of the situation of post–avant-garde art but nevertheless *comprehended only negatively*. Behind Bürger stands Hegel: "Already Hegel prognosticated the free disposition over forms and objects for art after the 'end of art.' This prospect becomes cogent at the moment when there is no longer any generally binding system of symbols" (DM129). Hegel's art after "the end of art," Adorno's music after the end of music, and Bürger's post–avant-garde art all speak of the situation of art after the end of the binding force of tradition. Each is a progressive construction which dialectically unfolds the self-destructive completion of aesthetic progress. Each remains tied to the idea of progress, positively with Hegel, negatively with Adorno and Bürger. It is for this reason that Bürger, despite his historicization of Adorno, cannot quite break out of the paradigm of progress in his theory of modern art. That is to say, he does not realize that his theory of the avant-garde and post–avant-garde art is in fact a theory of *postmodern* art. The free disposition over forms and techniques, over the material of tradition, and *not* the criterion of the most advanced material, is the

crucial aspect of the condition of art since the historical avant-garde.

Thus if the problem of neoclassicism is advanced as the touchstone for every interpretation of artistic modernity, then both the "modernist" and the "postmodernist" readings of neoclassicism are simply opposed interpretations of postmodern art, as applicable to the 1920s as to the 1980s. As Habermas observes, Venturi's "postmodernist" architecture recalls surrealist stage sets. This is not just a question of historicist reminiscence, of quotation, but rather the confirmation that style and idea remain alternative responses to the situation of contingency brought about by the end of tradition. As ever, theory lags behind practice. The "postmodernist" debates of the last years in the field of aesthetic theory are simply the belated recognition of what twentieth-century art has been demonstrating for some seventy years. Although Adorno's parti pris fatally flaws his aesthetic theory, *Philosophy of Modern Music* nevertheless remains seminal because Adorno's splitting of modernism into "authentic" idea and "historicist" style already draws the line of division between the positions of "modernism" and "postmodernism." This division, however, is artificial in that both positions are arguing about the same thing—art since the end of tradition, art after the "end of art"—and both are themselves reflections of the postmodern situation. In this sense Bürger's project of a dialectical continuation of modernism is unnecessarily defensive, for if modernism may not exclude the "neoclassicism" of Stravinsky and Picasso, why should there be any difficulty in accommodating contemporary manifestations of the "world of quotation," which is just as constitutive of aesthetic modernity (the postmodern) as Adorno's world of construction? Although we can distinguish "modernist" and "postmodernist" positions in contemporary critical *discussion*, it does not follow that we can identify recent *art* as "postmodernist," with the implication of an epochal threshold, which Bürger rightly rejects (DM117). Ironically, it is precisely the decline of the dominance of the progressive theorem of modernism which has led to the reaction which postulates the new epoch of postmodernist art—a reaction which itself remains tied to the idea of progress. Contemporary "postmodernist" art (not that it is possible to discern any agreement as to what would constitute

postmodernism in contemporary painting, music, and literature) remains a further manifestation of the postmodern condition since the end of tradition. The significance of Adorno's *Philosophy of Modern Music* and of Bürger's *Theory of the Avant-garde* lies in the fact that they make the radical break with tradition the turning point of their *reconstruction* of tradition and *construction* of post-traditional art.

Bürger identifies three readings of contemporary art. The *antimodern* reading sees in the decline of (Adorno's idea of) modern art an argument for a "postmodernist" return to academism (i.e., the return to tonality, realistic forms of narration, and traditional literary forms). He rejects this "abstract negation of modernism" (DM126).

The second reading is *pluralistic:* "The decline of modernism shows the onesidedness of a concept of tradition which recognizes in music only the Schönberg school, and in narrative literature only a few authors such as a Proust, Kafka, Joyce and Beckett. The music and literature of the 20th century were however, much richer. The consequence of this position for the present reads: there is no advanced material, all historical stocks of material are equally available to the artist. What counts is the individual work" (DM126). Bürger does not, indeed cannot, dispute this reading. He concludes that "aesthetic valuation today must detach itself from any link with a particular material" (DM127), but at the same time he is clearly worried by the implications of pluralism, the danger of the surrender to an indiscriminate eclecticism of taste. This problem of reception cannot be met, however, by calling upon artists to reflect upon the abundance of possibilities of production available (DM127). For even granted that every artist adequately reflects upon his or her contingent (arbitrary) freedom, this in no way alters the reality of pluralism for recipients and producers.

The unbanished danger of *eclecticism* leads Bürger to a third reading—"toward a contemporary aesthetic"—which is a statement of his own position. Eclecticism troubles Bürger because—shades of Adorno—he can conceptualize it only negatively. Still, *only* from the standpoint of the most advanced material (idea) is eclecticism and its synonyms—style, masks, historicism, license, debauchery (Boulez)—a dirty word for pluralism. From the

standpoint of pluralism, eclecticism means something very different: the necessity, determined by the multiplicity of choices, the freedom of contingency, of *individual selection* for both producers and recipients. This is the inescapable consequence of the postmodern condition of aesthetic nominalism. The familiar argument that anything and everything goes is impossible to sustain in practice. Its function is that of an abstract definition of the situation of contingency, whose concrete corollary is the necessity of selection. And this is, of course, precisely what Bürger does by stating his own position, which is a further specification of the second pluralist reading, while also including the first antimodern reading through his approval of the critical reappropriation of tonality, objectivity, and traditional literary forms (DM129).

Bürger's project of a contemporary aesthetics is not, strictly speaking, an aesthetic of contemporary art but rather an aesthetic of twentieth-century—that is, postmodern—art: "I would explicitly not like to place this third reading under the auspices of postmodernism, because the concept suggests an end to the modern era, which there is no reason whatever to assume. One could instead claim that all relevant art today defines itself in relation to modernism. If this is so, then a theory of contemporary aesthetics has the task of conceptualizing a dialectical continuation of modernism" (DM127).

It is not at all clear, however, what a dialectical continuation of modernism could mean after the abandonment of the distinction between style and idea, which replaces the "true spirit" of modernism by the recognition of the riches of twentieth-century art. In fact Bürger appears to mean no more than this: "Instead of propagating a break with modernism under the banner of the post-modern, I count on its dialectical continuity. That means that aesthetic modernism must also recognize as its own much that it has hitherto rejected. . . . The modern is richer, more variegated, more contradictory than Adorno depicts in the parts of this work where he sets up boundaries out of fear of regression, as in the Stravinsky chapter of *Philosophy of New Music*" (DM129). And the problem of "the bad wealth of historical eclecticism"? Here Bürger proposes (like Wellmer) that we distinguish between good and bad eclecticism—that is, "necessary actualization" as opposed to the "arbitrary toying with past

forms." More helpful is his second proposal, which reformulates the problem in the following way: "after the attack of the historical avant-garde movements on the autonomy of art, the reflection on this status ought to be an important trait of important art. To the extent that this reflection is translated into artistic conduct, it encounters the historic-philosophical place of art in the present. If this is plausible, then Brecht's work should have a place within the literature of our century which Adorno does not concede it" (DM129).

Below we shall consider the significance of Brecht's work for a theory of postmodern art. It is a question which Bürger had already raised in his *Theory of the Avant-garde,* to which we must now turn. Although only four years separate it from Adorno's *Aesthetic Theory,* Bürger's demand that aesthetic theory historicize itself not only continues Adorno's own practice, it also seeks to specify historically the limits of Adorno's theory of modern art.

BÜRGER: *THEORY OF THE AVANT-GARDE*

Bürger's concept of critical literary theory is based on the awareness of the historicity of the categories of aesthetic theory. The historicity of theory is tied up for Bürger with the Marxian idea of *self-critique:* just as the proletariat incorporates the self-critique of bourgeois society, so by analogy the avant-garde movements at the end of the First World War represent (or perhaps better, enact) the self-critique of art in bourgeois society. Although Bürger returns to Marx in order to define the historicization of theory as the insight into the connection between the unfolding of the object and the categories of theory, it is just as important to stress that the structure of his argument reveals basic parallels with Lukács and Adorno. At the risk of simplification Bürger's theory can be characterized as a *retrospective* version of Lukács's reification essay in *History and Class Consciousness.* These structural parallels are not surprising, since Lukács's essay, *Philosophy of Modern Music,* and *Theory of the Avant-garde* are all tied to the crisis of bourgeois tradition and posit the same fundamental link between self-critique and retrospective knowledge, radicalized in the form of the revolutionary break with bourgeois society and culture by the political or cultural avant-gardes. Bürger both

continues and historicizes Lukács and Adorno by making the caesura of the historical avant-garde (by which he understands dada, surrealism, and the Russian avant-garde) the turning point of his theory. This operation of historization signals, as we have seen, the end of the tradition of aesthetic theory from Kant to Adorno (AV94). What replaces it? One is tempted to say the ghost of Adorno's ghost. Adorno's negative progress dissolves into Bürger's negative registration of the end of progress, negative because it does not lead to the paradigm break implicit in his discussion of post–avant-garde art.

In order to place *Theory of the Avant-garde* in the context of the preceding discussion, Bürger's argument can be reconstructed in terms of the form/content dialectic. Just as in Adorno's philosophy of music, progress (tradition) comes to self-knowledge in the new music of Schoenberg, so with Bürger the self-knowledge of bourgeois art is reached in the avant-garde movements. The complete differentiation of bourgeois art—the aestheticism of the fin de siècle—is the precondition for the reaction of the avant-garde. As the self-critique of bourgeois art, the avant-garde constitutes the historical vantage point from which the unfolding of the form/content dialectic of art in bourgeois society can be reconstructed. The historical dynamic of the dialectic reveals the inherent developmental tendency of art in bourgeois society: the emergence of an autonomous aesthetic sphere in the eighteenth century sets in train a system-immanent process of differentiation (rationalization) which progressively eliminates content and whose endpoint is the doctrine and practice of art for art's sake. We can directly relate the absorption of content by form to the crisis of the languages of literature, music, and painting about 1900. On the one hand this absorption announces the exhaustion of tradition; on the other it is the precondition for the emancipation of the most general category of art: what Bürger calls artistic procedures (*Kunstmittel*). The avant-garde's free disposition over methods and materials drawn from different epochs announces the end of the binding force of tradition. *Within* the system of stylistic norms which constitute and define tradition, artistic procedures are not recognizable as such, that is, generalizable as a universal category.

As the example of artistic procedures shows, self-critique is

self-knowledge achieved *post festum*. The development of art in bourgeois society can be grasped from the vantage point of the avant-garde, but not the other way round—the anatomy of man is the key to the anatomy of the ape. Thus, comparably, twelve-tone music manifests the inner, progressive logic of autonomous (bourgeois absolute) music. It registers the exhaustion of the language of tonality—the end of the subject/object (or form/content) dialectic in indifference—through the emancipation of the most general category, the neutral undifferentiated material of the twelve semitones, no longer hierarchized and given meaning within the system of tonality. Music remains the clearest example of rationalization, just as painting can be taken as the most obvious example for the disappearance of content. Literature by contrast cannot eliminate its semantic content. There are necessary limits to its formalization. Nevertheless, Bürger wishes to claim that literary aestheticism, as typified by Stéphane Mallarmé, is the representative expression of the developmental logic of art in bourgeois society. The claim that the truth, the essence of art in bourgeois society, as revealed through the practical critique of the avant-garde, is the loss of all social function leaves Bürger open, however, to the objection that he is confusing and conflating aestheticism's *doctrine* of art for art's sake with the social *reality* of the differentiation of art (literature) as an autonomous sphere. Once the basic social tendency to ongoing differentiation is acknowledged, it is not at all evident what Bürger means by (the loss of) the social function of art. Here it becomes apparent that he remains caught in Lukács's critique of the formalization (reification) of bourgeois science, which can no longer grasp its own material content. Bürger speaks here of the loss of the "political content" of works of literature (AV32).

Bürger's thesis that the avant-garde represents the self-critique of art in bourgeois society thus reproduces Lukács's argument. The reduction of the form/content dialectic to formalization in bourgeois science (Lukács) and art (Bürger) leads to the avant-garde's *practical* critique of the alienation of form and content, subject and object. In the one case the historical mission of the proletariat is to reunite theory and practice, cancel and overcome the antinomies of bourgeois reason; in the other it is the mission of the artistic avant-garde to reunite form and content, subject

and object, art and life. In each theory the inherent formalistic tendency of bourgeois science and art calls forth the redemptive act of *Aufhebung*. The project of the political and artistic avant- garde defines in both theories the historical and theoretical site of the self-critique of bourgeois society, from which the totality of the foregoing developmental process becomes visible (cf. AV22) and thus capable of reconstruction. Thus in order to reconstruct the history of art in bourgeois society Bürger proposes that the progressive tendency for content to be absorbed by form be recognized and objectified by means of the distinction between the *institution of art* and the formed content (*Gehalt*) of *individual* works of art. By the *institution of art* Bürger means essentially the constitution and differentiation of a separate social subsystem in the form of the recognition of the autonomous status of art, which governs the production and reception of individual works of art. The *institution of art* thus stands for the historical dynamic of the progressive neutralization of the political contents of works (AV94), inherent in the concept of autonomous art since the eighteenth century.

I called Bürger's theory a retrospective version of Lukács. Bürger writes from the perspective of the failure, not only of the historical avant-garde's project of canceling the split between art and life—the provocations of dada and surrealism have entered the museum—but also of the failure of the renewal in the 1960s of avant-garde political and cultural impulses of the 1920s. What this means is that Bürger's primary *thesis*—the historical avant- garde represents the self-critique of art in bourgeois society—can appear only in *negative* form. The onslaught of the avant-garde succeeded only in laying bare the "institution of art." The institu- tional inertia of a restored and apparently unchallengeable auton- omous sphere enshrines the essence of art in bourgeois society. The end which was no end leaves history and theory in limbo. The stress on the institution of art as the revealed truth of art in bourgeois society appears to define post–avant-garde art as the eternal return of the same. Correspondingly Bürger concludes with a final section on Hegel's anticipation of the end of art. Lukács's intended renewal of Hegel—"Hegel out-Hegeled"— and Adorno's revocation of Hegel find their epilogue here. Al- though Bürger distances himself from Lukács's "neoclassicism"

and Adorno's "modernism," his *Theory of the Avant-garde* represents an epilogue to the tradition of dialectical aesthetics from the perspective of the end of art rather than from a change of paradigm. The ghost of Adorno has not been exorcised:

The standard for any contemporary theory of aesthetics is Adorno's, whose historicalness has become recognizable. Now that the development of art has passed beyond the historical avant-garde movements, an aesthetic theory based on them (such as Adorno's) is as historical as Lukács', which recognizes only organic works as works of art. The total availability of material and forms, characteristic of the post avant-gardistic art of bourgeois society, will have to be investigated both for its inherent possibilities and the difficulties it creates, and this concretely, by the analysis of individual works.

Whether this condition of the availability of all traditions still permits an aesthetic theory at all, in the sense in which aesthetic theory existed from Kant to Adorno, is questionable because a field must have a structure, if it is to be the subject of scholarly or scientific understanding. Where the formal possibilities have become infinite, not only authentic creation but also its scholarly analysis become correspondingly difficult. Adorno's notion that late-capitalist society has become so irrational that it may well be that no [*sic*] theory can no longer plumb it applies perhaps with even greater force to post avant-garde art. (AV94)

Bürger's thesis of the total disposability over the materials and forms of all traditions in post–avant-garde art does not seem to me related in any compelling or exclusive fashion to the revolt of the avant-garde movements. That is to say, the situation of post–avant-garde art is determined less by the failure of the avant-garde project than by the destruction of the organic work of art and the norms of tradition itself. Even if we allow that Bürger's historical avant-garde played a key role here, the destruction of the organic work of tradition since 1900 is in no sense necessarily identical with the surrealist's dream of *pratiquer la poésie*. Here we must go back to the basic model of the form/content dialectic in order to see why Bürger's revolutionary Lukácsian thesis of the self-critique of bourgeois art ends in the return to Hegel and why his thesis of total disposability over the materials of tradition cannot altogether break with Adorno.

Theory of the Avant-garde remains an epilogue to the dialecti-

cal tradition, rather than the break implied by its argument, because Bürger is confronted by the same problem as Lukács and Adorno: what happens to art in bourgeois society *after* "decadence," that is, after the epoch 1848–1914? For all three theorists the process of the exhaustion of the form/content (subject/object) dialectic defines the decadence and crisis of bourgeois art. Beyond lies for Lukács the identical subject/object of the proletarian revolutionary totality and the subsequent retreat to "neo-classicism," for Adorno the (totalitarian) totality of the indifference of subject and object, the "point of indifference" both reflected and resisted in authentic art and theory. With Bürger the failure of the avant-garde's project of overcoming the split between art and life lays bare the bad totality of the "institution of art," the stasis which announces the end of aesthetic theory.

How does Bürger's position relate to the basic split between *idea* and *style?* If the idea means pursuing its logic to the very end, then it is clear that Bürger writes the negative epilogue to the idea but without taking the decisive step of making the pluralism of style his alternative perspective of theory construction. The split between idea and style remains unresolved in the theory, it is present in the tension between Bürger's two theses. The *completion* of the differentiation of bourgeois art in aestheticism (the absorption of political content by form) is the precondition, as we have seen, (1) the avant-garde revolt as the self-critique of art in bourgeois society; (2) of the recognition of artistic procedures as a universal category and thus of the free disposition over past forms and materials. What follows is the negative continuation of the (Hegelian) end of art: the avant-garde's failed project of the reunion of art and life succeeded only in reinforcing the prison of the institution of art, just as the free disposition over past forms and materials leads to a plurality of styles and tendencies without discernible direction, calling the very possibility of aesthetic theory (norms) into question. The suspension of the idea of liberating self-critique in the institution of art and the post–avant-garde plurality of styles coexist uneasily, however. On the one hand the institution of art tells us that nothing has changed or can change in the bad continuum of bourgeois society; on the other hand the plurality of styles tells us that everything has changed, since the very possibility of aesthetic theory is called into question. If the

historical avant-garde is the decisive caesura in the history of art in bourgeois society, as Bürger claims, is it because it is the belated realization of Hegel's thesis of the end of art—the avant-garde as epilogue—or because it is the most radical expression of the end of the modern age and its dialectic of progress: the most radical index, that is, of the end of European tradition and of the birth of postmodern art? Bürger's whole theory announces the need for a change of paradigm.

JAMESON AND EAGLETON: PASTICHE, PARODY, POSTMODERNISM

The dialectic of enlightenment in modern art appears for Adorno in a double form: advanced art falls victim to the progress of artistic rationalization, and mass art is subsumed under the logic of the domination of capital and transformed by "cultural progress" into the culture industry. The shadow of progress falls over alienated art. If the rationalization of the material, whose end point is indifference, is the figure of the fate of modernism, then the triumph of the image in mass culture, the "absolute imitation" which destroys individuation and identity, prefigures in the indifference of universal parody the fate of postmodernism. The crux of Jameson's and Eagleton's critique of postmodernism lies in the fusion of Adorno's Stravinsky polemic with Adorno's verdict on the culture industry, a fusion which reflects what they see as the de-differentiation of high and mass art in the postmodernist surrender to commodity fetishism.

Jameson's continuation of Adorno's cultural critique is problematic in two important respects: (1) the positing of modernism and postmodernism as period concepts, (2) the recycling of the progress/decadence schema (in the form progress/catastrophe) which is invalidated by the impasse of the dialectic of enlightenment—the indifference of universal pastiche.

Jameson's object in "Postmodernism, or the Cultural Logic of Late Capitalism" is a "periodizing hypothesis" and not a description of postmodernism as one contemporary cultural style or movement (CL55). As his title indicates, the Lukácsian equation of art and the age is the basis for declaring postmodernism a cultural dominant, which means that every position in relation to

it is also necessarily a political position in relation to multinational capitalism: "This whole global, yet American, postmodern culture is the internal and superstructural expression of a whole new wave of American military and economic domination throughout the world" (CL57). Without the assumption that postmodernism is a "new systemic cultural norm," "we fall back into a view of present history as sheer heterogeneity, random difference, a coexistence of a host of distinct forces whose effectivity is undecidable" (CL57).

Jameson's evolutionary correlation of art and the age draws on Ernest Mandel's three stages of capitalism in his *Late Capitalism*. To market capitalism; monopoly, or imperialistic, capitalism; and multinational, or consumer, capitalism correspond the three stages of art: realism, modernism, and postmodernism. Gone is Jameson's hope of 1977 of a Lukács redivivis—the emergence of a new realism as the "ultimate renewal of modernism, the final dialectical subversion of the now automatized conventions of an aesthetics of perceptual revolution," a realism "rewritten in terms of the categories of *History and Class Consciousness,* in particular those of reification and totality."[14] What has taken its place is Adorno's standpoint of the irresistibility of history. Since postmodernism *is* the cultural dominant of the logic of late capitalism, moralizing is not only trivial, it is simply a "category-mistake" (CL85). Having abandoned moralizing for the higher ground of historical knowledge, Jameson declares in suitably postmoralizing fashion that capitalism is the best and the worst thing that has ever happened to the human race: the cultural evolution of late capitalism is both "catastrophe and progress" (CL86).

Wherein lies the progress? It looks suspiciously like the progress of catastrophe—that is, the catastrophe of a progress which has led to the loss of the semiautonomy of the cultural sphere and which now suffuses all social life, bringing with it the end of critical distance and total cooptation (CL87). Progress viewed from this *final* perspective of catastrophe allows Jameson on the one hand to distinguish between modernism and postmodernism, and on the other to arrive at the indifference of essence and appearance. Or in other words, simultaneously to assert progress and catastrophe (the end of difference). Not only that, it enables him to moralize and not moralize at the same time. We have not

escaped Adorno's aporias and this is hardly surprising as Adorno is the crown witness: "The disappearance of the individual subject, along with its formal consequence, the increasing unavailability of the personal *style,* engender the well-nigh universal practice today of what might be called pastiche" (CL64). The source of the concept of pastiche, which must be kept distinct from the more readily received idea of parody, is Thomas Mann's *Doctor Faustus* and Adorno's "great work on the two paths of advanced musical experimentation": "It would therefore begin to seem that Adorno's prophetic diagnosis has been realised, albeit in a negative way: not Schoenberg (the sterility of whose achieved system he already glimpsed) but Stravinsky is the true precursor of the postmodern cultural production. For with the collapse of the high-modernist ideology of style the producers of culture have nowhere to turn but to the past: the imitation of dead styles, speech through all the masks and voices stored up in the imaginary museum of a new global culture" (CL65).

The continuity of positions, which makes Adorno the "prophetic" diagnostician and Stravinsky the "precursor" of pastiche, conceals one important difference. Adorno's splitting of modernism—the opposition of Schoenberg and Stravinsky—is reactivated as the sequence of modernism and postmodernism understood as cultural periods and as cultural paradigms ("systemic cultural norms"). The equation of period and paradigm is integral to Jameson's evolutionary schema. One can indeed grant the temporal ascendancy of the "high-modernist ideology of style," challenged from the 1960s on by postmodernist revisions, as long as it is recognized that this paradigm in no way reflects the diversity of modernist practice, for which the montage of styles in Picasso or Brecht, dada or surrealism, remains the obvious example. Jameson's negative continuation of *Philosophy of Modern Music* simply reproduces the problem by substituting for Schoenberg's sterility universal pastiche as systemic norm. Jameson insists that such a norm is essential if we are to escape the view of the present as random difference, but what is the norm of the cultural dominant termed *postmodernism?* "If the ideas of a ruling class were once the dominant (or hegemonic) ideology of bourgeois society, the advanced capitalist countries today are now a field of stylistic and discursive heterogeneity without a

norm" (CL65). From this one can conclude only that the norm of postmodernism is no norm, a paradox whose corollary is the indifference of appearance and essence, manifested in a parody which is no longer parody, because there is no norm, but pastiche, which is the norm.

Going with the transition from modernism to postmodernism is the poststructuralist dissolution of the depth models of hermeneutics, for example, the dialectical model of essence and appearance, the psychoanalytic model of the latent and the manifest, the existentialist model of authenticity and inauthenticity (all three of which enter into combination with the schema of progress and decadence). Jameson reads this period and paradigm change in the manner of Adorno. The "progress" from depth to surface (itself a model of enlightenment) invalidates the binary categories of the depth models—if we cannot distinguish essence and appearance, then appearance becomes essence, similarly with the latent and the manifest, the authentic and the inauthentic. It was precisely this danger which drove Adorno to his aesthetic decisionism and now leaves Jameson with the paradoxes of indifference as the "essence" of the new systemic norm of postmodernism: parody which is no longer parody but pastiche—"Pastiche is thus blank parody" (CL65).

The outcome of the "well-nigh universal practice" of pastiche is that historicism effaces history. Pastiche represents a world "transformed into sheer images of itself." It is the world of surface: spectacle, pseudo-event, simulacra, in which "exchangevalue has been generalised to the point at which the very memory of use-value has been effaced, a society of which Guy Debord has observed that in it 'the image has become the final form of commodity reification' (*The Society of the Spectacle*)" (CL65). If we have reached the ultimate point (progress as catastrophe), however, in which not even the *memory* of use value survives, in which the image is the *final* form of commodity reification, what is the point of theory, blanked out in the neon glare of the nihilism which has wiped out progress, essence, the subject, and use value and has transformed moralizing into a "category-mistake"? We encounter the blank face of parody again in Eagleton and—with reversed signs—in Lyotard.

Eagleton's starting point in "Capitalism, Modernism, and

Post-Modernism" is a quotation from Jameson's article: "Pastiche is, like parody, the imitation of a peculiar mask, speech in a dead language; but it is a neutral practice of such mimicry, without any of parody's ulterior motives, amputated of the satiric impulse, devoid of laughter and of any conviction that . . . some healthy linguistic normality still exists." Against this Eagleton proposes to reinstate parody. What Jameson regards as pastiche is in fact postmodernism's parody of the revolutionary art of the avant-garde (CM60). The dissolution of art into the prevailing forms of commodity production is the caricature of the avant-garde project of the integration of art and life. Warhol's soup cans are the image of art emptied of political content, the image of the revenge of bourgeois culture not only on the challenge of the avant-garde but equally on the normative subject of humanism. The capitalist present as utopia is the grisly parody of socialist utopia, "having abolished all alienation at a stroke." Where there is no depth, there can be no signifying surface: "The depthless, styleless, dehistoricized, decathected surfaces of postmodernist culture are not meant to signify an alienation, for the very concept of alienation must secretly posit a dream of authenticity which postmodernism finds quite unintelligible" (CM61).

The reinstatement of parody is a quixotic gain. If it serves to distinguish between modernism and postmodernism, it is at the price of a contradictory recourse to Benjamin, and if it is to characterize postmodernist culture, it conjures up the familiar face of indifference, as Eagleton openly acknowledges without thereby calling his own or Jameson's position into question. The "progress" from metaphysical depth to blank surface transforms the mystery of identity of modernist art into the identity without mystery or scandal of postmodernism. As with Jameson this transformation transforms Adorno's splitting of modernism into an illusory temporal sequence. If the aesthetic of postmodernism is for Eagleton a "dark parody" of the avant-garde's attack on representation, what then are we to make of the avant-garde's attack itself? Was it not the dark parody of the mystery of identity, of the aura of autonomous art? And so when Eagleton equates postmodernism with the "commodity as mechanically reproducible exchange," which "ousts the commodity as magical aura" of modernism (CM68), he not only claims negatively for

postmodernism what Benjamin had already claimed positively for post-traditional revolutionary art fifty years earlier, he transforms Benjamin's once supposedly progressive thesis into Adornoian catastrophe with his own version of the dialectic of enlightenment: "In a sardonic commentary on the avant-garde work, postmodernist culture will dissolve its own boundaries and become coextensive with ordinary commodified life itself" (CM68). Eagleton is left with the rhetorical question which is unanswerable from the Adornoian premises of his and Jameson's critique: "From where, in a fully reified world, would we derive the criteria by which acts of affirmation or denunciation would be possible?" (CM68). In a world in which reality is spectacle, simulacrum, fiction, and art is the self-referential commodity which has become its own image, the "absolute imitation" of the culture industry, all that remains is the reinstated image of Adorno's negative aesthetics: "in such a condition the most authentically representational art becomes, paradoxically, the anti-representational artifact whose contingency and facticity figures the fate of all late-capitalist objects" (CM62).

The question of contingency and the relation between parody and contingency will occupy us in part 3. But first we must complete the "progression" from modernism to postmodernism with Lyotard, for whom the blank work of parody signifying nothing is the sign of the paradigm change, which takes us beyond Adorno.

LYOTARD: THE PARODIC WORK OF NOTHING

In *The Postmodern Condition*, Jean-François Lyotard proclaims the necessity of paradigm change, the escape from the Faustian conceptual framework of the modern age. The postmodern condition is defined by the recognition of an irreducible plurality of language games, the consequence and consciousness of the completion (exhaustion) of the grand narratives of modernity and its epistemologies of representation. By *modern* Lyotard understands any science which legitimizes itself by reference to some metanarrative, whether it be the dialectics of the spirit, the emancipation of the subject, the hermeneutics of meaning or equally their negation as in the negative dialectics of Adorno. The Devil is

also part of the grand scheme, and it is as the Devil—courtesy of Thomas Mann—that Adorno expounds the "tragedy of modern art." For Lyotard, however—as Thomas Mann already knew— the tragedy is also parody. *Doctor Faustus,* the novel of the end, which is also to be understood as the end of the novel, gives Adorno pride of place by making Leverkühn follow the strict constructions of Schoenberg and not the Nietzschean alternative of Stravinsky's parodistic "music about music." And yet of course the Devil is also inescapably a figure of parody: the dissection of the fate of music is entrusted to the theologian of the self-destructive completion of the grand narrative of the modern age, the passage of Faust. In Thomas Mann's double play with Adorno, the parodistic other of the tragedy of modern art asserts its presence. Lyotard makes explicit all that is implicit in Mann's double-edged use of Adorno. By presenting Adorno as the Devil, Thomas Mann captures the essential paradox of *Philosophy of Modern Music,* enclosed and objectified within his own grand narrative of the end. On the one hand Mann presents the "authentic" doctrine of the Devil, the progress of music to indifference, the identity of progress and nihilism (together with its theological corollary of the mystery of identity as the completion of the Faustian narrative). On the other hand, however, the presentation is one more quotation in a novel composed of a grandiose montage of quotations, in which the "authentic" is mediated through an endless series of masks in a play of nonidentity and difference.[15]

In his essay "Adorno as the Devil," on Adorno's *Philosophy of Modern Music,* Lyotard juxtaposes two perspectives on this ambivalence of tragedy and parody, which we may call the modern and the postmodern. The modern is that of Adorno's "theological dialectics" in response to the nihilism brought about by the loss of the creative subject in capitalism. For Adorno the task of art is "to hold itself inside nihilism, to assume it and thus to manifest it" (AD 127). But nihilism means the collapse of all criteria for judging a musical work, the breakdown of the *traditional* limits which ensured the standards which separated the authentic and the inauthentic. According to Lyotard, Adorno remains within nihilism by clinging to the category of the subject, "the nucleus not only of the interpretation of society as alienation and of art as its

martyred witness, but of all theory of expression" (AD127). Adorno's aesthetic theory, based on the subject, did not permit him to question representation and acknowledge what Lyotard calls the "theatrical relation" in all art. Indeed it is this threatening anti-expressive "theatrical relation" in Stravinsky's music— or Brecht's drama—which excited Adorno's ire and demanded the sharpest possible separation between tragic and parodistic art, the sacred and the profane, aura and image—but against his better knowledge, we must recall, against the very premise of *Philosophy of Modern Music,* which embraces *both* Schoenberg and Stravinsky. And so when Lyotard writes, "We have the advantage over Adorno of living in a capitalism that is more energetic, more cynical, less tragic. It places everything inside representation, representation doubles itself (as in Brecht), therefore presents itself. The tragic gives way to the parodic" (AD128), *his* postmodern perspective is on the one level the "cynical" reply to Adorno's despair. On a second level, however, it is already contained in negative form in Adorno's outraged rejection of Stravinsky's "cynicism."

Adorno's splitting of modernism (Vienna against Paris) into idea and style, the tragic and the parodistic, defines, as we have seen, the polemical debate that runs from Constant Lambert to Habermas, from Lukács to Lyotard. But behind the debate lies the diabolic paradox of Adorno, grasped by Thomas Mann: the enunciation of the identity of progress and nihilism, which concludes the grand narrative of modern art, allows Leverkühn only the choice between authentic and inauthentic *nihilism.* Negative aesthetics is thus the last stage of the "religion of history" (AD127), in which Adorno's whole method of immanent critique—like dissonance—acts as the dissolving ferment of the totality, and as such becomes the voice of the Devil of progress which ends in the indifference of all values.

At the end of the introduction to the *Philosophy of Modern Music* which dates from 1948, a year after the publication of *Doctor Faustus,* Adorno defines his method as a dialectics of works and contradiction: the modern work deserves the name when it gives form to contradiction, hence is imperfect; and contradiction leads to the work's destruction. It is a non-Hegelian dialectics, because the totality is missing: *the reconciliation of*

the subject and object has been perverted into a satanic parody, into a liquidation of the subject in the objective order (Adorno). Totality is missing = there is no god to reconcile = all reconciliation can only be represented in its impossibility, parodied = it is a satanic work. You wasted your time replacing God with the devil, the prefix super—with the old sub-terranean mole, you remain in the same theological deployment. You pass from shamefaced nihilism to flaunted nihilism. Adorno's work, just as Mann's and Schönberg's, is marked by nostalgia. The devil is the nostalgia of God, impossible god, therefore precisely possible as a god. (AD132)

Within the theological deployment—the Faustian narrative—the Devil expresses the nostalgia for God, the lost totality, but in terms of the cynicism of capitalism he is also the "authentic" voice of progress. In this sense *Philosophy of Modern Music* must be read, as we have argued, as the tragic reflection of the situation of postmodern art.

Lyotard completes our trajectory: he makes clear the need for a new paradigm which escapes from the tragic narrative rendered parodistic by the progress of capitalism. In the process, however, he appears to substitute for Adorno's tragic recognition a cynical recognition of the nihilistic force of capitalism: "at the same time that capital maintains, in life and in art, the law of value as separation, savings, rupture, selection, protection, privatization—at the same time, it undermines everywhere the value of the law, constrains us to regard it as arbitrary, forbids us to believe in it. It is a buffoon. It plunges everything into scepticism, that is, into asceticism and its uselessness. Criticism cannot go beyond that buffoonery" (AD136).

This is indeed the constellation we find in *Philosophy of Modern Music*. If the law of value dictates the investment in Schoenberg's asceticism and the separation of Schoenberg and Stravinsky, of the martyr and the clown, the paradox of the self-destruction of the law of value—the tragedy of modern art—must manifest at the same time capitalism's buffoonery which yokes the antagonists together. "Criticism cannot go beyond that buffoonery." But does Lyotard's reversal of signs provide the answer, the substitution as it were of Paris for Vienna, of good parody for bad parody? "The 'tragic' that Vienna produced in the

first half of the century in music, politics, theory, psychoanalysis, philosophy, science, poetry (and even a little in painting), belongs to the clown genre. Parody in the bad sense: the representation of something which 'outside' the representative space (in 'society') is already dead, dialectics' Finale" (AD135).

Lyotard rejects Viennese tragedy as bad parody, and who could dispute that the clothing of the horrors of our century in the mantle of fate and destiny is parody. As Friedrich Dürrenmatt put it, nowadays, the secretaries of Creon deal with the case of Antigone. Nevertheless, if Lyotard's refusal of the "tragic" in life escapes what he calls theological dialectics, his alternative of parody in art hardly escapes the logic of capitalism. Adorno's dialectic of enlightenment returns—not in the "tragic" form of the identity of the artistic material and progress but in the "comic" form of the progress of capitalism through which "the tragic gives way to the parodic" (AD128). And so in place of Adorno's opposition of traditional and emancipated music, the organic work as appearance and the fragmentary work as knowledge, Lyotard proposes his alternative: "the parodic work of nothing." "When Adorno sees well that modern art is the end of appearance, the elimination of the sensuous, the impossibility of the unity of concept (form) with intuition (material), it is to conclude that it sets itself to functioning as a process of knowledge. . . . We have to leave behind this alternative: neither appearance, *musica ficta*, nor laborious knowledge, *musica fingens;* the metamorphic game of sonorous intensities, the parodic work of nothing, *musica figura*" (AD133). Perhaps it is the case that the music intensity, the "sonorous machine without finality," which Lyotard calls for, citing Morton Feldman's program of "a surface music, without depth, preventing representation," is indeed the blank surface which no longer reflects capitalism's buffoonery. But if with Lyotard we must part from Adorno's nihilism of progress, it cannot be in order to embrace the "post-nihilism" of Lyotard's parodic work of nothing. The exchange of the tragic for the parodic is a reversal which takes us beyond but not outside *Philosophy of Modern Music.* Our point of departure remains that of Adorno, the premise of *Philosophy of Modern Music,* the impossibility, in Lyotard's words, "of the unity of concept (form) with intuition (material)."

Only by going back to Adorno's premise, the disjunction of form and content which signals the end of tradition, and rethinking its consequences for art since the end of tradition, that is, for postmodern art, can we escape from the unproductive alternative of the authentic and the inauthentic, tragedy and parody. This polemical confrontation is played out by Adorno against the more fundamental issue of the exhaustion of the dialectic of progress and manifests, as we have seen, the exhaustion of the dialectical model, of theory itself. In Lukács, Adorno, and Bürger, theory is brought to the impasse of the irrational limit at which progress and decadence (formalization, differentiation) meet in the indifference of reification (Lukács), the satanic parody of nihilism (Adorno), the irrational plurality of tendencies and styles contained and neutralized by the institution of art (Bürger). The irrational limit, which separates the modern and the postmodern, means that emancipated art can be conceptualized only negatively as posthistorical stasis. The irrational limit is the sign, as we have seen, of the self-destruction of the dialectical model of the completion of the grand narrative of the European modern age. It is thus the break from which we must reinterpret the "logic" of the progress to nihilism from the perspective of the *emancipation of contingency* both within and beyond tradition. Our alternative construction, like that of Bürger, is also "progressive" and "dialectical" in retrospect, in this sense a reworking of Adorno's model of progress—the birth of the postmodern from the modern—whose result is the situation of contingency and whose index *within* tradition is parody.

If Lyotard's parodic work of nothing, which refuses the theater of representation, is less than satisfactory, his essay itself is an acknowledgment of the new disposition of contingency. Lyotard pays tribute through the form of his essay to the aleatoric prescriptions for composition of John Cage (for Stravinsky the dadaist among contemporary composers), which may be read not only as the absolute negation of the determinism of the twelve-tone technique but also of course as its parody:

I have determined six ideas (dialectics, criticism, indifference, position, theology, and expression, affirmation) under which I have distributed all my reflexions in the form of items. A first drawing has assigned to each of

these items the face of a dice [*sic*]. A second drawing (another throw of the dice) has permitted me to establish the diachronic series of the ideas' appearance. . . . *The artist has become the mere executor of his own intentions,* plus: intensities, which do not belong to him. "We are getting rid of ownership," "our poetry is the realization that we possess nothing": Cage. The artist no longer composes, he lets his deployment's desire go its way. That is affirmation. The quotes from Adorno are noted in italics, those of others between quotation marks. The designation of this term is: affirmation 13. (AD131–32)

Postmodern Art

Art and
Enlightenment

◻

My analysis of *Philosophy of Modern Music* has been guided by a double interest. First, I have taken "Schoenberg and Progress" as the seminal statement of Adorno's aesthetic theory, whose negative complement is "Stravinsky and Restoration." Stravinsky figures as the type of nihilistic modernity whose aesthetic of dissociation reveals the sacrifice of individuation to the rite of the commodity. Adorno's unrelenting attack on Stravinsky stands in line of succession to Hegel's rejection of romantic irony and in opposition to what Adorno calls Nietzsche's *ultima ratio*, the justification of the world as aesthetic phenomenon. The Nietzschean masks of Stravinsky are the other of Adorno's construction of musical progress. Second, I have taken the opposition of Schoenberg and Stravinsky as prefiguring the current *querelle* between modernist and postmodernist positions. Ironically, however, the emergence of the counteraesthetic of postmodernism, which reverses Adorno's opposition of authentic and inauthentic art, has at the same time reinforced Adorno's dialectic of enlightenment, for the Stravinskian masks of parody also point forward to the impasse of indifference: the postmodernist world of pastiche. If Adorno's splitting of modernism is undercut by postmodernist revisionism, it in turn is undercut by the return of the same. Adorno's aesthetic theory thus casts a long shadow over subsequent debates, which were examined both from within and without the tradition of critical theory in part 2.

On the one side (from within) Habermas's defense of the idea of modern architecture against the escapism of postmodernist historicism acknowledges the dialectic of enlightenment—the de-differentiation of form and function—but without drawing conclusions. Wellmer and Bürger follow Habermas in their inconclusive attempts to negotiate a modus vivendi between modernism and postmodernism in terms of an immanent critique which is the dialectical continuation of the idea of modernism, just as Bürger's *Theory of the Avant-garde* may be seen as the incomplete break with Adorno's aporias of progress, which signals the need for paradigm change.

On the other side Boulez defends the idea of musical rationalization against what he sees as modernism's loss of nerve and surrender to the past. Here the charge of historicism is directed as much against Schoenberg as against Stravinsky. Boulez's injunction to forget the past in the name of the idea of integral serialism must also, however, like Habermas confront the conclusions of the dialectic of the enlightenment. As opposed to Wellmer and Bürger, Jameson and Eagleton see no possibility of the dialectical continuation of modernism. Postmodernism is not the immanent critique of modernism but its mockingly indifferent parody. And if Lyotard proclaims the need for paradigm change against what he sees as Adorno's theological narrative of nihilism, it is only to offer the alternative of the "parodic work of nothing," whose ultimate formulation is to be found in Baudrillard's version of the dialectic of enlightenment, which will be considered in the following chapter, where I explore the ambiguities of "appearance," of Benjamin's "profane illumination," in the age of mechanical reproduction and the mass media.

The question of the enlightenment which leads to the self-dissolution of art was first posed by Hegel, whose verdict was "taken back" by Nietzsche's dream of the rebirth of tragedy from the spirit of Wagner's music and tragically vindicated (against Nietzsche) by Adorno's *Philosophy of Modern Music*. The verdict of the end of art is the logical paradox of Hegel's aesthetics: the demise of art is the precondition of the philosophy of art. With Adorno, however, the crisis of theory is one with the crisis of art, and it indicates the limits of the modern paradigm, which can only theorize negatively what follows, the situation of emanci-

pated (postmodern) art. And yet, as we have seen, the "postmodernity" of art is for Hegel, Adorno, and Bürger the product of the progress of enlightenment. Since, however, art does continue, it leaves behind theory which has reached its limit and poses the question How do we reconstruct the break between the modern and the postmodern, which takes us to the other side of the indifference, whose outcome is the tragedy of modern art and the satyr play of postmodernism (just as, comparably, the avant-garde project of the reunion of art and life is parodied in the de-differentiation of art and life in the culture industry)? How, that is, do we work through the logic of enlightenment to an alternative issue, which enables us to reconceptualize the modernist and postmodernist positions and escape the shadow of Adorno?

What is required is that we accept the logic *not* of the conclusion of *Philosophy of Modern Music* but of its premise: the end of the language of tonality as the index of the end of European tradition. This rupture is both the historical and logical ground of paradigm change. Indifference is the vanishing point of aesthetic progress, which marks the boundary and the transition between the old and the new, brought about by the indifferentiation of the (dialectical) categories of the old paradigm. In this sense the paradoxes of Adorno's aesthetic theory become the substratum, the field of tension of postmodern art. Adorno's categories—freedom and necessity, subject and object, form and content, essence and appearance, the latent and the manifest, progress and decadence—are canceled and suspended in the *modality of contingency,* which is to be seen as constituting the a priori of emancipated art.

This makes postmodern art a new stage in the enlightenment of art, which entered the stage of open reflection in the second half of the eighteenth century. For Hegel this already heralded the "end of art," and we can agree that the enlightenment of art is indeed part of the open-ended project of the Enlightenment, which manifested itself at this stage primarily in literature. The freedom of negation articulated in romantic irony, which dissolves all determinate closure, clearly draws on the awareness of the contingency of the literary text we find in writers such as Laurence Sterne and Denis Diderot in the tradition of Cervantes. Agnes Heller has stressed the importance of Diderot's legacy for

philosophy—the presentation of problems as problems in the form of a perpetual dialogue—which points beyond the complete systems of philosophy to the recognition of the paradox of freedom as the condition of the modern world. Heller's example for moral philosophy is Diderot's dialogue *Le Neveu de Rameau:* "here it is not the old truth that clashes with the new, but two interpretations of the new and the modern that clash with each other."[1] For the openness of literature itself we can point to Diderot's tale *Jacques le fataliste,* that ironic and necessarily incomplete play of (narrative) determinism and chance.[2] Against Diderot's perpetual dialogue we must set the refusal of dialogue in *Philosophy of Modern Music,* evident in the loss of all mediation between the opposed extremes, which are yet forced together by the age. This failure of dialogue (the splitting of modernism) is the price of the closure of theory which invites the revenge of history. Nevertheless, the ground of this absent dialogue is given in Adorno's premise—the recognition of contingency conceptualized negatively as indifference.

It is for this reason that we return to Hegel and German romanticism in order to reopen the dialogue closed off by Adorno, that is, to the model of literature rather than music. What is evident for literature as the reflection of enlightenment already by the end of the eighteenth century applies, however, to the situation of the arts only with the end of tradition. It is only from this break (despite the historicism and academicism of much nineteenth-century art and architecture) that Hegel's prognosis becomes actual and the legacy of literature becomes generalized. Adorno's closure of theory—the totalizing of indifference as the terminus of enlightenment—fails to recognize the dialectical consequence of Hegel's conclusion: the henceforth partial character of art is the condition of its freedom. It means that postmodern art no longer stands under the sign of reification—the logic of the alienated totality.

What I propose is an alternative reconstruction of the enlightenment of art, in which the vanishing point of indifference, brought about by the progress of aesthetic necessity, becomes the ground of paradigm change—the emancipation of contingency. It is thus a reconstruction from the side of freedom, not necessity: freedom understood, as Richard Rorty puts it, as the recognition

of contingency, not necessity.³ If the recognition of the histor-
ically contingent nature of social structures, institutions, and
systems may be considered a general condition of modernity, my
interest is its consequences for art. These consequences were first
analyzed by Hegel. The freedom intrinsic to subjectivity as the
principle of modernity dissolves the concrete totality of poetry
into the split between subject and object, the inner world of
reflection and the external world of objects. The free productivity
of the artist in bourgeois society is accordingly both unbound,
manifested in the unlimited choice of contents and their treat-
ment, and bound, in that the contingency and finitude of the given
enters into human self-production.⁴ This contingency of subjec-
tivity is reflected in humor, irony, and comedy, which signal for
Hegel the farewell to art. What Hegel already registered as the
problematic condition of art in modernity becomes inescapably
evident in the crisis of tradition at the beginning of the twentieth
century. Here, above all with music and painting, the collapse of
the progressive paradigm of art history marks the point at which
the freedom of the artist is no longer defined and articulated
within and against the necessity and continuity of tradition. It has
become rather the problematic consciousness of potentially un-
limited experimental alternatives, a consciousness which takes us
beyond the limits of Adorno's determinate paradigm to give a
new indeterminate paradigm, in which the work of art is no
longer conceived as essence, whether negative or positive, but as
virtuality. Art has become its own risk. It is the open question of
emancipated art which Adorno closed in the name of tragedy.

My deduction of an emancipated or enlightened system of art,
which follows in both senses of the word Hegel's and Adorno's
conclusions, is a reading from within their philosophical-histori-
cal construction of the history of art which is to be understood in
social terms as the outcome of the functional differentiation of so-
ciety and the emergence of autonomous value spheres. Siegfried J.
Schmidt, drawing on and modifying Luhmann's social-systems
theory, has convincingly reconstructed in his *Die Selbstorganisa-
tion des Sozialsystems Literatur* the constitution of literature in
the second half of the eighteenth century as a self-organizing, self-
referential social system. I summarize some of the main points of
his argument relevant to mine. The self-constitution of literature

is accomplished through its differentiation from and against the other self-differentiating social systems. The medium and index of this differentiation is the *fictionalization* of literary discourse, which immunizes literature from extraliterary judgment, censorship, and control at the same time as it defines its irreducibility to the values, norms, and truth claims of theology, philosophy, politics, and so on. Emancipated literature is henceforth its own risk and "fictionalization" its "contingency formula" and the source of self-reflexivity and critical identity.

What is the function of emancipated literature? It is no longer the (undifferentiated) representation of the social totality. As a differentiated (partial) system it stands in a relation of freedom to society as a whole and articulates this freedom in the construction of possible realities, whose social function is to present and explore alternatives to the given order of society through the multiplication of imaginary models of reality, of possible experiences and actions. Reality is pluralized in the form of critical, utopian, dystopian, or fantastic alternatives. The freedom of literature—the fictionalization (or rendering contingent) of its truth claims—enables it to demonstrate the contingency of society without thereby calling (the real latency of) society into question (s021–22). (Censorship is the negative proof of this freedom: the denial of the autonomy of literature.)

The emancipation of literature from social controls is a slow process, which covers the long period of transition from hierarchically stratified to functionally organized society, in which the second half of the eighteenth century forms the epochal threshold of the emergence of bourgeois society. The constitution of literature as a social system is thus the precondition for what I have called the first critical turn of modernity. It is thus the other face of Hegel's thesis of the end of art. His polemic against romantic irony can be read as the negative recognition of the (arbitrary) freedom brought about by the fictionalization of literary discourse. In the following I attempt to reconstruct what Schmidt calls the process of fictionalization of literary discourse and Bakhtin, the novelization of literature in terms of a model, in which parody and irony within tradition have the same function in relation to literature that the autonomous system of literature takes on in relation to society: the articulation of contingency in

the form of alternatives which do not call the system (literature or society) into question.

My aim here is to oppose to Hegel's or Adorno's terminal dialectic of enlightenment an open-ended model of enlightenment which takes us from a determinate to an indeterminate system of art. And second, to apply my literary model of the end of tradition, tied to the first critical turn of modernity, to the second critical turn, the general crisis of tradition in this century. To literature's pluralization of reality corresponds the pluralization of perception in painting, which multiplies the possible worlds of vision and differentiates the experience of *space,* and the pluralization of audition in music, which multiplies the possible worlds of sound and differentiates the experience of *time.* And here it is particularly relevant for the priority of literature in relation to the other arts that the end of tradition (the death of art) is tied up with the technical possibilities of reproduction, as Schmidt observes (s020). The emancipation of literature from tradition and at the same time the emergence of the concept of world literature presuppose a rapidly expanding book market, just as the crisis of tradition in painting and music is related to the "age of mechanical reproduction"—Benjamin's version of the "death of art," but also the medium of Malraux's concept of world art (questions to which I return in the following chapter).

Hegel's, Adorno's, and Bürger's accounts of the enlightenment of art have in common the progression from depth to surface, the progressive manifestation and exhaustion of latency. The progress of art requires latency and destroys latency: all that is secret and mysterious (i.e., unilluminated, blind to itself, unconscious) is brought to self-consciousness to give the stage of the self-critique of art. This dialectic of enlightenment can be reconstructed by reference to Luhmann's analysis in his *Soziale Systeme* of the relation between enlightenment, latency, and contingency and can be exemplified in the outline of a theory of parody (ss456–70).

The function of latency is defined by Luhmann as the protection of the structure of institutions or systems from contingency. All structures represent selections which exclude other possibilities. The factual latency of a system is obvious—everything cannot be done at once. What interests Luhmann is the structurally

functional latency which secures structures against destruction through the consciousness or communication of alternatives. Certain things must remain unconscious for persons and institutions if they are to function, and this is the veil of latency. Luhmann distinguishes between hierarchical and functional structures and their corresponding strategies of defense. Hierarchical or stratified social orders confirm themselves through forms, whose latent function is the preservation of latency by means of semantic variations which do not appear as alternatives which challenge the existing structure. The unquestioned authority of the hierarchy permits the direct forms of inversion and parody. The examples Luhmann gives are the medieval subversive—but not serious—inversions of official religious or political authority (the court jester), the seventeenth- and eighteenth-century comedies of master and servant, the breaking and respecting of latency in jokes and irony.

These forms—the "alternatives" of parody—are not available to systems and institutions defined by function and not by hierarchy. Not only have the forms of hierarchy and the corresponding play of inversion disappeared, but structures which functionalize hierarchy are already in themselves "formulated contingency," that is, they incorporate contingency by recognizing the equivalence of alternative problem solutions. As Luhmann expresses it, echoing Brecht: "If something does not work, something else will" (ss463). "Alternatives" as critical alternatives thus serve as the legitimating principle of functional systems, even if their formulated contingency cannot establish itself as necessary. The result is that once the social system replaces hierarchical with functional orientation, latency becomes problematic. The relation between enlightenment and loss of latency becomes acute in the second half of the eighteenth century. The *philosophe* now symbolizes the self-reflection of the social system and *public* opinion is declared an *invisible* force (just as the "invisible hand" becomes the open secret of political economy or philosophy of history). The paradox of the latent as the manifest is preserved only by the fact that this fusion still remains latent. The emergence of radical critique in the eighteenth century—the search for a rational social order—and of radical practice in the nineteenth century—revolutionary social change—must there-

fore be seen in its relation to the problem of latency. Radicalization occurs because there are no longer forms which respect the latency of functions and structures (cf. Hegel's critique of romantic irony).

Luhmann defines enlightenment as the making manifest of latent structures and functions but also as functional comparison. The two processes contradict one another from the moment that functional analysis discovers the function of latencies. "At this point society informs itself that it may not know that it may not know what it may not know. The function of latency demands the latency of function" (ss468). Still, the transition from the closed, static order of stratified society to the open dynamic of functional society brings a radicalization in its train which threatens all latency of function. As Luhmann writes, "The search for some kind of counter instance, which contains the modern consciousness of contingency, continues" (ss468). For Luhmann too the process of enlightenment seems to possess a destructive terminus: the point of *open* contradiction at which the latent becomes one with the manifest—that is, their meeting in the indifference which signals the emancipation of contingency. This, I have suggested, corresponds to the situation of emancipated art, which is the third stage of my model of the enlightenment of art, an enlightenment or secularization beyond Adorno's dialectic of enlightenment. But, as we have also seen, this third stage has been construed in the wake of Adorno as the universalization of parody, as the postmodernist condition of panparody: the society of the spectacle. The reformulation of the dialectic of enlightenment in terms of the loss of latency and the emancipation of contingency offers a way beyond the limits of Adorno's construction and its extensions to postmodernism, a way which proceeds through the outline of a theory of parody, which follows Luhmann by distinguishing between the latent and the manifest functions of parody.

PARODY, LATENCY, AND CONTINGENCY

Bürger's *Theory of the Avant-garde* takes us from Adorno's method of immanent critique, which is one with Schoenberg's immanent critique of musical tradition, to the idea of the self-critique of art, which is one with the revolt of the avant-garde. In

place of the method of immanent critique and the idea of self-critique, parody can be understood as the immanent self-critique of art, immanent because it is the self-critique of art within tradition, but also self-critique in the sense that the progress of parody can be read as the progress of negation to the point at which the pregiven—parody's object—has lost all binding force, and artistic procedures are grasped as such—that is, as a fully conventional, contingent category. Bürger's institution of art can also be related to parody. Bürger defines the institution of art as comprising both the apparatus of production and distribution and the ruling conceptions of art which determine reception. Bürger's interest, however, is confined in practice to the concepts or norms, and above all the doctrine of autonomy, which govern reception. But here it must be added that *literature* as an institution, understood not as individual works but as the norms governing their production and reception, has always possessed its own self-critique in the form of parodistic self-reflection. What all such critical and self-critical reflections on the status (production and reception) of the literary work of art have in common is not only the awareness of the artifice and "autonomy" of art—its nonidentity, as formed content with life—but more significantly for the purposes of my argument, the awareness contained therein of the institution of "art." The function of parody may be defined in the most general sense as the critique of the representation of reality in literature and as such it is the *immanent* self-consciousness of literature as institution, since parody must necessarily foreground and estrange both the forms of production and the norms of reception.

It is not surprising that idealist aesthetics, which privileges the autonomy of the work of art, has remained indifferent or hostile to the practice of parody as the critique of "authenticity" and aura. What is surprising is that Bürger's *Theory of the Avant-garde* should be so blind to the totalization of the parodistic impulse—the assault on the autonomous work and the violent provocation of the norms of reception—in dada and surrealism. Parody as the self-critique of the institution "art" is identical, however, neither with Bürger's system-immanent criticism nor with the self-critique realized by the avant-garde: "Examples of system-immanent criticism would be the criticism the theoreti-

cians of French classicism directed against the Baroque drama or Lessing's of the German imitations of classical French tragedy. Criticism functions here within an institution, the theatre. . . . There is another kind of criticism and that is the self-criticism of art: it addresses itself to art as an institution and must be distinguished from the former type" (AV21). As opposed to the exclusive alternatives set up by Bürger, namely, theoretical discourse within the institution and the radical onslaught from without, the practice of parody *within* tradition, which involves the simultaneous negation and affirmation of the specific status of (the work of) art, points forward not only to the explosion of dada and surrealism, the moment when the creative possibilities of parody are released in the energy of destruction which sets free all the elements of tradition, but equally *beyond* tradition to the situation in which the recognition of contingency defines the status of emancipated art.

In traditional, stratified society parody expresses the possibility of reversal. Its most dynamic form is the discontinuous moment of freedom realized in the inversion of high and low and the transgression of boundaries in the feast of fools, the carnival, and the saturnalia, so eloquently evoked in Bakhtin's study of the carnival spirit in *Rabelais and His World*. Such moments of freedom, which spring from the underlying awareness of the contingency of the social order, are institutionalized and accorded recognition, like the Devil, as the other of the closed cosmos of the given world. Traditional parody therefore is the inverting mirror which lives from the contrast of high and low (sacred/profane, aristocratic/plebeian), reflected and codified in the hierarchy of genres and styles. In such a closed system the place of parody is overt. It is the licensed freedom of the court jester. Just as blasphemy is functional to faith (*parodia sacra*, the Black Mass), so parody is system-immanent. As "heresy," however, it carries within itself the secularizing potential of the "revaluation of values."

The techniques of overt parody are relatively uncomplicated, since the method of inversion is aimed directly at the codified hierarchy of the system of literature, which is both aesthetic and social, both literary form and the ideological representation of social stratification. Traditional parody is therefore primarily

satiric in intent, for its satire of literature is equally ideological satire. It is defined not by subjectivity but by its object, the idealizing self-representation of the system. It thus operates on the level of the system, which codifies the separation of high and low and reinforces social stratification. The hierarchical system is attacked by means of comic inversion. The closed order is satirized through the overt "contradiction" of form and content. The comic and incongruous juxtaposition of high form and low content (the mock epic, the *Roman de Renard,* François Villon's ballades) is the most obvious device for the estrangement of idealized representations of reality. Satiric parody thus serves as the distorting and mocking imitation of the authority of tradition, whose contextual reference is both literary and social. The reductive treatment of the relationship between literature and reality makes it the low, comic, materialist inversion of the ruling representations of reality: "In everything, in meaning and image, in the sound of sacred words, parody discovered the Achilles heel that was open to derision, some trait which denoted linkage to the bodily lower stratum."[5] This dualism of idealism and materialism means on the one hand that parody has its recognized place but on the other that it remains the reflection and confirmation of the *separation* of high and low, identity and difference, in which literary critique and ideological satire are not yet differentiated. The reflexivity of the system of literature is thus objectified, institutionalized in parody in the form of a reflection which is not yet self-reflection. Antiparadigm is opposed to paradigm. In this world of vertical inversion the dimension of time and of change remains latent. The utopian complement of satiric parody is the suspension of time, the *interruptus* of the carnival. The *latent* function of traditional parody is the preservation of the existing stratified order: in other words the open forms of parody preserve the separation of the latent and manifest functions of parody.

By contrast, *modern* parody is imbued with the destructive and creative spirit of time, which transforms the satiric oppositions of traditional parody into the internal dialectic of the self-ironizing work. Its progressive, dialectical impulse of self-negation thus corresponds to the ongoing transition from stratified to functional, from closed to open, society. Traditional and modern forms of parody coexist, the one directed as literary sat-

ire against formally codified high genres (travesty) or particularly prominent individual works (e.g., parodies of Richardson's *Pamela* or Goethe's *Werther*), the other, as the new awareness of historical change, of the expansion of horizons and the breakdown of rigid social and literary hierarchies—in short, the whole process of social change which brings with it a heightened consciousness of contingency. For literature since the Renaissance it means that the self-reflection of the system involves a new historical consciousness of tradition, and here parody takes on the role of the criticism and reconstruction of pregiven models. The closed order of the *vertical* hierarchy gives way to the *temporal* dialectic of the old and the new. The stratified genres based on the difference between high and low are drawn into the interplay and interference of the spheres (Rabelais, Shakespeare, Cervantes). At the same time, this final creative outburst of the carnival impulse (Bakhtin) brings about with Cervantes the birth of *the* genre of modernity, the novel, from the spirit of parody. In *Don Quixote* the high and the low, ideal and reality enter into an open-ended dialectic which remains constitutive for the process of secularization: the ironic ambiguities of enchantment and disenchantment, destruction and creation, lament and liberation, which will govern the emerging world of prose. The rise of the novel, which accompanies the decline of the classical genres (the verse epic, tragedy), is above all a result of the openness and indeterminacy of its form, which makes it the medium par excellence of social contingency, the chronicle of the vicissitudes of the individual face to face with an increasingly alien and problematic reality. Here again we can refer to Bakhtin: "Having achieved predominance the novel is able to bring about a *renewal* of all other genres, *it infects them with the spirit of development and its own unfinished quality*. It draws them into its sphere of influence because its development is one with the fundamental direction of all literature."[6]

The spirit of development, which characterizes the novel, owes much to the initial parodistic and self-ironic impulse of Cervantes, renewed by Henry Fielding, Sterne, Diderot, and Christopher Wieland in the eighteenth century. The play with the narrative code, the conventionalizing of its fictions, manifests the dialectical process of the negation and potentiation of represen-

tations. Parody, internalized as *irony,* thus becomes the self-reflection of the "fundamental direction of all literature." It is the self-thematization of the progressively autonomous system of literature: literature motivated by literature, literature criticized by literature.

Parody is no longer contained and localized as it was in stratified society. Now it permeates the system as *irony,* the expression of the progressive subjectivation and nominalization which dissolves all fixed hierarchies, boundaries, and genres in a dialectic of the old and the new, closure and innovation, representation as illusion and contingent fiction. The crucial figure of this process of enlightenment is the free, sovereign subject of romantic irony who plays with ambiguity and paradox, constructing and deconstructing meaning and illusion. The play of production calls forth in turn the play of reception. Irony plunges the literary work into the endless ambiguities of interpretation. If the utopia of satiric parody is the carnival, the utopia of romantic irony is the book of books, the endless play of fiction. It is the dream of the absolute suspension of disbelief, which only underlines the reality of the *temporal* contract between the subject as reader and author: the merely temporary suspension of disbelief toward hypothetical fictions. Don Quixote, the naive reader who *identifies* with the ideal book, is the ironic image of the self-reflection of literature in the age of print. Parody and irony are thus the modes alone adequate to the paradoxes of the freedom of production and reception *within* the literary codes. In this sense they constitute the (productive) negative self-reference of the literary system.

This negative self-reference may be defined as the *dialectic of identity and difference* (closure and contingency), as opposed to the *separation* of identity and difference in traditional parody. The unmediated oppositions of traditional parody are internalized and sublimated in a dialectical process of *Aufhebung*. The simultaneous negation and ironic affirmation of the code leads to forms of open integration which foreground contingency. The negative self-reference of the system becomes indirect: parody is transformed from oppositional criticism from below into internalized self-critique. The resulting dialectic of the old and the new, of "conventionalization" and innovation, means that differ-

ence becomes the dynamic principle of identity. The operation of estrangement, fundamental to parody, is no longer an act of inversion on the vertical axis of synchrony but is inscribed on the progressive, open-ended axis of historical consciousness. The alienation—in the double sense of estrangement and secularizing appropriation—of the chivalric romances in *Don Quixote* transforms the disjunction of high and low into the historical tension of form and content. The temporalization of styles and structures, which is the outcome of this historical dialectic, undermines and subverts the fixed genres in a simultaneous process of the individualization of works of literature and the generalization of self-reflexivity (the awareness of alternatives whose index and "contingency formula" is self-parody).[7] For Hegel this signified the self-dissolution of art, for Bakhtin, following the German romantics, it signifies the "novelization" of literature, that is, the dissolution of the direct authoritative discourse of traditional poetic genres into the indirect discourse of prose, the inner dialogism of the double-voiced (parodistic) word.[8]

Within tradition, traditional and modern parody articulate both the consciousness and the containment of contingency. We termed parody the negative self-reference of literature because it is the practical critique of the representations of reality, of the "fictions" of mimesis. Its function within tradition, like that of the Devil, is double, both subversion and submission. On the one hand, parody subverts all given authorities and orders; on the other, negation is also a form of recognition which reproduces the pregiven. In the dualism of the closed medieval cosmos the Devil is allotted the place of inverted order and this too is the place of traditional parody, of the world upside down. In the modern age the Devil is coopted by progress. The principle of negation (Goethe's Mephisto) is made to serve higher ends. The harnessing of parody in the name of progress thus unfolds the dialectic of enlightenment. That is to say, the dialectic of the latent and the manifest progressively reveals the contingency of the pregiven.

Modern parody is thus the critical, progressive spirit of negation, whose immanent impulse is the subversion of the (ideological) identity of form and content. It is an eminently ironic spirit, whose consciousness of the "theatrical relation" of representation dissolves the latency of the system at the same time as it

dissolves the hierarchical separation of parody's own latent and manifest functions. In other words, negation presupposes identity; difference depends on the pregiven. This is the condition of progress. The end of tradition—the disappearance of the Devil in the tabula rasa of indifference—brings about the transmutation of parody into the generalized consciousness of the wholly contingent nature of the emancipated system of literature. This consciousness, first articulated in the idea of romantic irony, is the premise of what Philippe Lacoue-Labarthe and Jean-Luc Nancy comprehend in *The Literary Absolute* as the romantic invention of "literature," which opens "the critical age to which we still belong." This self-critical identity of literature in modernity (reflected in opposed forms in Hegel and the Jena romantics) prefigures and points beyond Adorno's terminal dialectic of the enlightenment of music.

In Adorno's model necessity is inscribed within the musical material. The central, driving idea of his aesthetic theory is this inner dynamic which permits the identification of the material and progress, logic and history. Although the outcome in Adorno's argument is the exhaustion of the latency of tradition, the truth of the progression is nevertheless incorporated in Schoenberg's music, where Adorno once more affirms "dialectically," paradoxically, the identity of the emancipated musical material and progress, as against the negative equation of "material" and parody for Stravinsky's music. Moreover, it is *not* Stravinsky's parody which accomplishes the critique of traditional music but Schoenberg's destruction of illusion (*Schein*), in which the ideology of the closed, organic work is shattered from within to release knowledge. Adorno's exclusion of parody is one with the exclusiveness of his musical demonstration, for if we turn to the example of literature it is clear that its material was also always "material," not just in the sense as with music that literature presupposes literature, that literature and music are evolving systems, but in the sense that the system of literature (Bürger's institution) carries within itself in the form of parody the critical estrangement of its codes, of its material as "material." The negative self-reference of parody as the self-critique of the system is thus the (contained) other of the idealist expressive totality.

If the loss of the binding force of the pregiven is the devilish

situation of the arts today, it makes all the difference whether we construe this from the side of inescapable necessity, whose end is the satanic parody of a reified world, or from the side of freedom. The difference is this: Adorno's most advanced logic of the material, realized in Viennese serialism, no less than Stravinsky's "neoclassicism," is but one possible response to the contingency manifested by the disintegration of tonality. The task, however, is not to play off Stravinsky against Schoenberg, style against idea, but to escape from Adorno's fatal paradox of progress by going beyond its conclusion to the open paradox of freedom. Here the critical spirit of parody, which treats the subject/object and the form/content dialectic from the side of nonidentity, offers us an alternative path to the postmodern.

The prehistory of postmodern art can thus be reconstructed from two sides, from the side of "tragic" necessity (progress/nihilism) and from the side of "comic" freedom (parody/contingency). Music serves as the model for Adorno's dialectic of enlightenment. From the primacy of (absolute, instrumental) music springs his conception of the work of art as hermetic monad, which contains the "laws of motion" of the material within itself. Beyond tradition (the language of tonality) lies music as knowledge and the antinomian, subterranean longing of the subject to escape the incurable affliction of necessity in and through the reunion with nature, in the mimesis which escapes identity, compulsion, closure. Within tradition, however, the musical monad appears to be impervious to parodistic subversion (Mozart's musical jokes only confirm the rule). Adorno's response to Stravinsky's music about music is thus to declare it a *literary* phenomenon, just as Constant Lambert speaks of the literary treatment (estrangement) of content in neoclassical music and surrealist painting. If the self-referential language of music defines most clearly the inner logic of the progress and end of tradition, the critical, negative self-reference of parody in literature is better suited to the comprehension of the condition of art after the end of tradition.

Our division of parody into traditional and modern reflects the process of secularization, which correlates with the evolution of European society from stratified to functional society. For Luhmann the seventeenth and eighteenth centuries initiate this trans-

formation, which reaches the epochal threshold of consciousness in the second half of the eighteenth century. Together with the constitution of the autonomous sphere of art there emerges as the legacy of the foregoing *querelle des anciens et modernes* a new level of historical self-consciousness of the specificity of *romantic*—that is, European—art, and going with it the theory of modern literature as romantic irony in the aesthetic writings of the German romantics. In turn, at the conclusion of the modern epoch the Russian formalists conceived of literature as a system, in which parody—"estrangement"—is the motor of the evolution of the literary series. In understanding literature as a system we have followed Luhmann, for whom art is a subsystem particularly oriented to self-reflection, that is, to the *history* of the system, its concepts, problems and solutions.[9] Like all systems art is constituted by the difference between itself and its environment. This boundary is the precondition of autonomy and internal differentiation. When Luhmann defines differentiation as the replication within a system of the difference between a system and its environment, then we can adapt his definition for our own purposes and apply it to parody, whose function is to replicate within the literary system the difference between representation and reality, system and environment. (The play within the play—e.g., *A Midsummer Night's Dream*—or the reader within the book— e.g., *Don Quixote*—are obvious examples.) Parody is thus the index of the reflexivity (enlightenment) of the literary system. In traditional parody it takes the form of the "contra-dictions," whose latent function is to confirm the boundary of the hierarchical system. The ironic self-reflection of modern parody emerges in response to the increasingly open horizon of choice which forms the internal environment of the system. The terminus of the dissolution of the traditional limits is the "invention" of literature as conceived by the German romantics: the infinite reflexivity which transforms parody into the critical question of the identity of emancipated literature.

We have taken traditional and modern parody as the index of the progressive articulation of freedom within the aesthetic closure of tradition. The traditional form of parody characteristic of closed, stratified society tends, however, to be seen as the representative expression of parody because its inversion of high and low and its open contradiction of form and content make it the

most obviously recognizable form of parody. As the expression of the basic human impulse of imitation as mimicry, of the comic and aggressive potential of deflation in relation to the ritually codified, its place today is that of the (latently affirmative) satire of the conventions of popular genres (the Western, the soap opera, the horror film) or the clichés of advertising or political rhetoric. It thus continues to exist alongside modern parody, which can be seen as functional to the progressive autonomy of the system of literature from the Renaissance on. Modern parody is not so easily recognizable; it is sublimated into an ironic awareness of contingency, in which the free play of alternatives becomes the self-reflection of the dynamization and subjectivation of the system. The spirit of modern parody is thus frequently cited as the informing principle of postmodern literature, and this continuity in fact largely holds, because unlike music or painting, the specifically European arts, literature always stood within a larger tradition and lived with the burden of memory and thus the burden of options. The break could not be as sharp as with the collapse of the ordering perspective of tonality in music or of representation in painting. But by the same token the *outcome* of the process of self-reflection in literature since romanticism becomes relevant for the arts *after* the end of tradition.

THE QUESTION OF POSTMODERN ART

Our construction of the enlightenment of art posits a third stage beyond Hegel and beyond Adorno, for which the question is, how do we rethink indifference, the open contradiction of the coincidence of the latent and the manifest, the coincidence which is both logically and semantically the expression of contingency. If with Luhmann we define contingency as that "which is neither necessary nor impossible: which can be seen as it is (was, will be) but which is also possibly other" (ss152), then the question of postmodern art is problematic precisely in the sense that the modality of contingency suspends both affirmation and negation.

The latent function of parody is the preservation of latency, its manifest function is the articulation of the contingent nature of the literary system. In relation to closed hierarchical structures it takes the *overt* (dualistic) form of negation, the excluded other which is the acknowledgment and confirmation of the given

order. In relation to the open dynamic of functional society it takes the *covert* form of the internalized (dialectical) negation of the given, which leads progressively to the coincidence of the latent and the manifest functions of parody. The progress of parody is thus itself an index of the enlightenment which leads to the destruction of latency. If latency is the "unconscious" of the literary system, traditional parody is the open manifestation of this unconscious, which strictly speaking (nonanachronistically) is the stage of the preunconscious: the overt separation of the hierarchical spheres permits and recognizes the parodistic lower sphere just as the forms of parody recognize the given order of the hierarchy. Functionalization, however, draws its energy from repression. The Devil and the carnival are driven underground (cf. Bakhtin) to produce the "unconscious," from which arises the dialectic of the latent and the manifest and the progressive exhaustion of latency, that is to say, the progressive incorporation of the consciousness of contingency. The unconscious made conscious brings to an end both progress and blindness. Emancipated art is the stage of the postunconscious. The system of art is now enlightened, fully "rational" and self-referential, because it is no longer blind to itself.

We can now formulate the question of the "consciousness" of the system of literature. In hierarchical, stratified society the question of the system itself cannot be raised; it remains latent. The separation of the spheres ensures the separation of the latent and manifest functions of structures in both the high and low spheres. Parody is mirror inversion, reflection but not self-reflection. That is to say, *freedom,* the possibility of negation, of alternatives, is confined to the over forms of the licensed contradiction of parody. With the transition to functional society the internalization of parody as irony articulates freedom as dialectical negation (contradiction proper) in the form of the self-reflection and self-transcendence of the system within the system. That is to say, the question of the system can now be posed *within* the system. The third stage is that of self-critique, the point at which the question of the system has become manifest on the level of the system itself. Freedom is now the recognition of contingency, and this is the question of postmodern art.

The situation and consciousness of contingency can be defined in terms of the open contradiction of manifest latency. The end of

tradition means that the work of art is no longer predetermined, is no longer governed by unquestioned pregivens. This has a double and related consequence: the emancipation of postmodern art *from* tradition and the emancipation *of* tradition itself are the two sides of the enlightenment of art. The forms and contents of all previous art are now freely (indifferently) available. If with Bürger we speak of universal categories we are speaking of the profane illumination of previous art, its transformation into material as the "pregiven" of postmodern art. The outcome is a new historicism—the "indifference" of past and present in the museum—and a new dialectic between the old and the new. Equally the emancipation from tradition is another way of speaking of the loss of latency, which brings about the indifferentiation of the categories of the modern paradigm, poses the question of art on the level of the system, and makes this question problematic. If freedom is now the recognition of contingency, it transposes the dialectic of freedom and necessity into the problematic of "indetermination," in other words, the change from a determinate to an indeterminate system.

Latency, we said, is the latent, or bound, contingency of a determinate system. Correspondingly, unbound contingency is the manifest latency of an indeterminate system. What this means is that in a system without latency *contingency itself* becomes the latency (the ground) of the system, its problematic condition, its open contradiction which cannot be resolved on the level of the system and thus the means by which the system continues. It is a position the other side of indifference, and it enables us to reconsider and reformulate Adorno's splitting of modernism, since the whole thrust of Adorno's "aesthetic decisionism," as Bürger calls it, revolves around the question of the recognition and mastering of contingency. From this perspective the opposed responses of Schoenberg and Stravinsky can be seen as standing for the two main historical responses in postmodern art to the loss of latency: the search for new languages on the one hand and the search for new latencies on the other. Since the enlightened system of art is no longer blind, the artist is forced to work rationally, to raise to full consciousness his method, so that we can no longer speak of "natural" (pregiven) but only of "artificial" (self-given) languages or latencies.

The one response to the tabula rasa brought about by the end

of tradition we may call *pure rationalism:* the creation of a new language ex nihilo. As Le Corbusier, the advocate of purism, puts it, "Il faut recommencer a zéro." Comparable is Wittgenstein's logical construction of the world in the *Tractatus*. The situation of contingency is the challenge to reground aesthetic necessity through an axiomatic method, whose freely posited rules will generate a new order, a new language. It is essentially a process of abstraction which seeks to liberate the logic of the material by sweeping away all heteronomous limits to control. The technique of composing with twelve tones is Adorno's example for the pure rationalism which seeks to overcome the threat of contingency through the closure of pure integration, and which finds its continuation in a radicalized serialism, as, for instance, in the music of Boulez. Other obvious examples are the renewal of painting through the spirit of geometry (Mondrian, Schlemmer), the search for pure sculptural forms or more generally abstract painting as the emancipation of pure surface or color, the assertion of the absolute self-reference of the work of art. (By contrast, Mallarmé's dream of a pure poetry remains a dream in relation to ordinary language.) The response to contingency takes the form of the completely rational work. The axiomatic method is the determinate answer to the question of postmodern art. Its opposite and complementary extreme is pure chance (the throw of the dice) as the double of pure determinism, and here the precise prescriptions for random selection on the part of John Cage highlight the underlying problematic of indetermination.

The other main response we may call *impure irrationalism.* Here the recognition of contingency, of the open situation of tabula rasa, takes the form not of a rationally posited order but of the chance of disorder as the source of new latencies. On the one hand we can see the widespread recourse to primitivism and the archaic, the fascination with the darkness and mystery of madness as the return of the repressed no longer held latent by the order of tradition. Here the ground of art appears to be the unconscious itself, the prerational as the other of reason. Beyond this familiar dichotomy and dialectic of the rational and the irrational, order and chaos, classicism and romanticism, intrinsic to the paradigm of modern art, we must note, however, that the unconscious since Freud has become all too manifest. When the

surrealists took Freud as their master it was in the name of the "logic" of the unconscious, the arbitrary connections (free associations, dream images) of the mysterious power of coincidence as the manifestation of the higher logic of the realm of chance, such as we find in André Breton's autobiographical narrative *Nadja*. Such a calculus of contingency serves as the means to the creation of the shock of the new and the unexpected. This rational calculus of the irrational discovers the latent energy of chance as the logic of a contingent world which arises from the sleep of reason. Surrealism's *ars combinatoria* is one example of the techniques of collage and montage, which explore the possibilities of the assembly of materials, ranging from the objet trouvé of everyday life to the artifacts of the museum. Compared with the rational work of the artist-constructor, the artist appears here as the transgressor. Instead of the integration of art we have the disintegration of antiart; instead of the identity of the idea (the new language) we have the schizophrenia of style (the new latency). Both tendencies, however, accomplish the radical break with the past to become in relation to the modern paradigm art beyond art. The one recognizes contingency by positing necessity as the determinate answer; the other, by exploring the chance of freedom as the indeterminate answer. (And here it is sufficient to point to the comparable significance of chance for the latency of the system in physics [Werner Heisenberg], biology [Jacques Monod], chemistry [Prigogine], or chaos theory in mathematics.)

Since the responses of both "pure rationalism" and "impure irrationalism" are important tendencies of postmodern art neither can be privileged against the other. Adorno could privilege the one tendency only by splitting modernism apart, thereby preserving and asserting the distinction between authentic and inauthentic art, which is reproduced in the quarrel of modernism and postmodernism. Rather we must accept the indifferentiation of this distinction (and with it the problem of "universal inauthenticity" highlighted in the critiques of postmodernism, to which we return below), because the condition of postmodern art is the contingency of self-determination, for which identity is the product of nonidentity, the product (as Adorno was fully aware) of the loss of authenticity.

If traditional parody is defined by the difference (separation) of

identity and difference and modern parody by the dialectic of identity and difference, then the modality of contingency leads to undecidable ambiguities of identity. That is to say, whereas within tradition nonidentity (difference) arose from identity either in the form of its parodistic other or as ironic subversion, now identity arises from nonidentity. Within tradition parody articulated *freedom* in and against aesthetic necessity and closure by insisting on the interference of art and life, by transgressing the rituals and boundaries of religious, courtly, and autonomous art. It referred outside of the closed system of social and literary self-representation in a fashion more fundamental than that of content. Now, after the end of aesthetic closure, we might say that identity has become the *boundary problem* of the system itself, which makes the consciousness of contingency the ironic defense of aesthetic necessity, the consciousness, that is, of the "necessity" which is won from nonidentity as "appearance." And so against Adorno, nothing is restored by Stravinsky. His music is the historical knowledge of identity as nonidentity which uses forms historically.[10] The same applies to Schoenberg. His search for the restitution, the reconstruction of authenticity after the destruction of tradition also involves quotation—it leads Adorno to speak of the death mask of Viennese classicism and Boulez to speak of new wine in old bottles. But whether mask as construction or construction as mask, the new music of Stravinsky and Schoenberg belongs to postmodern art, which (whatever the fate of European music) is to be understood neither as tragic epilogue nor as satyr play to modern art. On the contrary, the uniqueness and significance of the European organic totality comes ever more sharply into focus since the end of tradition. The task is neither to engage in the endless (endlessly progressive/regressive) deconstruction of the completed totality of tradition, nor to comprehend the new as the destructive critique of the old, but rather to understand the paradoxes of postmodern art, which appear the more clearly in the open recognition of contingency.

Once the system of art becomes completely emancipated, its situation and status becomes openly paradoxical. We can interpret this situation, as Adorno did, as a desperate dialectic of works and contradiction: "the modern work deserves the name when it gives form to contradiction, hence is imperfect; and

contradiction leads to the work's destruction" (AD132). Or we can interpret the destruction of the work, that is, the closed work of tradition, as the open entry of contingency into the work of art in response to the new situation. The entry of contingency (the principle of indeterminacy) destroys the subject/object and the form/content dialectic of the organic work of tradition, centered in the integrating, synthesizing activity of the subject. The totality and its microcosmic representative, the organic work of art, is replaced by the open, indeterminate work which reflects the boundary problem of the open system, which paradoxically preserves its boundaries by destroying aesthetic closure. The integration centered in the subject, which found its self-reflection in the dialectic of identity and difference, appearance and irony, gives way to the decentered, disseminated reflexivity of contingency as the ground of the work. The open horizon of contingency is thus the internal environment of the system which is carried into the work. The boundary problem of the difference between system and environment is reduplicated in the postmodern work through the open presence and acknowledgment of indeterminacy. From it spring the paradoxes of postmodern art. That is to say, the principle of indeterminacy derives from the grounding of the system in contingency; its consequence is that of the self-definition of the system and of the work becomes paradoxical. Because these paradoxes arise at the boundary, it means that the situation and status of postmodern art can be grasped only from the limit, from the extremes. The self-reflection of the system is, to repeat, a boundary problem. What are these paradoxes?

To begin—and here the following is solely some refractions of the problem—dissociation, disjunction, and decomposition lead not to the destruction of the work but to its continuation and preservation in altered conditions and other forms. All deconstructions of the work of art probe the boundary, redraw and redefine it, and thereby reproduce the system. Postmodern art lives from deconstruction, from its own negation. This self-negation acknowledges that the process of the differentiation of art is irreversible, but at the same time it raises the recurrent question Is this art? As a result the decisive question for Adorno, Authentic or inauthentic art? is transformed on the level of system into the problematic question of art itself. This boundary

question remains paradoxical, that is, indeterminate, since deconstruction is equally construction. Deconstruction confirms the contingency of the work and gives rise to a new, more complex level of illusion (*Schein*) which applies as much to "traditional" as experimental responses to the end of tradition. On the one hand, in the face of all continuations of traditional forms of writing, composition, and representation, we are conscious of the nonidentity with tradition, of the sense of quotation which undermines integration and identity. The very endeavor to restore appearance as authentic self-evidence reveals the arbitrary occlusion of difference, and raises the suspicion, in Baudrillard's terms, of simulation. On the other hand, the extreme alternative of the apparently totally indifferent art object—for example, the blank image, Warhol's simulacrum of soup cans—cannot escape appearance. Warhol's soup cans are to be referred not so much to Lyotard's "parodic work of nothing" as to Magritte's self-conscious commentary on the representation of representation— *Ceci n'est pas une pipe:* an appropriately paradoxical affirmation of art in the form of the negative statement, which organizes identity as difference.

"This is not a pipe" is equally the question Is this art? The deconstruction of appearance produces the paradox of an open system, in which apparently anything can be art. The literary text dissolves into *écriture,* document, or intertextuality; the objet trouvé, the ready-made, is displayed on gallery walls; the musical work becomes a taped assembly of raw sounds; the happening or living art questions all boundaries between art and life. Correspondingly, anyone can be an artist. The automatic writing of the surrealists is presented as an invitation to all. Just as Molière's M. Jourdain discovered that he spoke prose, so everyone can be his or her own artist or, indeed, his or her own work of art, as the paradox of fashion shows: the individual nuance of the endless possibilities of a self-selected life style as quotation. And so all boundary works—the empty canvas but also the self-abnegation of photo-realism, John Cage's four minutes and thirty-three seconds of silence, or Beckett's "breathing"—are gestures of challenge, provocations of the limit, which at the same time are provocations of the public. The more familiar forms of the question Is this art? are thus the recurrent denunciations of postmod-

ern art as imposture, buffoonery, confidence trick. To take but the example of Joseph Beuys's notorious provocations of production and reception—it is impossible to decide whether the intention is profundity or pretense. As a recent commentator has observed: "In the chameleon nature of his artistic identity, Beuys made himself into an analogy for the contemporary art object—perceivable as masterpiece or monstrosity, as trick or treat."[11] The question art/nonart cannot be one-sidedly decided; its indeterminacy is the index of the paradoxical status of the postmodern work, which demonstrates the impossibility and the inescapability of appearance. The boundary works—since they exist—are thus the paradoxical answer to the question How are works of art possible after the end of tradition, after the destruction of all the hierarchies and boundaries which alone guarantee the work, the boundaries which Adorno so jealously and zealously guarded?

The paradoxical answer cannot directly define the difference between art and nonart; rather it transforms it into the question reduplicated. The indeterminate boundary of the system is thus one with the self-reflection of the system, whose most evident manifestation, as we have seen, is the entry of open contingency, of the random operations (selections) of chance into the work. The calculated utilization of chance procedures in the construction of identity—action painting, aleatoric compositions, computer programmed or nonsense poems—bears witness to the grounding of the system and the work in contingency. The procedures of "pure" contingency (as, for instance, in Cage's prescriptions for the elimination of subjectivity) or of "pure" determination (as in twelve-tone techniques of composition which likewise eliminate subjectivity), converge however, at the boundary of the system in the paradox of indetermination (the indifference of chance and determination). They are the complementary extremes of the "mastering" and rationalizing of contingency, which pose from opposite directions the question of the limit. At the limit is silence—the emptiest and the most general question of all. At the same time, however, Cage's silence (the ultimate musical joke which provoked Stravinsky to the question to Cage, When can we expect a concerto?) or the empty canvas is also to be understood as the endpoint of determination, the endpoint, that is, of the logical development and differentiation

of the material to the point of its absolute (de-)specification. The techniques of serialization demand the rationalization of every parameter of the work. Silence—the time interval—can be differentiated to the point of total emancipation. The ever more rational integration of the material is thus equally a process of dis-appearance.

In postmodern art every possible parameter of the material can be developed, specialized, absolutized, dissected, and driven to the limit: the poem as pure sound or pure print (an assembly of letters), the painting as pure color or pure (in-)determinate space, the musical composition as pure duration—Cage's 4'33"—which of course despite a stopwatch is indifferent, or as pure rhythm or pure identity, that is, repetition ("a rose is a rose is a rose"). The border, nevertheless, remains indeterminate. From the differentiation and atomization of the parameters new micro- and macroscopic worlds, time scales, and structures can emerge, as, for instance, Karl Stockhausen's speculative explorations of the inner life of sound, from the vibration in the rhythm of the smallest particles to cosmic sound waves, testify.[12] The attempt to push back the border, to operate at the limit lies in the nature of the emancipated system: the diffraction of the one ordering hierarchical perspective of space and time into a multiplicity of relations and relativities. Stockhausen's experiments are but one boundary example of the differentiation and relativization of perspectives (dimensions) which makes the relation of relations the organizing focus of (de-)composition. The juxtaposition of discrete contingent chains of events, the acceleration or the compression of time, the simultaneity of multiple perspectives which we find in *montage*, register not only the relativities of space and time but also the relativities and interferences of the various artistic media. Here we can refer only to Arnold Hauser's illuminating discussion in the chapter "The Film Age" of his *Social History of Art.*

The constructions of montage demonstrate particularly clearly—and here I follow Volker Klotz—the break with the idea of the organic work as the expression of the subject, based on bourgeois individualism and the cult of creative nature, which largely determined reception from the eighteenth into the twentieth century.[13] The emphasis on originality, uniqueness, genius, on the autonomy of the work, whose origin and "purposefulness

without purpose" (Kant) like nature lies in itself, requires the hiding of the methods of production behind the aesthetic closure of appearance. Montage by contrast is based on technology, not nature. As the word indicates, montage derives from the assembly of prefabricated parts. Instead of living, organic unity the process of production is demonstrated. The whole, made up of heterogeneous parts, is to be transparent, incomplete, and open to the everyday world, thereby avoiding the organic structure of beginning and end. Its materials (elements and relations) are no longer incorporated into unity: origin and originality are estranged in the face of an unnatural and impersonal reality. The montage work thus reflects and responds to the transformations of industrial society, to the age of mass production and reproduction which have destroyed the ideology of the bourgeois personality and the unique work.

Volker Klotz's contrast between the organic work of tradition and the montage work beyond tradition highlights basic aspects of the break between modern and postmodern art. In the face of an irreducibly complex world, montage becomes the organizing principle which permits the assimilation of heterogeneity in the form of the indeterminate work, which dissolves the form/content dialectic into the relation of its elements. The dehierarchized multiplicity of dimensions and materials signals the end of teleological integration, the regrounding of identity in the recognition of contingency. My example for the break with the teleological model is Brecht's rejection of the tradition of European drama since the Renaissance. His critique of "dramatic" development and of the aesthetic closure of "tragic" necessity leads to a conception of a scientific, experimental drama capable of demonstrating the changeability of the world, which draws its critical energy from the liberating consciousness of the contingency of all historical formations.

BRECHT AND CONTINGENCY

The situation of contingency as the consequence of the end of tradition is the premise of Adorno's *Philosophy of Modern Music*. It forces him into unfolding the tragedy of modern art. The inescapable irony of Adorno's progress, however, is that the

"identity" (indifference) of progress and nihilism takes us—behind Adorno's back, as it were—from the aesthetic of identity of modern art to the aesthetic of nonidentity of postmodern art. Our example for the change of paradigms is Brecht, not only because, as has often been noted, his work is a limiting case for Adorno's and Lukács's aesthetics, but also because, by expressly seeking to articulate and master contingency, he places himself on the other side of Adorno's indifference. "Brecht and Contingency" is thus our reply to "Schoenberg and Progress"; it denotes the switch from the perspective of necessity to that of relativity, from the vanishing point of dialectics to the dialectic at a standstill, from history to historicism. The new standpoint of relativity means of course that Brecht can only be *one* paradigmatic example of postmodern art, not, as with Schoenberg for Adorno, *the* paradigm.

Volker Klotz's comparison of the organic and the montage work is not without similarities to Brecht's familiar (polemic) schema of the differences between dramatic and epic theater, which he elaborated into the epistemological break which separates the new drama of a scientific age from the prescientific, "Aristotelian" drama of the past. The driving force behind Brecht's revolution in the theater in the 1920s was his conviction regarding the bankruptcy of bourgeois society and the exhaustion of tradition, summed up by the laconic judgment that the classics died in the Great War. The great divide of the war and the Bolshevik Revolution meant that there was no inheritance to continue. The empty stage of the future waited to be claimed. The change of function of the theater, announced by Brecht, is a declaration of war, no less radical than that of the avant-garde movements, on the whole tradition of bourgeois art and the bourgeois subject. Here Brecht draws on the Russian avant-garde and its program of art as social intervention and production rather than the anarchic shock tactics of dada and surrealism. His aim too is to break down the boundaries between art and life by carrying the revolution into the theater, and it finds its most extreme expression in the didactic plays of about 1930, of which the best known is *The Measures Taken,* whose message is that of the sacrifice of the bourgeois individual to the collective and whose purpose is the self-disciplining and self-production of revolutionary cadres.

The revolutionary impulse of Brecht's project, like the revolts of the avant-garde movements, cannot be understood in the light of the idea of progress as a dialectical negation and continuation of tradition. On the contrary, the new drama represents a deliberate and total rupture, to be effected by a secularization which will liquidate what Brecht called the remnants of the "old cultic institution," based on the twin pillars of the celebration of the unique individual (i.e., unique fates, stories) and the vicarious catharsis of emotions. Brecht's response to the exhaustion of tradition is the rejection of the autonomous work, of the self-sufficient sphere of Aristotelian drama, insulated from the contradictions of society and consumed as art.

Our interest here, however, is not Brecht's contribution to the theater as such but the exemplary significance of his response to the situation of art opened up by the disintegration of tradition. However we estimate Brecht's program, it remains but one (politically defined) possibility for the theater. We could equally point to the opposed "cultic" program of Antonin Artaud's challenge to the aesthetic closure of the theater of representation, which emerges from surrealism.[14] The significance of Brecht's project for our purposes lies elsewhere: not so much in its results as in the scope of his *method*. As I shall try to show, Brecht's method can be fully comprehended only if his techniques of estrangement are grasped as both the product and perception of contingency. Estrangement is the informing spirit of his oeuvre, the manifestation of its conscious grounding in contingency. This means that the unity of theory and practice realized in his method, which has made him perhaps the most influential figure for twentieth-century drama is, at the same time, beyond all applications in the theater, a highly instructive exemplification of the new stage of the self-reflection of art. Brecht's literary-political project brings to full consciousness the consequence of the long process of the emancipation of art from the constraints of social selection, codified by tradition, into the freedom of self-selection. Hence the radicality of his break with the past, hence the alienating wedge driven by the techniques of estrangement between the past (of the present) and the future (of the present). It is this borderline, this line of division, which defines Brecht's paradigmatic change of perspective.

Above I argued that the problem of the limit, of the boundary, is constitutive for postmodern art. The problem art/nonart becomes critical once the boundaries of tradition collapse. The system of art must seek its self-definition at the limit, and here Brecht is no exception in his probing of the limit which separates stage and audience, work and reception. If the change of function of the theater demands that the world be shown as changeable, that what is represented on stage escape the confinement of the stage, then his plays are both ends and means to another end. In seeking to transcend the system of art Brecht's plays are situated on the indeterminate border between reception and a realization which would transform the audience into actors in their own right. This position within and beyond art gives rise to the double perspective of past and future, of the opposed realms of necessity and freedom, whose vanishing point is the aesthetic-political utopia of the identity of art and life. The techniques of estrangement can thus be understood as the demonstration of the double optic of necessity and freedom, whose realm is that of contingency, in which all determinations and closures have become provisional. In the realm of contingency, the in-between time, in which everything that is could be other, Brecht's work remains necessarily an unfinished, open-ended project; the unfree anticipation of the self-transcendence of art is its open horizon.

The primacy of method derives from the epistemological break inherent in the application of the (Marxian) science of society to the drama. Science alone for Brecht transcends the limits of bourgeois consciousness by overcoming the illusory viewpoint of individualism. The Copernican turn of the epic drama resides in the abandonment of the subject as origin and center. The irreducibly chance individuality of actions, which flows from the irreducibly fixed point of "character," is to be dissolved into the specification of social fields of force, in which individual actions are presented as the resultant of a concrete, dynamic whole. The assumption of the knowability of the laws of society, of the dynamics of social movement and motivation is thus intended to eliminate the pre-scientific dichotomy between individual freedom and social determination, chance and law. This means that for Brecht all history becomes prehistory: the realm of determination—that is, illusory freedom—is to be laid bare by the cold gaze of sociohistorical

specification in the play as the experimental model. To liberate the future from the past, the *otherness* of history must be shown. The paradigm change, instituted by the epic theater, is thus a practical and theoretical transformation, whose goal is to detach the theater from its ideological prehistory by creating a new, scientific drama, in which it is the task of the model to demonstrate the contingency of causality.[15] The primacy of method is carried over into the structural primacy of the scene in the epic drama. The parts are greater than the whole, which is broken down into its constituent elements. The arrow of teleology is arrested in midflight, the flow of time is transformed into the spatial field of force, the goal gives way to the dissection of the process. As the paradoxical term "epic drama" indicates, Brecht's theater represents the negation of the teleological model. In his words, the work has an end but no goal. It is, as Benjamin writes, the dialectic at a standstill: "But the dialectic which epic theatre sets out to present is not dependent on a sequence of scenes in time; rather it declares itself in those gestural elements that form the basis of each sequence in time. . . . The conditions which epic theatre reveals is the dialectic at a standstill."[16]

The move from the closed teleological form of the drama to the open, indeterminate structure of the epic theater correlates directly with the break with the "Aristotelian" concept of genetic—historical-empirical—causality (the individual case) and its replacement by a "Galileian" concept of social causality as a dynamic system of relations and forces. Here the function of epic discontinuity, the decomposition of the action into elements (gestures) and relations, lies for Brecht in the possibility of the direct confrontation and comparison with reality through the foregrounding of the causality underlying the events represented on stage. It leads Brecht to define estrangement as the means by which causality is made apparent. And here the function of the model is the reduction of the complexity of relations in the world through the simplifications of form, from the scene as basic unit to the parable or fable itself. The model demonstrates causality in such a way that the world can be presented and comprehended as an object for intervention. Brecht's "scientific" drama thus revolves around the idea of causality. The laws of society are the index of social unfreedom, of the absence of self-determination.

They form the deep structure of social being, which must be brought to consciousness through estrangement in order to reveal the historicity (contingency) of all social formations. Suspended between the past and the future, the place of Brecht's project is the place of nonidentity, that is, no place, the u-topia of contingency. The present alienated from itself, reality divided against itself is the line of rupture, the contradiction effected by estranging historization. The u-topia of universal contingency produces the paradox of the possibility of freedom through the demonstration of unfreedom, of the possibility of identity through the demonstration of nonidentity. We can therefore redefine the methods of estrangement as the making apparent of causality *from the standpoint of contingency*. This function provides the key to the unity of theory and practice in Brecht's theater. The representation of reality is consciously for Brecht re-presentation, and re-presentation in turn necessarily implies the representation of representation.

We can now formulate the nature and significance of Brecht's paradigm break in more precise terms. It is not by chance that Brecht's rejection of the traditional theater in the 1920s is contemporary with Gaston Bachelard's first explorations of paradigms and discontinuities in the history of science. For Bachelard the emergence of a new method defines a new problematic and institutes a new level of discourse which is discontinuous with earlier paradigms. The constitution of a new field and a new method of investigation accomplishes the advance from ideological to scientific discourse through which practice becomes conscious of itself and attains a new level of self-reflection, objectified in a new level of formalization of its object. Formalization reflects the perspective of antinaturalism, which abandons the historically given commonsense standpoints of realism and substitutes for them a conception of reality as scientific construct. It denotes the emergence of an experimental, hypothetical, and contingent perspective, in which the object is produced and defined by the method. With Brecht, it takes the form of the conscious reflection of the relation between representation and reality. That is to say, the "scientific" nature of Brecht's theater is to be found not in the illusory concreteness of his ideology of a science of society and its supposed laws of motion but in the new level of abstraction and

self-reflection realized by his method in response to the disintegration of the traditional—ideological in retrospect—paradigms of representation. This new level of self-reflection demands the simultaneous construction and critique of reality *and* its representation.

Through *re-presentation* the self-identical is made nonidentical. It is estranged, that is, historicized and specified in the distance of its "otherness" as quotation. The theater of identity (realism as illusion, naturalism, aesthetic closure) and of identification (empathy and catharsis) is anathema to Brecht. And so his antinaturalism becomes the double program of the estrangement of reality and the self-estrangement of representation. The contingency of reality is reflected and reduplicated in a nonidentical representation, just as in turn the critique of existing representations of reality reveals the contingency of all aesthetic closure. All previous representations of reality are to be exposed from the perspective of historical specification as ideological models, but by the same token the Brechtian drama must incorporate itself in its critique, must comprehend itself as the object of its own theory, that is, as itself a historically specified product. Self-relativization is the liberating impulse of Brecht's utopian standpoint. If it necessarily affects his work as *result,* it defines the productiveness of his method.

Brecht's method is "essentially" a critical operation: estrangement, alienation, and parody divide identity. Estrangement expropriates, doubles, and differentiates its object by representing it. It is thus the experimental practice of Brecht's realism: the demonstration of the nonidentity of the actor with his role (the representation of representation) places all action and speech within quotation marks—thus his or her gesture, so he or she said—in order to foreground the nonidentity, that is, the split self of the subject. Estrangement is thus the critical operation of specification through repetition (quotation) which makes the same other, thereby producing a more complex construction of reality, in which identity is grounded in difference. It subverts not only the naive identity (illusion) of representation but equally the separate identity and the difference of the two spheres of art and life. For an art constituted by re-presentation, the formalization or modeling of reality means not only that life is re-presented as

"art" but that "reality" in turn becomes a script to be rewritten. Where everything is quotation, everything can be other. In his models Brecht exhibits the sovereignty of the artist rewriting reality. That is to say, in the new perspective of relativization historical specification and quotation tend to fuse in the analytic realism of the model: specification is repetition, and repetition is quotation. This analytic "indifference," however, is a necessary consequence of the project of a new drama, which opposes to the tradition of dramatic *identification,* which turns literature into "reality," the self-reflection of *alienation,* which transforms, as it were, reality into literature. Only by treating reality as "literature," by quoting it, can its otherness, its contingency, be demonstrated.

The sovereignty of the Brechtian "work" is thus the sovereignty of estrangement which critically reworks the given, the preformed, as material. Estrangement can be seen, through its operations of adaptation, translation, and transposition, as the "scientific" practice of Brecht's theater. His method of systematic quotation must therefore be distinguished from other conceptions of parody. Although he appears to have adopted the concept of estrangement from the Russian formalists, who exemplified it by reference to the techniques of parody (cf. Viktor Shklovskii's *Theory of Prose*), estrangement for Brecht is in no sense the immanent mechanism of an autonomous literary evolution that it was for the formalists. On the contrary, it manifests not the evolving continuity of the internal dialogue of tradition but the discontinuity of mutation. This change of function means that Brecht's techniques of estrangement cannot be identified, for instance, with the traditional techniques of comedy, although of course he makes use of them. Such an approach is in danger of reducing his "translations" to an eclectic pillaging of world literature. Equally we must distinguish his method from the romantics' view of parody as the progressive, dialectical dissolution of tradition which raises it to a higher power. Brecht's estrangement is the operation of historical specification outside of and against tradition. The change of function of the theater reduces tradition to material to be refunctioned.

Brecht's sovereignty springs from the revolutionary desire to "make it new," to catapult himself free from the dead weight of

tradition. The radical break with the past, whose formula is estrangement, brings out in the sharpest programmatic form the fundamental impulse of the avant-garde movements from futurism to Russian constructivism, from cubism to surrealism: from the perspective of the break, tradition exists only as material to be reused and recombined. This "nihilistic" intention—the assault on all hierarchies and boundaries—opens the era of postmodern art. Henceforth art enters into an alienating relation to tradition. The emancipation of the postmodern work manifests itself in the sovereign disposition over the materials of tradition. Estrangement, the disenchanting principle of antiart, sets free the endless circulation and recombination of procedures, styles, and forms by which tradition is transformed into an "exchange value," a mutation which is in fact the emancipation of its "use value." Cut off, as in montage, from its origins, context, and "intrinsic" meaning, the wealth of tradition has become freely convertible.

Brecht's "scientific" theory and practice thus serves as a concentrated focus for the crucial question of the relation of the new to tradition, since the function of estrangement is the destruction of the identity, continuity, and *immanent* values of tradition. The principle of alienation subjects all individuality, identity, and self-evidence to the leveling universality of the law; it transforms everything into material, example, demonstration of the workings of social causality. Estrangement, as it were, universalizes exchange value by specifying the object and destroying identity. At the same time, however, this "nihilism" also opens the way to the construction of a new, more complex tension between the reality of representation and the representation of reality for the system of art. Among its obvious manifestations are, as we have seen, the multiplication of elements and relations as in montage, the radical differentiation of individual parameters, materials, and media together with their complex recombination, the experimental exploration to the limit of the possibilities of the system, and not least the liberating and unhappy consciousness of contingency which demands of the artist ever-greater self-reflection. Moreover, the freedom of self-selection beyond tradition necessarily brings about a heightened consciousness of *historicity* in relation to tradition, even where, as with the young Brecht, it appears as nihilism and celebrates itself as vandalism. T. S. Eliot

seeking in *The Waste Land* to shore up fragments against the disintegration of tradition is not so very different from Brecht sifting through the rubbish heap of culture in search of its "material value." They are both postmodern responses to the end of the European tradition. And so Brecht's new standpoint of *relativity*—"what a wealth of material is offered by adaptation, made possible by the new standpoint"—is the Archimedean lever of his "historical materialism" applied to tradition. Just as Stravinsky uses forms historically, so Brecht will alienate "classical models and stylistic elements" in order to demonstrate their contingent causality.

The refunctioning of the codes of tradition presupposes their transformation into material as the basis for the recombination of the elements. It makes Brecht, like Stravinsky or Picasso, the *time traveler* in the museum of world art, who takes what he needs where he finds it. The theater of all peoples and all times becomes the world horizon of his project. Here again we register the primacy of method, of the sovereign, scientific standpoint, for which all past totalities, formed contents, and structured wholes are reduced to preformed material. The Brechtian work is no longer an autonomous organic microcosm but a process of the reworking and respecification of material. The work ceases to be identical, it transforms itself into a critical *relation,* whose mode of being is estrangement and self-estrangement. The continuity of tradition is transformed into the difference of discontinuity by the paradigm break, which emancipates the new from its genesis. The standpoint of relativity (nonidentity) permits the alienating revision of the past, through which its exchange value is released as the "material value" of the new paradigm. The primacy of method thus means that potentially everything can be adapted, translated, refunctioned. Here we need only point to Brecht's innumerable sketches, plans, projects, and formal experiments for the evidence that the new standpoint of relativity as the consequence of the exhaustion of tradition "absolutizes" the perspective of estrangement.

The horizon of world art, the synchrony of all traditions, can emerge only with the end of the grand narrative of progress. Its corollary in Brecht is the "epic" discontinuity of the dialectic at a standstill. Philosophy of history gives way to the science of histor-

ical specification, whose corollary in turn is the timeless present of Brecht's parables. The absence of historical time and place in his "historicizations" of the past and the present comes from the abstraction effected by the new standpoint, for which all history has become the material of demonstration. The freezing of time into space, the decomposition of movement into the fields of force of social relations announces the new time of the contingent world, in which the dialectic has migrated to the open (ever-receding) horizon of possibility. With the suspension of the telos of history, Brecht enters the field of historical relativity. We can understand this new field as the time-space continuum of historicism beyond tradition and progress. In viewing Brecht from this perspective of radical historicity (whose theoretical expression is given in Karl Korsch's *Karl Marx* [1935], written in close collaboration with Brecht), I am reading his "epic" method against Brecht's own commitment to the class struggle.[17] If the grand narrative of the Marxian philosophy of history is undoubtedly the key to Brecht's sense of living between two epochs—the capitalist and the socialist—the form it takes is that of the in-between time of the contingency of all experience. The concentration on the wider implications of his break with dramatic tradition is thus in its turn an "estrangement" of Brecht's revolution in the theater.

The example of Brecht must serve here as an illustration of the situation of art after the end of tradition. On the one hand Brecht stands like Stravinsky outside Adorno's theorem of the progress of the material; on the other the determination of the place of Brecht's work in the literature of our century involves for Bürger the determination of the "historico-philosophical place of art in the present" (DM 129). Central to such a determination is the question of the translation into artistic practice of the status of art since the attack of the avant-garde movements on bourgeois autonomous art. Here, I believe, the example of Brecht offers an answer. Of course it can be only one possible answer, but it is one which helps define the status of postmodern art.

The exhaustion of tradition is the key to Brecht's revolution in the theater. It leads him to affirm the supersession of European drama by the project of a new scientific, secularized drama which is to be simultaneously the critical enlightenment of "dramatic"

tradition and the self-critical union of "epic" theory and practice. The historicizing perspective of the changeability of the world grounds the emancipatory change of function of the theater as institution in the consciousness of the contingency of all social and aesthetic determinations. In short, Brecht's whole project of emancipation represents a new stage in the dialectic of art and enlightenment. That is to say, Brecht can be understood as the response not only to the exhaustion of tradition but also to Hegel's verdict that modernity is the epoch of reflection which signifies the end of art. Brecht's abandonment of the illusory concreteness of traditional "realism" in favor of the experimental constructions of his sociological models both accepts and answers Hegel's verdict. The "theater of the scientific age" demands a level of self-reflection which can be attained only through the union of art and science.[18]

Profane Illuminations

◻

THE END OF MODERNITY

The end of modernity is the ambiguous "truth" of postmodernity. It can be understood as the afterglow which indefinitely prolongs the end. This is the Heideggerian perspective of Gianni Vattimo's *The End of Modernity*. Coming after, however, can mean not only the disappearance of the old but also the appearance of the new. This ambiguity invites further reflection on Vattimo's account of the death of art in postmodernity. In his account the death of art is brought about by the explosion of the traditional institutional limits of art which leads to a general aestheticization of existence. Since this aestheticization renders the status of art ambiguous, the focus of the present chapter is the ambiguity of the "appearance" of aesthetic illusion after the disappearance of the traditional limits of the aesthetic.

Vattimo advances three perspectives on the death of art in the twentieth century. The first arises from the avant-garde's negation of the defining and confining place and space of aesthetic experience (from the concert hall to the museum) in order to overcome the barriers separating art and life. The result is that the status of the work of art becomes "constitutively ambiguous": "The work no longer seeks success which would permit it to position itself within a determinate set of values (the imaginary museum of objects possessed of aesthetic quality), but rather defines its success fundamentally in terms of rendering problematic such a set

of values, and in overcoming—at least momentarily—the limits of the latter. In this perspective, one of the criteria for evaluation of the work of art seems to be, first and foremost, the ability of the work to call into question its own status" (EM53).

In other words, in terms of my argument, once the confining walls of tradition (Vattimo's imaginary museum) fall, the boundary question of the emancipated system—art/nonart—emerges in the form of the work which calls its own status into question. And here the critical question, posed perhaps most radically by Marcel Duchamp's ready-mades, is precisely that of the "disappearance" of aesthetic illusion.

The second perspective on the death of art takes us "from the explosion of aesthetics as it appears in the early avant-garde movements—which conceive of the death of art as the suppression of the limits of aesthetics in order to move toward a metaphysical, or historical and political, meaning of the work," to the explosion of the newer avant-garde movements, which derives from the impact of technology. Vattimo follows Benjamin's—but also Baudrillard's—understanding of technology as the means which "at once permit and determine a form of the generalization of aestheticity" (EM54). Benjamin's technological interpretation of the death of art takes the form of a theory of mass culture (EM55). Here too, it is clear, the transformation of aesthetic experience envisaged by Benjamin poses the question of aesthetic illusion (the destruction of aura).

In the third perspective the suicide of authentic art is to be understood as the protest against the death of art brought about by the aestheticization of existence. Vattimo's witnesses are Adorno and Beckett. Authentic art withdraws into the silence which is the simultaneous affirmation and negation of aesthetic experience, just as for Adorno the progress of artistic technique finally serves to guarantee the "more perfect impenetrability" of the work of art (EM57). The death of art—in its three versions of the reintegration of art and life, the aestheticization of mass culture, and the self-negation of authentic art—necessarily involves for Vattimo the death of philosophical aesthetics, because both are manifestations of the end of metaphysics: "The death of art is a phrase that describes or, better still, constitutes the epoch of the end of metaphysics as prophesied by Hegel, as lived by Nietzsche and as registered by Heidegger" (EM52).

Postmodernity, accordingly, is the epoch of the end of metaphysics. Since the end, however, is endlessly deferred, the death of art is to be understood as the epoch of decline, which is best defined, Vattimo argues, by Heidegger's concept of *Verwindung*. The end of metaphysics—the epoch of being as presence—is for Heidegger our destiny, a destiny which cannot be overcome but only accommodated by yielding and resigning ourselves to it (EM60). In this perspective the (terminal) task of philosophical aesthetics is to "complete" the death of art. It is a completion, however, which is rendered indeterminate by the "persistent life of art and its products": "The philosophical description of the situation could finally become complete through the recognition that the key element in the persistent life of art and its products—which nevertheless continue to define themselves from inside the institutional frame of art—is precisely this interplay of the various aspects of its own death" (EM58).

From this "final" perspective of Vattimo, Heidegger's stance of *Verwindung* and Adorno's negative aesthetics, which both historicize the metaphysical truth of art, appear as complementary versions of the disappearance of art in postmodernity. Adorno's terminal enlightenment of art is situated between the Hegelian end of art and the aestheticization of existence which follows from the avant-garde's explosion of tradition. If Hegel's end of art is the utopia of the return of the spirit to itself, the coincidence, in Vattimo's words, "between being and a completely transparent self-consciousness" (EM51), then Schoenberg's twelve-tone music is its tragically negative exemplification, while Stravinsky's impersonations prefigure its ultimate parody in Baudrillard's universe of simulation, where representation can no longer be distinguished from reality.

Vattimo's account of the decline of art leaves us with the henceforth constitutively ambiguous status of art. The tension of this ambiguity of "dis-appearance," which reflects the tension of the indeterminate boundary of the system of the arts, must be maintained against the dystopian and utopian versions of the death of art, for which my examples are Baudrillard's and Benjamin's "transaesthetic" accounts of the destruction of aesthetic illusion in the age of the mass media. Against Baudrillard's dialectic of enlightenment I argue that the explosion of the traditional limits of the aesthetic results in a new, more complex dialectic of

illusion and transparency. Against—but also with—Benjamin I argue that the mechanical reproduction of art opens the way to a new, more complex historical consciousness of our relation to tradition.

In the tradition of philosophical aesthetics art is the appearance of truth. The crisis of this tradition manifests itself in Adorno's dissolution of the dialectic of illusion of the organic work of art into the unmediated extremes of truth beyond appearance in Schoenberg's music and of appearance void of truth in Stravinsky's music. Aesthetic progress consumes itself in revealing truth, the restoration of appearance parades as parody. The postmodernism debate remains caught up, as we have seen, in Adorno's conclusions: the postmodernists' proclamations of the exhaustion of the progressive spirit of modernism seem to lead only to a renewed play with appearance.

If the "parodic work of nothing" is Lyotard's response to the *Philosophy of Modern Music,* then Baudrillard's universe of simulation can be read as a "transfinal" response not only to Lyotard but also to Jameson's and Eagleton's extrapolation of Adorno's critique of Stravinsky and of the culture industry into a critique of postmodernism, which grasps its "cultural logic" as a universalizing of parody, the parody which is no longer parody but pastiche. Baudrillard's position is that of the "transfini" beyond politics, economics, the subject, and the social, which drives the paradoxes of indifference into the vertigo of simulation in a final nihilistic potentiation of romantic irony. Jameson and Eagleton invoke Baudrillard's simulacra together with Guy Debord, whose "society of the spectacle" is for them the totalizing of appearance, the triumph of the image, the emancipation of the signifier from all reference which liquidates the possibility of any critical position outside alienation. And yet the paradox of indifference—total parody—can be maintained only from such a vantage point. Jameson and Eagleton thus still occupy that privileged position of critical theory which allows them to see through appearances. As Baudrillard puts it in *Simulacres et simulation,* believing that (other) people believe is the trap of critical thought, which must

presuppose the naiveté and stupidity of the masses (BS124). In other words, Jameson and Eagleton must presume a latent function of the manifest; they must give an interpretation in depth of the progression from depth to surface. In short we are still entangled in the logical dilemmas of indifference to which Baudrillard proposes the following syllogistic resolution in the epigraph to *Simulacres et simulation:* "The simulacrum is never that which hides the truth—it is the truth which hides the fact that there isn't any. The simulacrum is true."

Baudrillard's overt nihilism goes beyond Jameson's and Eagleton's critique of postmodernism and yet it too comes after Adorno, as Baudrillard acknowledges. Baudrillard cannot resist the totalizing gestures of the dialectic of enlightenment, and so his radicalization of the "transfini" brings out the more clearly the dead end of indifference (for Baudrillard the coincidence of ecstasis and inertia) at the same time as, taken at its word, it suggests a way out. What is involved here is the question of the final order of the image—the situation of panparody or pastiche, of "absolute imitation" (Adorno), of simulation—since the image-become-simulacrum signifies for Baudrillard the disappearance of difference in the indifference of appearance and thus the end (in both senses) of enlightenment. Baudrillard's theory of the image replays and reaffirms the nihilistic dialectic of the progress of enlightenment to indifference.

But before we turn to Baudrillard's model and to an alternative reading of the world of simulation we must start at the end with the nihilistic credo which concludes *Simulacres et simulation.* Nihilism today is transparency. We have entered living the world of simulation—the false transparency of the functioning of things (BS229). Given Baudrillard's indifferent use of terms, "transparency" is anything but transparent. It seems to turn on the equivalence of the triumph of *appearance* (surface) and the disappearance of *illusion* (the illusion of depth), which is simultaneously the uncovering of the real (the obscene) and the loss of the real (the scene of illusion). The real beyond the real is the hyperreality of simulation, of the image, which in turn marks simultaneously the end of aesthetics (the aesthetics of representation, the dialectic of absence and presence) and the total aestheticization of reality (the indifferentiation of absence and presence, or

equally indifferently, the universal presence of absence and the universal absence of presence in simulation).

Baudrillard's genealogy of nihilism presents a history of enlightenment or secularization, since the image from the idol or fetish on has always been a simulacrum. The disenchantment of the world had to await, however, the onset of modernity. The revolutionary task of modernity—the Enlightenment and romanticism—was the destruction of the seduction of the order of appearances and the abandonment of the world to the violence of interpretation and history. The second revolution of the twentieth century—dada, surrealism, the absurd, political nihilism—accomplished the task of *postmodernity:* the destruction of the order of meaning, leaving the scene of dialectical reason empty. Beyond lies the fascination of indifference, the nihilistic passion which belongs to the mode of disappearance. Our passion is this melancholy (BS230–31). As Baudrillard puts it in *Les Stratégies fatales:* "Today art only exercises the magic of its disappearance" (BF13). *Adorno transfini.*

The radicality of the mode of disappearance, Baudrillard's nihilism—the end without end of history, of the real, and of meaning—is prefigured for him in the nostalgic dialectical exercises of Adorno and Benjamin. The deeper tonality beyond dialectics of their melancholy science lies for Baudrillard, however, in the incurable melancholy of the system itself, which appears in the ironic transparency of the forms which surround us (BS234). We have learned that meaning is mortal and that the reign of the enlightenment was ephemeral. What the Enlightenment sought to dissipate—appearances—that alone is immortal, the nihilism invulnerable to nihilism (BS236). *Nietzsche transfini.*

Needless to say, Baudrillard's version of the enlightenment, which ends in the opaqueness of transparency, is itself a myth, which embraces the seduction of the logic of indifference. The question is, can Baudrillard's dis-appearance of meaning and disillusion of the image be read another way? At stake is Baudrillard's model of enlightenment, which we have encountered in one form in his genealogy of nihilism and its terminal dialectic of meaning and appearance. The structure of his model is that of the latent and the manifest, whose point of no return is the manifestation of the latent—the coincidence of total enlightenment and

total nihilism in the truth of the simulacrum beyond the distinction true/false.

The simulacrum and the age of simulation are the third and fourth stages of the image. Stages 1 and 2 belong to the theology of the secret of truth, that is, the image as (1) the reflection of deep reality and (2) the mask of deep reality—the hidden god. Against this stands the revelation of the "secret," that is, the image as (3) the masking of the absence of deep reality and (4) the liquidation of referentiality in the pure self-reference of the simulacrum without relation to reality (BS17). At this point (the end beyond the end) differentiation reverses in a double sense. First, by following the reifying logic of the separate spheres—the logical evolution of a science distances it more and more from its object until it no longer needs it—autonomy attains its pure and empty form (BS19), which cancels differentiation. We enter the world of the transpolitical, thereby, second, canceling the separate spheres of the political, economic, social, and so on in the totality of the system, which absorbs and indifferentiates all critical energies of negation (BF12) in a transfinal evacuation of meaning. And since where there is no meaning everything must function perfectly, hyperreality simulates hyperfunctionalism. The response to the vacuum from which erupts chance, indetermination, relativity, is the hypertrophy of overdetermined theories (BF15) (see above "pure rationalism" and "impure irrationalism" as the two main tendencies of postmodern art in response to contingency).

The image as simulacrum becomes the omnipresent form of indifference. The annihilation of content by form, the disappearance of objects in their representation (BS72), brings about the generalization of the aesthetic of simulation (BS43). The perspectival depth of the theater of politics is transformed into the two-dimensional surface of the television screen—the medium is the message of the transpolitical. The explosion of information in the media is in reality the implosion of meaning: information devours its contents (BS123), leaving the superficial transparency of the absolute publicity of things (BS134). This inflation is the entropy in which ecstasy and inertia coalesce. Baudrillard takes his argument a stage further in *Les Stratégies fatales* when he declares the hyperreality of absolute publicity to be the obscene (BF37). The transparency which uncovers and

irrealizes the real defines the obscene as the *latent made manifest*. The loss of all that is secret, the loss of distance and the mastery of illusion, lays bare the pornography of the transpolitical, which gives the formula: if the mode of appearance of illusion is the scene (the stage), the mode of appearance of the real is the obscene (BF71). From this it would appear to follow that the real amounts to appearance minus illusion, which attains its apogee in the "exacerbated visibility" of the obscene (BF80). The simulacrum is this truth of the transpolitical, transfinal mode of disappearance, in which all that is latent must render up its secret in the glare of publicity and communication.

We thus arrive at a third version of Baudrillard's model of enlightenment—the obscene—which correlates closely with our outline of parody.

1. The *duality* of the latent and the manifest: the place of *traditional* obscenity is offstage. In the beginning there is the secret which permits the rule of the game of appearances.

2. The *dialectic* of the latent and the manifest: *modern* obscenity is produced by repression. It is neither visible nor representable on stage, and yet it possesses the energy of rupture and transgression. From it comes the rule of the game of depth.

3. The *indifference* of the latent and the manifest: the place of *postmodern* obscenity is everywhere. It is the rule of the game of the world of transparency without appearance or depth, which has made us all voyeurs without illusions. (BF89–91)

The third stage of the postmodern under the sign of the media radicalizes the cultural critique of Adorno, the emigré in Hollywood, and here the question is, Is the state of absolute publicity a new stage of enlightenment (secularization) or is it precisely the total parody of enlightenment? The question of the image, just as the question of postmodern art, is that of a system without latency, and it permits no unproblematic, no unequivocal answer. Least of all does it permit the seductive closure of nihilism à la Baudrillard, which announces that if history has come to an end, theory after all can go on as the revenge of posthistory on the enlightenment which has disillusioned the enlightener. The radicality of Baudrillard's "fury of disappearance" (Hegel) is a grand but painless gesture. It is the cynicism of a theory which rhetorically proclaims the advent of the era of total visibility and trans-

parency, while both denying the possibility of insight and conceding that no one is deceived.[19]

Baudrillard thus stands as the "ultimate" expression of theory after Adorno, because he consciously situates himself beyond the irrational limit which irrationalizes theory. At the same time his universe of the "transfini" takes us beyond aesthetics to the "transaesthetic": the universe of the disappearance of illusion (*Schein*). And here the logic of indifference means that the transaesthetic is both the end and the totalization of aesthetics, that is, the aestheticization of reality, just as the totalization of pastiche is equally the end of parody. This leaves the simulation of the image, the coincidence of the latent and the manifest, reality and appearance. This indifference, however, contains the tension of a *difference,* of an ambiguity, which must be turned against the unproblematic and seductive generalizations of both Jameson and Baudrillard. If the image is naked reality (the obscene) then it is not simply pastiche; if the image is appearance it is not simply naked reality, it is also illusion (*Schein*). Contrary to Baudrillard the transaesthetic is not the end of illusion but its extension to the wider sphere of the media, advertising and politics, and if this produces the appearance of pastiche, of panparody, it is because the image has absorbed and internalized parody in the form of the self-reflection of illusion. The question of the image can be understood only on the level of the system as the total tension of appearance and reality, that is, as the consciousness of contingency. This is the open, problematic condition of enlightenment.

The self-reflection of the system on the level of the system—in other words, the progression from depth to surface—does not simply represent the annihilation of content by form (the medium is the message). More important, it manifests the self-referentiality of what we might call the frame effect, which follows from the impossibility of presupposing a natural, naive realism of illusion in the face of the contingency of appearances. The visual media must constantly foreground their production of reality because reality has lost its "real" illusion and is perceived as what it is, man-made, manufactured reality of the second or third order. This is the reason why the image and the pseudo-events of public relations cannot be deconstructed (parodied), they are their own construction and deconstruction, as the flood

of information on the making and the unmaking of the president or on how Coca-Cola or General Motors launched its new image testifies. And this is the reason why the visual media are so fascinated by the (im)possibility of the spontaneous, the naive, the private, and the "real," which the camera eye must violate and destroy but transforms in the process of enlightenment *not* into the blank face of simulation but into the inescapable reflection of the tension of appearance and reality.

If the truth of Baudrillard's simulacrum is that there is no truth to hide, then the truth of the image is that the commodity is naked. Everyone knows and nobody is deceived except those, like Baudrillard, who are beyond deception. Only the disenchanted commodity requires the aura of the image. Advertising is the metareflection of the commodity and so the advertising industry is "obscenely" open about its banal strategies of manipulation. This cynicism is matched by that of the consumers, since the illusion lies not in its reality but in its artificiality. "Real" illusion has lost its taste; there are no secrets to advertise. The rule of the game of the commodity is transparency, and its "contingency formula" is fashion, the clothing of the eternal return of the same in the strategy of the season. The end of "real" illusion is the open acknowledgment that illusion cannot escape self-consciousness. We know that the emperor wears clothes. Enlightenment makes the codes transparent in their conventionality. Warhol's simula- tion of soup cans not only foregrounds the contingency of the work of art as commodity but also the appearance of the com- modity as work of art. *His* simulation works through the non- identity, the critical distance, and the difference of repetition. The representation of representation does not destroy illusion (*Schein*), it raises it to the level of metareflection. It is the differ- ence between Baudrillard's illusion, predicated on depth and la- tency, and the illusion which is manifest latency: the conscious- ness of contingency which places illusion between quotation marks. This, against Baudrillard, is the truth of the simulacrum.

The same applies to politics. Politics has not disappeared into the transpolitical; rather, it has entered the stage in Western democracies of self-critique. Politics is now openly part of the society of the spectacle, that is, a society highly conscious of the "theatrical relation" of representation, not a society which is totally naive and totally manipulated. In a system without la-

tency, "leaks" are the overt (cynical) concession to the pretense that there is latency, just as "disinformation" is the covert (cynical) recognition of the insistent demand for information. The political spectacle cannot escape the "transaesthetic" enlightenment of aesthetic illusion brought about by absolute publicity. The "pornography" of politics is that of a system which cannot tolerate the hidden and the mysterious and is provoked by the real illusion of the secret. The point is not so much that presidents become actors or actors president but that the public sphere with good reason is suspicious of presidents who want to be more than actors on the public stage.

This of course does not mean that public politics is not problematic. The protection of latency against the democratic right of freedom of information poses the real problem of how government is to continue. But this is a problem of the democratic system and cannot be decided secretly by the restoration of illusion. The crux of the latency of the political system is national security. If this is the issue much more directly of Irangate than Watergate, Baudrillard's dismissal of Watergate as the political equivalent of Disneyland—the rule (phoniness), isolated and presented as the exception which guarantees the rule (BS28)—is nevertheless cynical, because his fatal strategies refuse differentiation. The control of presidential powers is not a matter of indifference (but it is an inconvenient reminder that history hasn't stopped). The function of public hearings is not, pace Luhmann, to tell us that "we may not know that we may not know what we may not know," but that we may find out as in the case of Irangate whether the president knew that he knew what he knew. The latency of government is threatened not by public hearings but by what has become known ironically as covert operations. Media politics is just as real as all earlier "real"—that is, restricted—politics. When Baudrillard laments the loss of illusion or when the society of spectacle is denounced—is this really the expression of the wish to return to the good old days when presidents were really presidents, whose manifest functions of representation hid their latent powers and "real" politics was still possible? It is strange to observe such avant-garde radicals longing for the old-fashioned illusions of realism because they recoil from the "obscenity" of enlightenment.

The spectacle of politics is the extension of the theater. As in

the theater we believe and do not believe in the play of identity. Secularized politics, like the disenchanted commodity, is naked and requires "cynicism" from both the actors and the spectators, that is, the knowledge of the illusion of the spectacle as the form of the appearance of naked reality. This knowledge was the traditional function of the chorus, the voyeurs without illusion of Greek tragedy (in which enlightenment brings the moment of truth), which has been taken over by the media commentators of our political comedy. Our comedy, however, is not, pace Hegel, the farewell to politics but its problematically enlightened continuation in which the "deceptions" of the political system are endlessly discussed and dissected in terms of the all-too-familiar criterion of credibility. It is a formal criterion on the level of the system which assumes a sophisticated and cynical audience. The society of the spectacle is not so distant from the Brechtian theater of estrangement. Both acknowledge in their different ways the reality of contingency, and if politics approaches art in its foregrounding and framing of appearances, it is because like epic theater it can no longer represent itself naively. Either we believe the audience is naive—then the play can appear to continue, but only as Beckett's *Endgame*—or we acknowledge that the audience is not endlessly deceived, that the recognition of contingency (loss of latency) is the form in which the play really continues. And if we are in danger of forgetting this, then the media chorus is always there to break the illusion. Or rather the chorus is part of the play: it is the metareflection of the society of spectacle.

When we speak of the self-reflection of the system we mean the logic of the autonomous spheres, the logic of differentiation. Only the indifferent totality of Baudrillard permits the nihilistic invocation of lost essence. Without the idea of totality there can be neither essence nor the illusion of realism and the realism of illusion. The progression from depth to surface, from content to form is the logic of differentiation not, pace Lukács, of reification, and this logic is that of a secularization which does not extinguish illusion but foregrounds it as the question of the system. The authenticity of the expressive totality—the *Schein*, the aura of the classical work of art—cannot be restored. Its place is the museum.

Since for Baudrillard the age of simulation means that everything is already dead and resuscitated, the museum is everywhere, the fourth dimension, as it were, of life (BS 19). It is the visibility of the past, violated by a society without secrets and possessed by an irreparable violence toward all secrets (BS 23). This very visibility of history, resuscitated in the hyperreality of the cinema and the photo, is the extinction of its mythic energy, its irreversible secularization (BS 76). These questions—the secularization of the past through technical reproduction, but also the museum as the resurrection of the dead—will occupy us in the following section.

BEYOND PROGRESS: THE MUSEUM AND MONTAGE

Habermas sees historicism as the Janus-faced legacy of the Enlightenment. It defines the conditions of modern identity and offers at the same time the possibility of flight from the present into borrowed costumes. In both senses it reflects the problematic of modernity. The idea of progress and historicism are the two faces of the nineteenth century. We could call historicism the decadence of progress. Retrospectively, however, progress and decadence appear as complementary interpretations which meet in the indifference which signifies the end of the modern age. This is the crisis, emphatically underlined by the outbreak of the war in 1914, which is registered in various forms: for Spengler and Adorno as the end of Europe's time, of the time of music. But it is also for Lukács and for Ernst Bloch, and here precisely in the form of a philosophy of music (*Geist der Utopie*), the dawn, the advent of a new chiliastic time. At the border between the old and the new, between ends and beginnings, the end of a world announces itself in contradictory constellations. When we turn to painting and music, we see in the eruption of primitivism— Picasso's African masks and Stravinsky's *Rite of Spring*—the signal of the break, which opens up a new relation between the old and the new beyond tradition. It prompts Hans-Georg Gadamer to the following reflection:

The art precisely of our century has shown us how a changing world can liberate new possibilities of form and how in particular the general bringing closer of all distances expresses itself in new productive possi-

bilities. What would artists such as Giacometti or Henry Moore or Bissier be without such new stimuli, and what would our music be without the challenge of the exotic impact of rhythm on our musical sensibility. Where the limits of language create barriers the situation is not so evident. There can be no doubt, however, that here too as everywhere the break in tradition, accomplished in our century, has blocked off the false historicising escape routes of our grandfathers and opened our ears to the voices of remote traditions.

It could be argued that this was always the case. . . . It is nevertheless a new situation. Formerly it was the inheritance of a single culture, its religion, philosophical and artistic tradition, into which the foreign was assimilated as the new which was yet like the old—with the same self-evidence as that which allowed Altdorfer, for instance, to represent Persians and Macedonians in his Battle of Alexander in the costume of the German Renaissance.

Such a power of assimilation, such self-evident subsumption of the old under the new, of the new under the old, exists nowhere any longer, not in our little Europe, not in the great Europe of today's world civilization. The world in motion challenges all closed historical traditions and confronts them with the question of self-identity.[20]

The art of our century articulates the new historical consciousness which follows from the collapse of the defining and confining structures of a single culture, prepared of course within the confines of the culture of "Faustian" transition by the tradition of the modern since the sixteenth century, since the Enlightenment. The new historical consciousness of our century transforms historicism into what Agnes Heller has called radical cultural hermeneutics, and for which, following Malraux in his *Museum without Walls,* I propose the term Museum.[21] The museum without walls is the radical cultural legacy of the Enlightenment which universalizes historicism and defines the conditions of the identity of postmodern art. The Museum is the product of progress. That is to say, the legacy of the exhaustion, the self-destruction, of the idea of progress is the emancipation of the past. The temporal hierarchy of modern art (progress/decadence) issues into the simultaneity and presence of the museum without walls. In this sense we can say that the end of progress (the grand narrative of history) is also the end of the future, which brings the past

increasingly into focus. Beyond tradition the arts enter into a continuum of past and present, in which a universal historicism responds to the situation of contingency (the loss of the "pre-given" of tradition), for which everything can be potentially material and model, irritation and inspiration.

The museum without walls thus expresses a new relation of the old and the new, under the organizing hierarchy no longer of progress but of historicity. It involves a transposition and reversal of signs, a revision of perspectives which take us from the hypertrophy and atrophy of the *present*—the fetish of the contemporary—to the complex simultaneity of *presence,* whose paradoxical "progressive" formulation is the synchrony of the nonsynchronous. In postmodern art, however, the synchrony of the nonsynchronous—which so disturbed Adorno in Stravinsky's music that he could account for it only negatively, as the absence of developmental logic, as a succession of inauthentic masks, as schizophrenic dissociation, as time travel—can be considered the Alexandrian world of quotation only as long as we think in terms of a "progress" which lives from tradition, and identify present art as the parodistic parasite of the past, the product of "organic" dissolution.

The verdict of decadence, however, not only fails to escape the paradigm of progress, it fails above all to recognize the new, more complex level of the self-reflection and the self-problematization of identity which characterizes the art of our century, which in turn has called forth the charge of arbitrary eclecticism and linguistic chaos. Both charges fail to recognize or, rather, confront the fact that neither producers nor recipients can situate themselves in any *one* historical tradition, let alone any single functionally differentiated sphere. The "linguistic plurality," which is perceived as "linguistic chaos," is rather to be seen in the light of a universalized historicism as the complement of the open, indeterminate possibilities of the system of the arts and a corresponding expansion and differentiation of the past, whose necessary corollary is the task of selection: the task of self-definition effected by the respecification and recombination of materials and codes.[22] W. H. Auden defines clearly the consequences for the artist of the Museum, that is, the "consciousness of the whole of the past as present":

Further, the fact that we now have at our disposal the art of all ages and cultures has completely changed the meaning of the word tradition. It no longer means a way of working handed down from one generation to the next; a sense of tradition now means a consciousness of the whole of the past as present, yet at the same time as a structured whole the parts of which are related in terms of before and after. Originality no longer means a slight modification in the style of one's immediate predecessors; it means a capacity to find in any work of any date or place a clue to finding one's authentic voice. The burden of choice and selection is put squarely upon the shoulders of each individual poet and it is a heavy one.[23]

The burden of options applies no less to the recipient, and it is of course the consequence of the emancipation of the individual.

Not only production but also reception is emancipated from tradition. We must all construct our own individual contingent "traditions" from the Museum in the form of a montage of juxtaposed preferences which combines the nearest and the most distant. We recall here Constant Lambert's pejorative but prescient observation of 1934 that modern taste is represented far more by the "typical post-war room, in which an Adam mantelpiece is covered with negro masks" than by the austerities of Le Corbusier. Aztec sculpture, Balinese music, Polynesian masks, Japanese theater, and so on coexist in a continuum with postmodern art.

All this was prepared by historicism, the first *self*-comprehension of the specificity, the identity of a culture, whose complement was the recognition of the immanent developmental logic of autonomous, differentiated spheres. The emergence of historicism and of autonomous spheres marked the point of the highest fusion of organic time and the developmental time of progress, of the synthesis of *self*-differentiation on the threshold of modernity, whose outcome is the decentered relationism of fully differentiated functional society. The nexus between historicism and the differentiation of art as an autonomous sphere, which leads to the transformation of the museum (tradition) into the museum without walls, is Malraux's starting point. Up to the nineteenth century the work of art was essentially a representation of something, real or imaginary. Only in the artist's eyes was painting

specifically painting (MW10). The self-reference of art—what Malraux calls rendering and execution—can emerge only when painting has become *a* supreme value in the vacuum left by the disappearance of the supreme value of society (MW66). With the loss of a patron class and a public, painting abandons the fiction of three-dimensional *illusion*—the conception of painting as narrative—and turns to two-dimensional color (MW36, 46). Autonomous art found its cathedrals in the museum, and as the museum expanded, the non-European arts revealed to artists their freedom (MW71). The walls of the museum fall. European art is no longer the whole history of art, and the way to the resurrection of the past is open.

For Adorno the new in art remained an unquestioned, if tragic, value which annihilated the past. The one crucial criterion was the dialectic of the age and the work. It was the irreversibility of this dialectic which lent necessity and dignity to the work, even if it only mirrored the progress of art to unfreedom. However problematic the new, the real paradox from the standpoint of progress resided in the old: how could the art of the past survive the ravages of time. This was the question *progress* posed and could not answer, as Marx's famous Homer conundrum testifies.[24] Marx's answer—the presumably eternal appeal of departed conditions, the youth of Greek culture—hardly satisfies. The conundrum remains caught in the ambivalence of the interfering perspectives of progress and historicism. It is here that we can situate Benjamin's "Theses on Philosophy of History," for *his* version of historical materialism is defined by the rejection of both legacies of the nineteenth century, progress and historicism. But at the same time we must resituate Benjamin's "Theses" in relation to the museum without walls, for the Museum alone cancels the irreversibility of time in the synchrony, the presence of the contemporaneous. This presence can be seen as the *secular* meaning of Benjamin's messianic "Jetztzeit": the revolutionary re-volution of time which redeems the past. In his third thesis Benjamin writes: "Of course only a redeemed humanity gains full possession of its past. That is to say: only for a redeemed humanity is its past in each of its moments citable. Each of its lived moments becomes a *citation a l'ordre du jour,* which day is precisely—the last."[25]

We wait in vain for the messianic-revolutionary redemption of mankind, however. Past suffering cannot be redeemed, but mankind's past *is* citable in the "lived moments" of its art. Moreover, it is a past which cannot be touched by Benjamin's storm of progress which piles ruins on ruins (thesis 9), because it is not the past of the past but our past, our creation. That is to say, the Museum is the true legacy of the convergence of progress and historicism, which has emancipated the past and brought it close to us. Above all this past cannot be touched because it is the antithesis to the "homogeneous and empty time," which Benjamin identified as the common denominator of all the conceptions of mankind's (endless) progress. If the art of the past is present as presence, that is, citable, it is because it contains the filled time of "Jetztzeit" emancipated from the continuum of history. The Museum is thus the repository of all the times of the past which speak to us across time. Benjamin's concept of a present, which is not transition but the standstill of time in a constellation imbued with tensions and crystallized by shock into a monad (theses 16, 17), can therefore be reconceptualized as the "Jetztzeit" latent in the work of art which is actualized by the shock of reception. "*Mona Lisa* is of her time, and outside of time. Our reaction to her is not on the level of knowledge but of *presence*" (MW233).

In the face of the fragmented—differentiated and mutually indifferent—times of functional society, the aesthetic experience of filled time—and here we could define aesthetic experience as fulfilled time—becomes more significant than ever. It is the presence of the past which now, beyond progress, conquers time and answers Marx's conundrum. The works of art of the past are "timeless" because they are filled with time, with the time of their culture. The discovery of the past was the achievement of the modern age. It was subsumed, however, under the progressive perspective of universal history. From a postmodern perspective this universal history can also be grasped as the universality of an emerging world tradition, which also calls into being the balance of the old world against the new, the horizon of the past against the horizon of the future. The past becomes the cultural counterweight to a progress which unfolds the hubris of the domination of nature. The new sense of solidarity with human culture in all

its particularistic manifestations is now more than ever the pro-
test of a living past against the dead hand of progress and the
homogeneity of a world civilization which destroys the particu-
lar. With the end of progress the other of the contemporary world
has become the past and not a future endlessly deferred by the
progress of modernity. After the end of tradition we live from the
emancipated past. As Malraux puts it, we live in a world "in
which each masterpiece is supported by the testimony of all
others, and becomes a masterpiece of a universal art whose val-
ues, still unknown, are even now being created from the as-
semblage of all its works" (MW231).

The emancipation of the past signifies, however, that our "tra-
dition" stands outside tradition. The result is a historical con-
sciousness, a dialectic of the old and the new, more complex than
that of the modern age, for the condition of the emancipation *of*
the past is our emancipation *from* the past. This is the double
meaning of the explosion of progress effected by the avant-garde
movements. The effects of the explosion—the acceleration and
inflation of the new—were long mistaken for progress. The shock
of the new, caused by the radical rupture of the breakout from
tradition (the museum of the one culture), was transformed into
the ideology of avant-gardism: the celebration of the new for its
own sake, whose outcome was the symbiosis of art and fashion
which reduced the most advanced to the eternal return of the new.
Just as progress culminated in the revolt of the avant-garde in the
name of progress against the self-consuming progressive differen-
tiation of aesthetic rationality in bourgeois art, so in turn the
fetishization of the new in avant-gardism—this last shock wave
of the explosion—led to the hypertrophy and emptying out of the
contemporary moment, the moving point of the new. Avant-
gardism's abstract cult of innovation provoked in its turn the
critical reflections of "postmodernism" on the progressive spirit
of "modernism." Only the collapse of the pathos of the contem-
porary brought to full, belated consciousness the explosion of
progress and led the way to the "postmodernist" reaction and
behind "postmodernism" to the recognition of the secular rup-
ture, the new time of postmodern art.

It is this *new time* which Benjamin sought to articulate in
contradictory fashion in *The Work of Art in the Age of Mechan-*

ical Reproduction and in his "Theses on Philosophy of History."
For Adorno no less than for Lukács the new time is schizophrenic
and dissociated; for Ernst Bloch it is the synchrony of the non-
synchronous; with Benjamin it manifests itself in the unrecon-
ciled ambivalence of nihilistic progress and messianic restoration,
emancipation from the past and emancipation of the past. That
the two belong together is what we must disengage from Ben-
jamin's opposed theses. Benjamin proposes two contradictory
versions of the emancipation of the past: secularization and re-
demption. In *The Work of Art* the argument is this: technical
reproduction destroys the unique aura of the art of the past by
alienating the reproduced from its context, by breaking it free
from the matrix of tradition. Reproduction thus emancipates for
the first time in world history the work of art from its parasitic
existence in and as ritual, whose final expression was the theology
of art for art's sake. In this progression from depth to surface the
whole function of art is revolutionized. The liberation of the art
of the past from the alienating function of magic and religious
representation (cultic value) and aesthetic self-representation (au-
thenticity) frees art for its new function. Mass reproduction to-
gether with the new techniques of reproduction in the film de-
stroy the distancing aura of cult and bring art close to the masses.
Against this secularization stands, as we have seen, the contrary
redemption of the past in the "Theses on Philosophy of History."
The destruction of aura is reversed into the redemption of aura
through the act of revolutionary reception which constitutes the
nunc stans of "Jetztzeit." This reversal (and our comparison) is
possible only because the *one* avant-garde operation of *montage*
underlies both constructions: the breaking of the monadic con-
stellation—the work of art but equally a specific epoch, work, or
life (thesis 17)—out of the homogeneous course of history.

In order to go beyond the contradictions of Benjamin's eman-
cipation of the past we must redeem his secularization of aura and
secularize his redemption of the past. The only redemption of the
past which is possible is the presence of the past in the museum
without walls, and the means of this redemption of the past is
technical reproduction. In this sense Malraux's *Musée imaginaire*
is the answer to Benjamin's version of the secular transmutation
of the work of art in the age of reproduction, just as "Jetztzeit" is

the messianic version of Malraux's Museum. The reconciliation of the contradiction requires, however, that we distinguish clearly between the effects of technical reproduction. Benjamin's uncritical faith in the politically emancipatory powers of technology in "The Work of Art"—Brecht's influence in particular is unmistakable here—is a simplistically "revolutionary" response to the end of the age of print and the revolutionary impact of the media age. Against Benjamin's argument technical reproduction is on the one hand the medium of the contemporaneous, the time and space travel which brings the distant near; on the other hand it is also the medium of the contemporary manufactured by the culture industry. For Benjamin the destruction of aura was the signature of a new perception, whose "sense for the similar in the world" imposes itself on the unique. But this sense of the similar (the "scientific" perspective of Brecht's method of estrangement) is also the Midas hand of the culture industry, which "magically" alienates the world into exchange value. The emblem of this alienation is the image. The image, whose manifest, "obscene" function is the enchantment of mass production, is the aura of the culture industry, the signature not of the unique but of the eternally same, which imprisons art in the vanishing moment of the contemporary, in the timeless present of repetition. It is this which paradoxically but necessarily makes technical reproduction also the medium of the redemption of the past.

In Auden's words, "the fact that we now have at our disposal the art of all ages and cultures" presupposes the qualitatively new situation of the manifold possibilities of technical reproduction. They are the precondition for what Gadamer calls the general bringing nearer of all distances. And so just as we must reverse Benjamin's "progressive" thesis, so we must reverse his definition of aura. Instead of the "unique appearance of distance, however near" of the traditional work of art, which is destroyed by reproduction, aura in the age of technical reproduction is the *unique appearance of nearness, however distant,* manifested in the presence of the Museum. Through technical reproduction William Byrd is as much our contemporary as Luciano Berio or Boulez, and Beethoven is more our contemporary than he was for the Vienna of his time. The wall paintings of Lascaux stand side by side with Michelangelo's *Last Judgement* and twentieth-century

Mexican murals. Now that the imaginary of the future fails us and the utopia of possible worlds has turned into dystopian visions of horror, the art of the past increasingly becomes the only dimension of time available to us to escape the prison of the present. To quote Auden again: "the wonderful, the other nice thing about the arts, the invaluable thing about them, is that they are almost the only means we have of breaking bread with the dead. That is to say, all right, Homer is gone, his society is gone, but you could still read the Iliad and get a lot from it. And I do. I personally think that, without communication with the dead, we'd be entirely enclosed in the present, and that is not a fully human life."[26]

The museum without walls has replaced the museum of a single culture. It is the move from the European to a world tradition which has brought with it an enormous expansion of horizons and a corresponding openness and indeterminacy of the boundaries of the system of art. The museum without walls is the correlate of our tradition without walls, brought into being by the emancipation from the past which is at the same time the emancipation of the past. From this explosion of progress—the end of the European tradition—postmodern art emerges in all the contingency of its freedom, which confronts it and us as the burden of options. Adorno's desperate opposition of Schoenberg and Stravinsky only confirms that the new music seeks in vain to restitute identity (appearance, authenticity). Adorno's self-defeating endeavor to restore the boundaries of identity ends in the paradoxicality of endless negativity. It is "dialectics' finale," which opens up the problematic of the postmodern beyond the vanishing point of the death of art. Beyond lies the "profane illumination" of past and present. The Janus-face of our historicism is that of an identity, which is not the indifference of nihilism (progress) but the difference of our tradition beyond tradition and progress.

This difference emerges sharply in the contradictions of Benjamin's "historical materialism," but it also underlies Malraux's resurrection of the past, for the standpoint of both is the new standpoint of relativity, of estrangement, whose instrument is technical reproduction. Just as for Benjamin the photograph contains virtually the film, so too Malraux's vision is that of the film age. What this means is that space and time travel, in all the forms

made available by technical reproduction, brings about a *twofold estrangement* of the unifying perspective of tradition, of the hierarchizing vision of a single culture. This twofold estrangement we may call the Museum and montage. The space and time travel of the museum, the general bringing nearer of the most distant, is dependent on technical reproduction. Technical reproduction, however, is not simply the medium of the Museum, it is itself the instrument of a qualitative change of perception through its sovereignty over time and space. Perception is differentiated and relativized through the expansion and contraction of space and time, the alteration of relations and dimensions made possible by photographic enlargement and the changing speeds, focuses, and positions of the camera (slow motion, the close up, longshots, perspectives from all angles, and so on). The techniques of cutting, the assembly of sequences in the film mark the end, as Brecht and Benjamin saw, of the unitary perspective of the camera obscura, the box-frame of *illusion* in drama and painting, and inaugurate the multiperspectivism of montage.[27]

The estrangement of perception is one with the estrangement of the object reproduced. Benjamin, however, interpreted this emancipation of the work of art too reductively. It is for this reason that I turned to "Theses on Philosophy of History" not only to redress the balance but also to reinterpret both "The Work of Art" and the "Theses." We no more need to see the secularization of art as the destruction of aura any more than we need deny that the redemption of the past, of which Benjamin dreamed, remains quotation and not identity. If the fruit of historical comprehension of Benjamin's historical materialist carries the seed of time within it (thesis 17), then the secularization of art effected by technical reproduction can also be understood as the emancipation of aura. The estrangement, which transforms the use value of all closed cultures into the exchange value of "art"—the context-free material of our "tradition"—releases in the process its surplus value from its original bonding: aura as the seed of time. Malraux grasped the implications of this epochal secularization far more profoundly than Benjamin. Technical reproduction enables us not only to gather together the art of different cultures, it permits us to analyze and compare whole corpuses of art (MW79). Just as time-lapse photography animates the growth

of a plant, so the reproduction of a whole corpus of art animates style (MW160). Reproduction is thus one of the most effective tools of the intellectualization and enlightenment of art which reveals a style in its entirety (MW80). As a consequence all European art becomes one style compared with non-European art: "The past of art, which to Europe had been only the past of one style termed art, appears to us as a world of styles" (MW182). Not until the twentieth century did we discover that style is the resurrected expression of other cultures: now "we think of every great style as the symbol of a fundamental relationship between man and the universe, of a civilisation with the value it holds supreme" (MW162).

Nevertheless, Malraux's resurrection is possible only as secularization. The gods we resurrect are no longer divine, all that is *sacred* has been metamorphosed into *art* (MW180). We can admire the amazingly different heritage of the world's cultures only because we have transformed them into art. Picasso did not see African masks with the same eyes as those for whom they were intended (MW208–209). Picasso's use of African masks in *Les Demoiselles d'Avignon* can now be seen as *the* symbolic act of montage which opens the museum of world art. The Museum and montage are thus the twin aspects of the end of tradition: the emancipation of art from its organic context. The new time of montage is reflected in the grandiose montage of the art of all times *and* all the times of art in the presence of the Museum.

All this, we may say, is contained in the fundamental configuration of Benjamin's thought in *The Origin of German Tragic Drama*, in "The Work of Art," and in the "Theses on Philosophy of History." Whether allegory, destruction of aura, or redemption of the past, the one fundamental idea returns as the ambivalence of secularization and redemption: *only that which is dead can be resurrected*. This is Benjamin's theological version of the Museum and montage. The time between original sin and redemption is the realm of fallen nature. All history is the natural history of transience and decadence. It is thus the realm of dead matter, of reification, of material as "material." And this in turn points to the esoteric meaning of Adorno's and Lukács's historical materialism, of their tragedy of modern art, which finds its crystallization in *Doctor Faustus*. Through his reading of Benjamin's *Origin*

of German Tragic Drama, Thomas Mann can unfold in the figure of Adrian Leverkühn the "satanic sphere" of advanced music. The satanic sphere is for Benjamin the parodistic synthesis of the poles of the purely material and the absolutely intellectual, which mimic the authenticity of life. This is the temptation of the Devil, the temptation of knowledge, the beckoning illusion of infinity in the bottomless abyss of evil, which opens an unending progress into the depths.[28] This unending progress, Benjamin's "theology of evil," becomes Thomas Mann's interpretation of what we can only call the theology of the material in *Philosophy of Modern Music.* Lukács's infinite process of bourgeois science and Adorno's dialectic of enlightenment are the "progressive" formulations of the Fall, which is Benjamin's (timeless) origin, genesis. In *Philosophy of Modern Music* the laws of motion of the musical material bring about the second Fall: the rationalization of the material into reified "material."

We have now reached the point at which we can go back to the beginning. *Philosophy of Modern Music* begins with a quotation from *The Origin of German Tragic Drama:* " 'Philosophical history viewed as the science of origins is that process which, from opposing extremes, and from the apparent excesses of development, permits the emergence of the configuration of the idea as a totality characterized by the possibility of a meaningful juxtaposition of such antitheses inherent in these opposing extremes.' "

To Benjamin's configuration of the idea Adorno opposes the construction of the idea because the history of the new music no longer tolerates the meaningful juxtaposition of the contraries. From this opposition flows Adorno's construction of progress, of the progress of music after the end of music, of art after the end of art. Adorno is thus the death mask of the modern paradigm, Benjamin the Janus-face of the postmodern paradigm. And this brings us to the most difficult question of all. Adorno held fast to the Devil of unending progress because he feared the Devil of endless possibilities, the transformation of the *time* of progress into the *space* of simultaneous possibilities, the *meaningless* juxtaposition of the contraries. It is the question of the paradigmatic work, even if it is possible for Adorno only as its own negation. This negation, however, is precisely the death mask of the modern paradigm—endless progress as the endless deferment of *Waiting*

for Godot. The only way we can break out is by accepting the paradigm break, which transmutes this bad infinity into the indeterminacy of the emancipated system of art. Benjamin's totality as the configuration of the idea is no longer meaningful or meaningless per se, it has become the indeterminate juxtaposition of the contraries, the realm neither of necessity nor redemption but of contingency.

The question of the paradigmatic work is a question of the paradigm. The paradigmatic work is the replication, the microcosmic expression of the paradigm, which excludes most actual works to concentrate on the representative work, which is the highest realization of the idea of the paradigm. Thus for the modern paradigm the normative work is for Adorno the organic-teleological work, which gives form to dynamic time. The teleological work is an organic totality because it articulates and masters the telos of progress. It contains the true dialectic of the totality: "If Beethoven developed musical essence out of nothingness in order to be able to define it as a process of becoming, then Schoenberg in his later works destroys it as something completed" (MM77). The modern paradigm is grounded in the subject; its values are expression, creativity, subjectivity, originality; its form is the inner form of the unfolding of essence in time: the self-differentiation of identity realized through the dialectic of subject and object, freedom and necessity, form and content. Microcosm and macrocosm correspond in the self-realization of the subject as humanity and of humanity as subject. The microcosm is the *totality given form:* the definition of identity and the self-definition of the paradigm.

In what sense can we speak of self-definition, of the paradigmatic work in relation to the indeterminate boundaries of postmodern art? The answer is logical—here too the microcosm reflects the macrocosm—and paradoxical, for we have to think of the possible and the paradigmatic together, that is to say, the indeterminate system demands an indeterminate number of possible paradigmatic works. A paradigm grounded in difference can have no one exemplary and hierarchizing norm of self-definition. Instead of the concrete dialectic of form and content of the modern paradigm we move to the more abstract level of the relation of relations both as self- and system-reference, the self-consciousness,

that is, of the work as a "possible world." It presupposes the arbitrary relation of sign and signified, the contingent relations of form and content (whether this finds open or closed expression). Where originality once meant inner substance, the self-differentiation of the origin, originality now means something completely different, namely, difference: the awareness and exploration of alternative possibilities. What is important here is not so much the endless range of possibilities as this consciousness of difference. It is the break with the organic work as self-expression and its replacement by a concept of the work not as necessity but virtuality—and of course all methods of strict organization only confirm this, for they define the rules of the game, delimit the possibilities of permutation and combination.

Just as the privileging of individuality and creativity in the organic work excluded the conception of the work as experiment and construction (montage), so the identity based on temporal hierarchization precluded the mixture of past and present styles (the Museum). Leonard Meyer, in *Music, the Arts and Ideas,* has expressed the consequences of this paradigm change: in place of the unique organic work we now conceive of the work as an objective construction, whose creativity pertains to the organization of the materials. Creativity (originality) has become a species of problem solving for which any style or combination of styles can constitute the basis of construction. Form and technique have thus taken the place of inspiration and self-expression (MA188). Correspondingly, the primacy of materials and forms tends to subsume ends under means, so that content and material converge in aesthetic self-representation (MA214). This move to formalism is reinforced by the pluralism of taste because formalism is itself inherently relativistic and pluralistic (MA232), since it operates with the awareness of the possibility and validity of alternative selections and solutions.

The plurality of styles and tendencies as the presence of alternatives, as the simultaneous exploration of differing possibilities so characteristic of the situation of the arts in this century, cannot be grasped progressively; it lies beyond progress. Here too we can follow Meyer, who has sought to clarify the consequences for the arts of the "demise of the idea of Progress" (MA146). His thesis is this: "the paradigm of style history and cultural change which has

dominated Western thought since the seventeenth century does not seem able to illuminate or make understandable the situation in the arts today." If we accept that the present pluralism of coexisting styles "represents not an anomalous, transient state of affairs, but a relatively stable and enduring one," then our understanding of the present age as a time of crisis is a misunderstanding (MA171–72). Meyer argues instead that art since the First World War has brought to an end the preceding five hundred years of ordered sequential change. We have entered "a period of stylistic stasis, a period characterized not by the linear, cumulative development of a single fundamental style, but the coexistence of a multiplicity of quite different styles in a fluctuating and dynamic steady-state" (MA98). The end of the idea of progress is thus a new *secularization,* which brings with it the realization of the artificial nature of style. As a result "the past, whether recent or remote, has become as available as the present" (MA149). "Past and Present are chronologically separate but epistemologically equal" (MA151). Hence the fluctuating steady state of the arts since 1914, in which all styles continue to coexist (as opposed to the illusory temporal sequence of modernism and postmodernism) and the repertory of available styles grows to include earlier Western art and the art of non-Western civilizations. Artists may work in one style or shift from style to style (MA173–74). The pluralism of styles reflects the pluralization of reception and taste, the loss of a cohesive audience for serious art, music, and literature since 1914. Meyers does not lament the loss of stylistic consensus, since he regards unity of style as incompatible with the values, freedom, and world scope of our culture. Moreover, technical reproduction and communication have made pluralism inescapable (MA175–79).

If this situation of postmodern art is "normal" and not one of crisis, if the "norm" is the fluctuations of the steady state, which allows space for awareness of the latency of alternatives in any given structure or selection, what consequences does this have in turn for aesthetic theory? What replaces the ahistorical prescriptive classification of traditional society, the historical-normative aesthetics of the modern age? To attempt an answer to this question requires, I believe, that we put it in the wider historical context of the dialectic of art and enlightenment since the first critical turn of modernity.

The dialectic of art and enlightenment has been the guiding interest of my inquiry. It is the critical question which arises on the threshold of modernity from the recognition that the art of the past is both complete and completed. The emergence of philosophical aesthetics from the *querelle des anciens et modernes* signaled a new stage in the historical self-reflection of modern art, in which the question of the enlightenment of art and thus of the relationship between art and philosophy becomes a question for both art and philosophy. The opposed answers given by the Jena romantics and Hegel mark this turning point of aesthetic modernity. It leads Hegel, as we have seen, to a posthistorical closing of accounts. The enlightenment which dissolves art from within points beyond itself to the philosophical enlightenment of art. The end of art is the retrospective truth of Hegel's historical-systematic aesthetics. The recognition that enlightenment is indeed destructive of all completed forms of literature leads the Jena romantics by contrast to open the account of critical modernity. When Friedrich Schlegel observes, "Other kinds of poetry are finished and are now capable of being fully analysed" (Athenaeum fragment 116), he anticipates the historical verdict of Hegel and at the same time grasps the critical supersession of the poetry of the past as the condition of the birth of modern literature from the spirit of criticism. From this turning point Hegel looks back to announce the sublation of art in philosophy; Schlegel, forward to herald the sublation of philosophy in a "progressive universal poetry" raised to the higher power of critical self-illumination. The brief moment of Jena romanticism can thus be seen as inaugurating critical modernity, as the French philosophers Philippe Lacoue-Labarthe and Jean-Luc Nancy argue in their study of the theory of literature in German romanticism: "romanticism is first of all a *theory*. And the invention of literature. More precisely, it constitutes the inaugural moment of literature as *production of its own theory*—and of theory that thinks itself as literature. With this gesture, it opens the critical age to which we still belong."[29]

The question of aesthetic theory after Adorno has prompted on the one hand, as with Bürger, a return to Hegel's diagnosis of the (post)historical situation of art in (post)modernity and on the

other, as with Lacoue-Labarthe and Nancy, the return—via Benjamin's study of the concept of criticism in German romanticism—to the romantic model of the dialectic of art and enlightenment.[30] In this model the critical identity of modern literature derives from the irresolvable tension between the idea of art (the literary absolute) and the inescapable incompletion of the fragmentary work. It thus involves its own infinite questioning, and the form this perpetual positing takes is that of the question endlessly deferred.[31] The romantic "invention" of literature is therefore particularly relevant to the situation of the arts as a whole after the crisis and disintegration of tradition at the beginning of this century.

The question of postmodern art is once more the question of the relation of art and philosophy—a second enlightenment of art, which can be read in the light of the first as either the philosophical disenfranchisement of art or as the philosophical self-enfranchisement of art. In speaking of philosophical disenfranchisement I am taking up Arthur C. Danto's formulation, which he applies to twentieth-century art. For Danto the "terminal fermentation" of twentieth-century art vindicates Hegel. His argument, however, can be read with equal or greater justification as vindicating Schlegel.

Danto's starting point is the collapse in the first decade of this century of what he calls the progressive model of art history, most clearly evident in painting and sculpture.[32] Since then art has been characterized by a history of discontinuities in which each new movement supposes some kind of theoretical understanding. Driven by the urgency of the question What is art? following the collapse of the received model, each movement poses the question in the form of a possible final answer (PD108–109). It leads Danto to propose, "the wild effervescence of the artworld in the past seven or eight decades has been a terminal fermentation of something the historical chemistry of which remains to be understood. I want to take Hegel quite seriously, and to sketch out a model of the history of art in which something like it may even be said to make sense" (PD85).

From this Hegelian perspective it seems to Danto as if the whole point of art in our century revolves around the question of its own identity (PD110). That is, Hegel's theory of the progres-

sion by which art comes to self-knowledge serves as the key to this terminal fermentation. Art "depends more and more upon theory for its existence as art," but by the same token art objects approach zero as their theory approaches infinity (PDIII). Art today thus approaches the absolute knowledge which signified for Hegel the end of history, "for the object in which the artwork consists is so irradiated by theoretical consciousness that the division between subject and object is all but overcome, and it little matters whether art is philosophy in action or philosophy is art in thought" (PDI12).

The crisis of tradition—the collapse of the progressive paradigm of art history—opens for Danto the posthistorical stage of art: "The historical stage of art is done with when it is known what art is and means. The artists have made the way open for philosophy" (PDIII). Once the question of the philosophical nature of art has been posed from within art—Danto's key example here is Duchamp's ready-mades—art has become philosophy: it has "discharged its spiritual mission by revealing the philosophical essence at its heart" (PDI6). Once recognition has become its own object "the further evolution of art could henceforth take place only on the level of philosophy" (PD206). This evolution, however, can only be posthistorical in an artworld which has lost all historical direction, and where change without development amounts only to the recombining of known forms. The outcome is a kind of cultural entropy, since "whatever comes next will not matter because the concept of art is internally exhausted" (PD84). Danto's conclusion is the following: "We have entered a period of art so absolute in its freedoms that art seems but a name for an infinite play with its own concept. . . . Artmaking is its own end in both senses of the term: the end of art is the end of art. There is no further place to go. . . . Having reached this point, where art can be anything at all, art has exhausted its conceptual mission. It has brought us to a stage of thought *outside* history, where at last we can contemplate the possibility of a universal definition of art" (PD209).

"The end of art is the end of art," Danto asserts in ambiguous fashion. On the one hand, it vindicates Hegel. Danto envisages the possibility of a posthistorical definition of art which will be the ultimate philosophical completion and disenfranchisement of

art. On the other hand, the Hegelian frame of Danto also contains the romantic project of the philosophical self-enfranchisement of art. If Danto returns to Hegel, what he describes—the mutual sublation of art and philosophy in twentieth-century art (PD112), the disappearance of the boundaries separating art and criticism (PD209)—can equally well be read as the extension of the romantic model of literature to painting and sculpture.

Danto's interpretation of the condition of postmodern art serves to remind us that Hegel's conclusions remain the point of departure for aesthetic theory today. More important, the ambiguity of his reading indicates that the Hegelian death of art in modernity and the critical age of modernity, inaugurated by German romanticism, constitute the two perspectives of post-traditional or emancipated art which must be thought together, not least because Hegel's prognosis and Adorno's diagnosis of the end of art propose an inherently ambiguous terminus. The death of art is both a theoretical *conclusion,* constantly renewed, and at the same time the historical *epoch* of the death or decline of art, characterized, as Vattimo puts it, by the "persistent life of art and its products" (EM58). This apparently "endless" disjunction between the death of art and its persistent life suggests that emancipated art lives from its own death, just as aesthetic theory lives from the death of metaphysics. Endless reflection on the end of tradition is thus the critical condition of aesthetic modernity.

I do not think that we can escape the ambiguity of this Hegelian legacy, since it haunts even the most decided advocates of the death of art and returns in the very notion of postmodernity. I think, however, that it can be accounted for more adequately in terms of a paradigm change, which expressly thematizes the end of tradition as the break which brings about the transition from a determinate to an indeterminate system of art (the arts). This paradigm change transforms the terminal dialectic of art and enlightenment, in which philosophical aesthetics completes the history of art, into an open-ended dialectic in which the conclusions of theory constitute the "critical identity" of artistic practice.

The very finality of the dialectic of enlightenment, proclaimed by Adorno and Baudrillard, is its own undoing. The vanishing point of progress is equally the vanishing point of theory. The

enlightenment, which becomes transparent to itself by uncovering its own latency, discovers this transparency to be nihilism. What this "endgame" of enlightenment leaves behind is not only the suicide of authentic art, exercising the magic of its disappearance, but also the endless paradoxes of Adorno's negative aesthetics, or what Baudrillard has described as the position of objective irony—the vanishing point of discourse itself, which discloses the catastrophe of that which has already disappeared: "This ambiguity probably remains throughout the text at every point. One is compelled to produce *meaning* in the text, and one produces this meaning *as if* it arises from the system (even if in fact the system lacks meaning) in order precisely to play that meaning against the system itself as one reaches the end. So there is a position here . . . which I would describe as that of *objective irony.*"[33]

If, ironically, it seems as though we have arrived back at Hegel's analysis of romantic irony as "infinite absolute negativity," this is not by chance: the vanishing point of Hegel's account of the self-dissolution of art is precisely the romantic "invention" of literature. In other words, Baudrillard's "objective irony," which appears "as one reaches the end" describes the "enlightened" system of art which has become transparent to itself. This is the question for art since Hegel's prognosis, the question which the explosion in this century of the traditional limits of the aesthetic has rendered acute. The answer of philosophical aesthetics, as we have seen, is the "completion" of the death of art, which is at the same time a deferment which endlessly prolongs the end of progress and of art.

Baudrillard's "objective irony" is thus the nihilistic version of the profane illumination which reveals the critical condition of the arts since the end of tradition. To it corresponds the constitutively ambiguous status of the work of art (Vattimo), art's infinite play with its own concept (Danto), even Adorno's desperate dialectic of contradictions. In other words, what is terminal for theory becomes the ground, the condition of emancipated art beyond the aporias of progress. The progressive enlightenment, that is, exhaustion, of the latency of tradition (the time of progress, the modern paradigm of progressive art history) issues into the indeterminate system of art, in which the recognition of

contingency becomes the a priori of the critical identity of the work, just as the indeterminacy of the system renews latency by opening up the space of alternatives.

The explosion of aesthetic limits signifies not the death of art but, on the contrary, the incorporation of its own death in the form of self-negation. It is this which makes the system of enlightened art indeterminate, since the function of latency in a determinate system—in other words, the latent function of tradition—is to exclude all alternatives which call the system into question. And it is for this reason that literature both prefigures and points beyond the "death of art," because it alone of the arts always carried within itself, within tradition, its own (contained) self-negation in the form of parody and irony.

Thus just as the invention of modern literature from the negativities of romantic irony can be seen as the answer at the first critical turn of modernity to Hegel's philosophical disenfranchisement of art, so the constitutively ambiguous status of art since the second critical turn of aesthetic modernity can be interpreted not only as the reflection of the renewed verdict of the death of art but also as the self-reflection which is the answer to this verdict. The enlightened system of art, fully conscious of its free (unbound) and contingent condition, constitutes and exemplifies the *one* epoch of the death of art and of critical modernity. Postmodern art lives its "death" by incorporating the "death of art"—the explosion of the traditional limits of the aesthetic—through the critical reflection of its indeterminate and henceforth ambiguous status. This dialectic of disappearance and appearance, depth and surface, leads, I would suggest, not to Baudrillard's simulacra but to a new and more complex level of aesthetic illusion.

Postmodernity is thus to be understood not, with Vattimo, as the epoch of the "end of modernity" but as the epoch of the critical self-reflection of modernity after the demise of the grand but terminal narrative of progress.[34] Correspondingly, aesthetic theory can no longer claim identity with its object and the unfolding of its truth, integral to ontological aesthetics from Plato to Heidegger, more particularly from Hegel to Adorno. Equally it must recognize that the mantle of theory has passed from philosophy to art, once art becomes its own end. The "death of art" is

another way of saying that the work of art has become its own contingency formula. It is no longer to be thought as essence but as the virtuality of a communicative potential, which is its own question and risk and whose indeterminacy follows from the destruction of the unity of the organic work and the explosion of the traditional limits of the aesthetic. This is the problematic condition of the continuation of art—and of aesthetic theory. And here, as I have sought to argue, the way beyond the conclusion of aesthetic theory from Hegel to Adorno lies in rethinking the dialectic of art and enlightenment in modernity.

Notes

◻

INTRODUCTION

1. Of particular interest here is Siegfried J. Schmidt's analysis of the emergence of literature as an autonomous social system in the course of the eighteenth century in *Die Selbstorganisation des Sozialsystems Literatur im 18. Jahrhundert.*

2. Toynbee, *A Study of History,* 39.

3. For use of the term *postmodernism* by Irving Howe, Harry Levin, Ihab Hassan, and Charles Olsen, see Michael Kohler's survey of the term in Pütz and Freese, eds., *Postmodernism in American Literature,* 1ff. For Lyotard's dating of the postmodern, Lyotard, *The Postmodern Condition,* xxiii and 37–41. Baudrillard dates postmodernity from dada and surrealism; cf. Jean Baudrillard, *Simulacres et simulation,* 230.

4. Jencks, "The Evolution and Mutation of Modern Architecture," in Jencks and Chaitkin, *Architecture Today,* 14.

5. Meyer, *Music, the Arts, and Ideas,* 98. I return to Meyer's argument in the last chapter.

6. See "The Position of Art Relatively to Finite Reality, Religion, and Philosophy," in Hegel, *The Philosophy of Fine Art,* 1:125–44.

7. See "The Principle of Tragedy, Comedy, and the Play," in Hegel, *The Philosophy of Fine Art,* 4:301–305.

8. See "Irony," in Hegel, *The Philosophy of Fine Art,* 1:87–94.

9. See "The End of the Romantic Type of Art," in Hegel, *The Philosophy of Fine Art,* 2:388–401.

10. Hegel's end of history in absolute knowledge is not to be equated of course with its parodistic echo in postmodernism, as, for instance, in Baudrillard's version of *posthistoire,* examined in the last chapter, where

Arthur C. Danto's application of Hegel's thesis of the end of art to twentieth-century painting is also considered.

11. Rüsen, *Aesthetik and Geschichte*, 66–67.

12. Henrich, "Kunst und Kunstphilosophie der Gegenwart," 15.

13. Henrich, "Kunst und Kunstphilosophie," 13.

14. Henrich, "Kunst und Kunstphilosophie," 14.

15. I have used the translation by Anne G. Mitchell and Wesley V. Blomster of Adorno's *Philosophy of Modern Music* in my citations. My alterations to their translation are enclosed in square brackets.

16. Cf. Jürgen Habermas, "Der Universalitätsanspruch der Hermeneutik," in Jürgen Habermas, *Kultur und Kritik* (Frankfurt: Suhrkamp, 1973), 266.

17. Cf. Mihaly Vajda on the relation between aesthetic illusionism, bourgeois rationalism, and science, "Aesthetic Judgement and the World View in Painting," in Heller and Feher, eds., *Reconstructing Aesthetics*, 119–49.

18. See, however, Adorno's letter of 7 Oct. 1934 to Ernst Krenek in Rogge, *Theodor W. Adorno und Ernst Krenek. Ein Briefwechsel*, 47. For Adorno's indebtedness to Lukács see Feher, "Rationalized Music and Its Vicissitudes."

19. For an analysis of the importance of Adorno's writings on music in the 1920s and 1930s for the genesis of his dialectical thinking, see Sziborsky, "Dialektik aus dem Geist der Musik," 90–129.

20. Buck-Morss, *The Origin of Negative Dialectics*, 131, 188.

21. Buck-Morss, *The Origin of Negative Dialectics*, 187, 189. In 1934 Adorno believed that the technical progress inherent in Schoenberg's rational dialectical order, which he compared to the most advanced social theory, was the path to freedom: "Does not this music (I want to express myself cautiously) have something to do with what Marx calls the 'association of free men' " (Letter of 7 Oct. 1934 to Ernst Krenek).

22. See Redner, *In the Beginning Was the Deed: Reflections on the Passage of Faust*.

23. See Feher, "Lukács in Weimar."

24. Cf. here Hegel's analysis of Solger's concept of irony as the highest principle of art: "A truly speculative impulse of his innermost nature made him probe the very depths of the philosophical idea. And in so doing he came upon the dialectical phase of the idea, the transition point, which I call the infinite absolute negativity, the activity of the idea in its negation of itself as infinite and universal, in order to pass into finiteness and particularity, and with no less truth once more in order to annul this negation, and in so doing to establish again the universal and infinite

within the finite particular. [Solger] never got beyond this aspect of negativity, which possesses an affinity with the dissolution by irony of all that is determinate no less than essentially substantive, a negative movement which he identified with artistic activity" (Hegel, *The Philosophy of Fine Art*, 1:93–94).

25. See Moreton D. May, "A Collector's Note," in *Ritual Art of the South Seas: The Moreton D. May Collection* (St. Louis: St. Louis Art Museum, 1975), 7.

PART I

1. Given Adorno's critique of "authenticity," directed notably against Heidegger, in his *The Jargon of Authenticity*, trans. Knut Tarnowski and Frederick Will (London: Routledge and Kegan Paul, 1973), it is important to distinguish the sense in which Adorno uses the term. I quote here from Max Paddison's excellent review article of Adorno's *Aesthetic Theory:* "From this it becomes clear that Adorno is quite specific in his use of concepts like *authenticity* and *quality* in art works, and that, seen within the framework of his broader aesthetic (and social) theory these value-laden and rather perilous terms do take on a more precise meaning. In this context, therefore, he is using the concept *authenticity (Authentizität)* in a very different sense from its current use in connexion with a) performance of early music . . . and b) German existential philosophy (his book *The Jargon of Authenticity* is a critique of the notion of *Eigentlichkeit* also translated into English as authenticity—in the work of existentialists like Buber, Jaspers and, in particular, Heidegger). Adorno's notion of authenticity is founded on the idea of appropriate responses to the changing historically and socially mediated demands of the material of art. It thus at the same time operates as a critique of those ahistorical notions of authenticity which are based on ideas of unmediated 'pure being' (*Dasein*) or ultimate origins" (*Music Analysis* 6 [1987], 366).

2. For a recent discussion see Richard Wolin, "Modernism vs. Postmodernism," *Telos* 62 (1984–85), 9–30.

3. See Habermas, "The Entwinement of Myth and Enlightenment," 13–30.

4. Adorno, "New Music and the Public."

5. "Fortschritt und Reaktion," in Theodor Adorno, *Moments Musicaux* (Frankfurt: Suhrkamp, 1964), 153.

6. Jacques Attali, *Noise: The Political Economy of Music*, trans. Brian Massumi (Minneapolis: University of Minnesota Press, 1985), 34.

7. The idea of progress is a product of bourgeois thought and as such an immanent concept of modern European history. As Agnes Heller

argues in *A Theory of History,* however, progress can no longer be thought of ontologically; the function of the concept can only be that of a regulative idea. Philosophy of history must give way to theory of history.

8. Feher, "Negative Philosophy of Music," 99.

9. Feher, "Negative Philosophy of Music," 103, 105.

10. Feher, "Rationalized Music and Its Vicissitudes," 49.

11. For an analysis of the differences between Adorno's and Lukács's concepts of reification, see Rose, *The Melancholy Science,* 27–51.

12. Markus, "Life and Soul," 19.

13. Feher, "Lukács in Weimar," 92.

14. Wellmer, "Truth, Semblance, Reconciliation," 90.

15. In a letter to Adorno of 1 Nov. 1949, Krenek speaks of the tone of *Philosophy of Modern Music* as being closer to Spengler than Adorno might like (Rogge, *Ein Briefwechsel,* 149). See Friedmann, *The Political Philosophy of the Frankfurt School,* 79–86, 214–18, for a strong statement of the influence of Spengler on Adorno and the Frankfurt school.

16. "Spengler nach dem Untergang," in Adorno, *Prismen,* 61, 67 ("Spengler after the Decline," in Adorno, *Prisms*).

17. "Fortschritt" in Adorno, *Stichworte, Kritische Modelle* (Frankfurt: Suhrkamp, 1969), 37.

18. Adorno, *Prismen,* 61.

19. See Rousseau, ed., *Organic Form,* 8ff.

20. Susan McClary, "Afterword" to Attali, *Noise,* 153.

21. Lukács, *The Destruction of Reason,* 464.

22. Lukács, *The Destruction of Reason,* 469, 525.

23. On the combination of romantic anticapitalism and Marxist critique in Lukács, see Arato and Breines, *The Young Lukács,* 211–13.

24. Jay, *Marxism and Totality.*

25. Jay, "The Concept of Totality in Lukács and Adorno," 117–38, esp. 124–25.

26. Markus, "Alienation and Reification in Marx and Lukács," 155.

27. Arato and Breines, *The Young Lukács,* 140.

28. See here "Louis Althusser and the Structuralist Reading of Marx," in Jay, *Marxism and Totality,* 385–422.

29. See Roberts, "Lukács and Kafka."

30. Jay, *Marxism and Totality,* 59.

31. Luhmann, "Das Problem der Epochenbildung," 23–24.

PART II

1. In his identification of Schoenberg with the dialectical side of music, Adorno conveniently forgets at this point not only that his whole

concept of the progress of music as rationalization stands in the age-old tradition of the comprehension of music as mathematics but that one of the chief grounds of his indictment of twelve-tone music is the superstition of its number games (MM66).

2. One could also say an imaginary planet: see Schoenberg's setting of Stefan George's poem "Entrückung" in the last movement of his second string quartet (1908), where the "air of other planets" heralds the new world of atonality, just as the setting of George's "Litanei" in the third movement, the mourning for the abandonment of everything once loved, expresses Schoenberg's farewell to tonality. See Alan Philip Lessem, *Music and Text in the Works of Arnold Schoenberg: The Critical Years, 1908–1922* (Ph.D. diss., University of Illinois, 1973).

3. Lyotard, "Adorno as the Devil," 127.

4. See the photographs in Stravinsky and Craft, *Dialogues and a Diary,* 176.

5. Although Brecht's preference for pre- and antibourgeois forms of the theater for his models cannot be dismissed as restoration or regression, Adorno's hostility to Brecht's antisubjectivism does in fact point to the problematic of his didactic plays (*Lehrstücke*), which substitute for the individuation of form and content the ethos of a false collectivity.

6. For Lukács's judgment on montage see, for example, his *The Historical Novel,* trans. Hannah Mitchell and Stanley Mitchell (London: Merlin Press, 1962), 252–53. For a recent analysis of Benjamin's concept of allegory and montage, see Geyer-Ryan, "Counterfactual Artifacts."

7. Lambert's book appeared the same year Adorno arrived in England, 1934. Whether Adorno read it must remain a matter of conjecture.

8. Schoenberg, "New Music, Outmoded Music, Style, and Idea," in Stein, *Style and Idea,* 119–24.

9. Schoenberg, "Igor Stravinsky—Der Restaurateur," in Stein, *Style and Idea,* 482.

10. Schoenberg, "New Music, Outmoded Music, Style, and Idea," 124.

11. Boulez, "Stravinsky: Style or Idea?"

12. Stravinsky and Craft, *Conversations with Stravinsky,* 126.

13. Pierre Boulez, *Boulez on Music Today,* trans. Susan Bradshaw and Richard Rodney Bennett (Cambridge, Mass: Harvard University Press, 1971), 29.

14. Fredric Jameson, "Reflexions in Conclusion," in *Aesthetics and Politics* (London: New Left Books, 1978), 211.

15. See my article on Adorno and *Doctor Faustus,* "Die Postmod-

erne—Dekonstruktion oder Radikalisierung der Moderne?" in *Akten des VII. Internationalen Germanisten-Kongresses Göttingen 1985,* vol. 8, ed. Walter Haug and Wilfried Barner (Tübingen: Niemayer, 1986), 148–53.

PART III

1. Heller, *Beyond Justice,* 112–14, 320.

2. For the importance of the dialogic principle for the theory of the novel, see Mikhail Bakhtin, *The Dialogic Imagination.* Diderot's *Le Neveu de Rameau* first appeared in Goethe's translation. The dialectic of fate and chance is the guiding thread of narrative metareflection in Goethe's *Wilhelm Meisters' Years of Apprenticeship.* Cf. here my study *The Indirections of Desire: Hamlet in Goethe's Wilhelm Meister* (Heidelberg: Winter, 1980).

3. Richard Rorty, "The Contingency of Language," "The Contingency of Selfhood," and "The Contingency of Community," *London Review of Books,* 17 Apr., 8 May, and 24 July 1986. See Rorty, *Contingency, Irony, and Solidarity.*

4. Cf. Hegel, *Philosophy of Fine Art,* 2:296: "For that reason we find, to put it in general terms, as the fermentation of the romantic, the contingency of the exterior condition and internal life, and a falling asunder of the two aspects, by reason of which Art commits an act of suicide [*die Kunst sich selbst aufhebt*]." See also Rüsen, *Aesthetik und Geschichte,* 30–47.

5. Mikhail Bakhtin, *Rabelais and His World* (Cambridge, Mass: MIT Press, 1968), 87.

6. Bakhtin, *The Dialogic Imagination,* 7.

7. See Luhmann, "The Work of Art and the Self-Reproduction of Art."

8. Bakhtin, "Epic and Novel" and "Discourse in the Novel," in *The Dialogic Imagination.*

9. "The Differentiation of Society," in Luhmann, *The Differentiation of Society.*

10. Cf. Stravinsky and Craft, *Expositions and Developments:* "I believe, with Auden, that the only critical exercise of value must take place in, and by means of art, i.e., in pastiche or parody; *Le Baiser de la fée* and *Pulcinella* are music criticism of this sort, though more than that too. . . . *Pulcinella* was my discovery of the past, the epiphany through which the whole of my late work became possible. It was a backward look, of course—the first of many love affairs in that direction—but it was a look in the mirror too. No critic understood this at the time, and I was therefore attacked for being a pasticheur" (109, 113).

11. John McDonald, "The Power of Irony: Contemporary German Art in Australia," *Age Monthly Review* 6, no. 3 (July 1986).

12. See Cott, *Stockhausen: Conversations with the Composer.* The following is a random selection from topics of discussion: Non-Aristotelian Logic; Music of the Spheres; Enlargement of the Musical Parameters; The Breath of the World; A Composition Which Produces Its Own Children; Synchronicity; Micro-macro Continuum; Spectral Harmonics.

13. Volker Klotz, "Sprache und Montage in neuerer Literatur und Kunst," *Sprache im technischen Zeitalter* 60 (1976), 259–77.

14. Cf. Jacques Derrida, "Le théâtre de la cruauté et la clôture de la représentation," in his *L'Écriture et la différence* (Paris: Editions du Seuil, 1967), 341–68.

15. For a fuller account see Roberts, "Brecht and the Idea of a Scientific Theatre."

16. Benjamin, *Understanding Brecht*, 12.

17. Roberts, "Brecht and the Idea of a Scientific Theatre," 54–55.

18. Here I have drawn on Martin Jürgens, "Zum Prinzip der Montage in Bertolt Brechts 'soziologischen Experimenten,'" *Lili. Zeitschrift für Literaturwissenschaft und Linguistik* 46 (1982), 88–103.

19. The pathology of the age of transparency according to Baudrillard is schizophrenia. For Peter Sloterdyk the preservation of the schizophrenic self is possible only by means of cynicism. See Peter Sloterdyk, *Critique of Cynical Reason*, trans. Michael Eldred and Leslie A. Adelson (Minneapolis: University of Minnesota Press, 1988), for his version of the dialectic of enlightenment which transforms the cynic impulse into cynical reason.

20. Hans-Georg Gadamer, "Das Rätsel der Zeit—über Altes und Neues," *Universitas* 444 (May 1983), 45–57, my translation.

21. Agnes Heller, *A Theory of History*, 41–50: "'Radical hermeneutics' means a generalizable approach to histories on the level of everyday consciousness. It is 'not yet' scientific, even though it provides the point of departure for historiography. Hermeneutics has a dialogical relation to the past. Radical hermeneutics is also dialogical: it mediates the consciousness of planetarian responsibility towards the past. It approaches the past not only in order to find out the meaning, the sense, the value of former historical actions, objectivations and agents, but also in order to disclose what is *in common* between them and us. We communicate with past beings as with *equally* human beings. In approaching each past history we communicate with humankind. Thus each historical period will be equally close to humankind, which does not mean that each of them is equally *valuable* for us. Lukács once described art as the

organ of memory and the self-consciousness of humankind. Art enables us to incorporate all past-present ages into our present-present age, either with cognitive love or with cognitive resentment, but without authorizing the use of them to justify the present. By the same token, the understanding of history *sub specie* their common humanity implies their *alienation* as past histories or historical pasts" (47).

22. "Linguistic plurality": Robert Morgan, "Secret Languages: The Roots of Musical Modernism," *Critical Inquiry* 10 (1984), 458; "linguistic chaos": George Rochberg, "Can the Arts Survive Modernism (A Discussion of the Characteristics, History, and Legacy of Modernism)," *Critical Inquiry* 10 (1984), 317–41.

23. W. H. Auden, *The Dyer's Hand and Other Essays* (London: Faber and Faber, 1975), 79.

24. Karl Marx, *Grundrisse* (Harmondworth: Penguin Books, 1979), 110–11.

25. Walter Benjamin, "Theses on Philosophy of History" and "The Work of Art in the Age of Mechanical Reproduction," in Benjamin, *Illuminations*.

26. Quoted from Charles Osborne, *W. H. Auden: The Life of a Poet* (London: Macmillan, 1982).

27. The impact of the most recent technologies of the electronic age on perception and on the relation of nearness and distance in the world of "real time" is the subject of Götz Grossklaus's illuminating article "Nähe und Ferne. Wahrnehmungswandel im Übergang zum elektronischen Zeitalter," in Götz Grossklaus and Eberhard Lämmert, eds., *Literatur in einer industriellen Kultur* (Stuttgart: Cotta, 1989), 489–520.

29. Lacoue-Labarthe and Nancy, *The Literary Absolute*, xxii.

30. Walter Benjamin, *Der Begriff der Kunstkritik in der deutschen Romantik* (Frankfurt: Suhrkamp, 1973).

31. Lacoue-Labarthe and Nancy, *The Literary Absolute*, 83.

32. Arthur C. Danto, *The Philosophical Disenfranchisement of Art*, 90. See also for a comparable view of the crisis of tradition in art history and the end of the "historic style," Peter Por, "Fin de siècle, fin du 'globe-style'? Le concept d'objet dans l'art contemporain," *Diogène* 147 (July-Sept. 1989), 97–114.

33. "Interview with Jean Baudrillard," in Baudrillard, *The Evil Demon of Images*, 38.

34. Cf. the reflections of Ferenc Feher on the situation of "coming after," especially the question of aesthetic emancipation in his "The Status of Postmodernity."

Bibliography

◻

Adorno, Theodor. *Aesthetic Theory.* Translated by C. Lenhardt. London: Routledge and Kegan Paul, 1984.

———. "New Music and the Public: Some Problems of Interpretation." In *Twentieth Century Music,* edited by Rollo H. Myers. London: John Calder, 1960.

———. *Philosophy of Modern Music.* Translated by Anne G. Mitchell and Wesley V. Blomster. New York: Seabury Press, 1973.

———. *Prismen. Kulturkritik und Gesellschaft.* Munich: dtv, 1963.

———. *Prisms: Cultural Criticism and Society.* Translated by Samuel Weber and Shierry Weber. Cambridge, Mass: MIT Press, 1982.

Arato, Andrew, and Paul Breines. *The Young Lukács and the Origins of Western Marxism.* New York: Seabury Press, 1979.

Bakhtin, Mikhail. *The Dialogic Imagination: Four Essays.* Edited by Michael Holquist. Translated by Caryl Emerson and Michael Holquist. Austin: University of Texas Press, 1981.

Baudrillard, Jean. *The Evil Demon of Images.* Translated by Paul Patton and Paul Foss. Sydney: Power Institute of Fine Arts, 1984.

———. *Simulacres et simulation.* Paris: Galileé, 1981.

———. *Les stratégies fatales.* Paris: Grasset, 1983.

Benjamin, Walter. *Illuminations.* Edited by Hannah Arendt. Translated by Harry Zohn. New York: Harcourt, Brace and World, 1968.

———. *The Origin of German Tragic Drama.* Translated by John Osborne. London: New Left Books, 1977.

———. *Understanding Brecht.* London: New Left Books, 1977.

Boulez, Pierre. "Stravinsky: Style or Idea?—In Praise of Amnesia"

(1971). In *Orientations: Collected Writings,* by Pierre Boulez, edited by Jean-Jacques Nattiez; translated by Martin Cooper, 349–59. London: Faber and Faber, 1986.

Breton, André. *Nadja.* New York: Grove, 1988.

Buck-Morss, Susan. *The Origin of Negative Dialectics: Adorno, Benjamin and the Frankfurt School.* New York: Free Press, 1977.

Bürger, Peter. "The Decline of the Modern Age," *Telos* 62 (1984–85), 117–30.

———. *Theory of the Avant-garde.* Preface Jochen Schulte-Sasse. Translated by Michael Shaw. Minneapolis: University of Minnesota Press, 1984.

Burgin, Victor. *The End of Art Theory: Criticism and Postmodernity.* London: Macmillan Press, 1986.

Cott, Jonathan. *Stockhausen: Conversations with the Composer.* London: Pan Books, 1974.

Danto, Arthur C. *The Philosophical Disenfranchisement of Art.* New York: Columbia University Press, 1986.

Dufrenne, Mikel. "Mal de Siècle? The Death of Art," in *In the Presence of the Sensuous: Essays in Aesthetics,* by Mikel Dufrenne. Edited and translated by Mark S. Roberts and Dennis Gallagher, Atlantic Highlands, N.J.: Humanities Press International, 1987. 87–104.

Eagleton, Terry. "Capitalism, Modernism, and Postmodernism." *New Left Review* 152 (July/August 1985), 60–73.

Feher, Ferenc. "Lukács in Weimar." In *Lukács Reappraised,* edited by Agnes Heller, 75–106. New York: Columbia University Press, 1983.

———. "Negative Philosophy of Music—Positive Results." *New German Critique* 4 (1975), 99–112.

———. "Rationalized Music and Its Vicissitudes." *Philosophy and Social Criticism* 9 (1982), 43–65.

———. "The Status of Postmodernity," *Philosophy and Social Criticism* 13 (1987), 195–206.

Fowkes, William. *An Hegelian Account of Contemporary Art.* Ann Arbor: UMI Research Press, 1981.

Friedmann, George. *The Political Philosophy of the Frankfurt School.* Ithaca, New York: Cornell University Press, 1981.

Geyer-Ryan, Helga. "Counterfactual Artefacts: Walter Benjamin's Philosophy of History." In *Visions and Blueprints: Avant-garde Culture and Radical Politics in Early Twentieth-Century Europe,* edited by Edward Timms and Peter Collier, 66–99. Manchester: Manchester University Press, 1988. 66–99.

Habermas, Jürgen. "The Entwinement of Myth and Enlightenment: Re-Reading *Dialectic of Enlightenment.*" *New German Critique* 26 (1982), 13–30.

———. "Moderne und Postmoderne Architektur." In *Die neue Unüber-sichtlichkeit*, 11–29. Frankfurt: Suhrkamp, 1985.

Hegel, Georg Wilhelm Friedrich. *The Philosophy of Fine Art*. Translated by F. Osmaston. 4 vols. New York: Hacker Fine Art, 1975.

Heller, Agnes. *Beyond Justice*. Oxford: Basil Blackwell, 1987.

———. *A Theory of History*. London: Routledge and Kegan Paul, 1982.

Henrich, Dieter. "Kunst und Kunstphilosophie der Gegenwart." In *Immanente Aesthetik*. *Aesthetische Reflexion*, edited by Wolfgang Iser, 11–32. Munich: Fink, 1966.

Horkheimer, Max, and Theodor Adorno. *Dialectic of Enlightenment*. Translated by John Cumming. New York: Herder and Herder, 1972.

Jameson, Fredric. "Postmodernism, or the Cultural Logic of Late Capitalism." *New Left Review* 146 (July/August 1984), 53–92.

Jay, Martin. *Adorno*. Cambridge, Mass: Harvard University Press, 1984.

———. "The Concept of Totality in Lukács and Adorno." *Telos* 32 (1977), 117–38.

———. *Marxism and Totality: The Adventures of a Concept from Lukács to Habermas*. Berkeley: University of California Press, 1984.

Jencks, Charles, and William Chaitkin. *Architecture Today*. New York: Abrams, 1982.

Kern, Stephan. *The Culture of Time and Space, 1880–1918*. Cambridge, Mass: Harvard University Press, 1983.

Lacoue-Labarthe, Philippe, and Jean-Luc Nancy. *The Literary Absolute: The Theory of Literature in German Romanticism*. Translated by Philip Barnard and Cheryl Lester. Albany: State University of New York Press, 1988.

Lambert, Constant. *Music Ho! A Study of Music in Decline*. 1934. London: Penguin Books, 1948.

Luhmann, Niklas. *The Differentiation of Society*. Translated by Stephen Holmes and Charles Larmore. New York: Columbia University Press, 1982.

———. "Das Problem der Epochenbildung und die Evolutionstheorie." In *Epochenschwellen und Epochenstrukturen im Diskurs der Literatur- und Sprachhistorie*. Edited by Hans Ulrich Gumbrecht and Ursula Link-Heer, 11–33. Frankfurt: Suhrkamp, 1985.

———. *Soziale Systeme. Grundriss einer allgemeinen Theorie*. Frankfurt: Suhrkamp, 1985.

———. "The Work of Art and the Self-Reproduction of Art." *Thesis Eleven* 12 (1985), 4–27.

Lukács, Georg. *The Destruction of Reason*. Translated by Peter Palmer. London: Merlin Press, 1980.

———. *History and Class Consciousness: Studies in Marxist Dialectics*. Translated by Rodney Livingstone. London: Merlin Press, 1971.

Lyotard, Jean-François. "Adorno as the Devil." *Telos* 19 (1974), 127–37.

———. *The Postmodern Condition: A Report on Knowledge.* Foreword by Fredric Jameson. Translated by Geoff Bennington and Brian Massumi. Minneapolis: University of Minnesota Press, 1984.

Malraux, André. *Museum without Walls.* Translated by Stuart Gilbert and Francis Price. London: Secker and Warburg, 1967.

Markus, György. "Alienation and Reification in Marx and Lukács." *Thesis Eleven* 5/6 (1982), 139–61.

———. "Life and Soul: The Young Lukács and the Problem of Culture." In *Lukács Reappraised,* edited by Agnes Heller, 1–26. New York: Columbia University Press, 1983.

Marsh, James L. "Adorno's Critique of Stravinsky." *New German Critique* 28 (1983), 147–69.

Meyer, Leonard. *Music, the Arts, and Ideas: Patterns and Predictions in Twentieth-Century Culture.* Chicago: University of Chicago Press, 1967.

Pütz, Manfred, and Peter Freese, eds. *Postmodernism in American Literature.* Darmstadt: Thesen Verlag, 1984.

Redner, Harry. *In the Beginning Was the Deed; Reflections on the Passage of Faust.* Berkeley: University of California Press, 1982.

Roberts, David. "Brecht and the Idea of a Scientific Theatre." *Brecht Performance: The Brecht Yearbook* 13 (1987), 41–62.

———. "Lukács and Kafka: 1914 and 1957." In *Antipodische Aufklärungen—Antipodean Enlightenments. Festschrift für Leslie Bodi,* edited by Walter Veit et al., 403–408. Frankfurt: Peter Lang, 1987.

Rogge, Wolfgang, ed. *Theodor W. Adorno und Ernst Krenek. Ein Briefwechsel.* Frankfurt: Suhrkamp, 1984.

Rorty, Richard. *Contingency, Irony, and Solidarity.* Cambridge: Cambridge University Press, 1989.

Rose, Gillian. *The Melancholy Science: An Introduction to the Thought of Theodor W. Adorno.* London: Macmillan Press, 1978.

Rousseau, George S., ed. *Organic Form: The Life of an Idea.* London: Routledge and Kegan Paul, 1972.

Rüsen, Jörn. *Aesthetik und Geschichte.* Stuttgart: Metzler, 1976.

Schmidt, Siegfried J. *Die Selbstorganisation des Sozialsystems Literatur im 18. Jahrhundert.* Frankfurt: Suhrkamp, 1989.

Schoenberg, Arnold. "New Music, Outmoded Music, Style, and Idea." In *Style and Idea: Selected Writings of Arnold Schoenberg,* edited by Leonard Stein, translated by Leo Black. London: Faber and Faber, 1975.

Spengler, Oswald. *The Decline of the West.* Translated by Charles Atkinson. 2 vols. London: Allen and Unwin, n.d.

Stravinsky, Igor, and Robert Craft. *Conversations with Stravinsky.* London: Faber and Faber, 1959.

———. *Dialogues and a Diary.* London: Faber and Faber, 1968.

———. *Expositions and Developments.* London: Faber and Faber, 1962.

Sziborsky, Lucia. "Dialektik aus dem Geist der Musik." In *Die negative Dialektik Adornos,* edited by Jürgen Naeher, 90–129. Opladen: Leske und Budrich, 1984.

Toynbee, Arnold. *A Study of History.* Abridgment of volumes 1–6 by D. C. Somervill. London: Oxford University Press, 1946.

Vajda, Mihaly. "Aesthetic Judgement and the Word View in Painting." In *Reconstructing Aesthetics: Writings of the Budapest School,* edited by Agnes Heller and Ferenc Feher, 119–49. Oxford: Basil Blackwell, 1986.

Vattimo, Gianni. *The End of Modernity: Nihilism and Hermeneutics in Post-Modern Culture.* Translated by Jon R. Snyder. Cambridge: Polity Press, 1988.

Wellmer, Albrecht. "Art and Industrial Production." *Telos* 57 (1983), 53–62.

———. "Truth, Semblance, Reconciliation: Adorno's Aesthetic Redemption of Modernity." *Telos* 62 (1984–85), 89–116.

Wolin, Richard. "Modernism vs. Postmodernism." *Telos* 62 (1984–85), 9–30.

Index

☐

Abstraction, 43–44, 82–83
Adorno, Theodor. *See titles of works*
Aestheticism, 136, 139
Aestheticization, 195–96
Aesthetic Theory (Adorno), 16, 32, 59–69
Alienation, 11, 190
Allegory, 114
Althusser, Louis, 122
Animism, 104–5
Aporia. *See* Blindness
Architecture, 122–28
Art: Greek, 7, 8; hermetic, 48–49; institution of, 137–39; quotation in, 131, 178, 180; Romantic, 8, 20, 39, 52, 234 n.23; truth in, 29–30, 61. *See also* Postmodernism
Artaud, A., 185
Atonality. *See* Tonality
Aura, 196, 206, 214–15, 217
Authenticity, 19, 37, 99, 102, 131, 178, 179, 233 n.1
Avant-garde movements, 1, 5–7, 17, 36, 93, 124, 134–40, 191, 195–96
Axiomatic method, 122, 176

Bach, J. S., 67
Bachelard, Gaston, 188
Bakhtin, Mikhail, 165, 167–69
Barbarism, 115, 119

Baroque style, 12–14, 114
Baudrillard, Jean, 21, 23, 156, 180, 197, 198, 202, 227, 231 n.10, 237 n.19
Bauhaus style, 114
Beckett, Samuel, 60, 62
Beethoven, Ludwig van, 2, 39, 46, 100
Benjamin, Walter, 21–23, 28, 88, 114, 145, 187, 211–15, 235 n.6
Berg, Alban, 87
Blindness, 2, 44, 46, 48–49, 54, 72
Bloch, Ernst, 101, 214
Body, 104–6
Bolshevik revolution, 17
Boulez, Pierre, 117–21, 156
Boundaries, 168, 178, 179, 186
Bourgeois society, 31–34, 47, 68–70, 84, 105–9, 135–39, 183
Brahms, Johannes, 39
Brecht, Bertolt, 23, 106–7, 183–94, 215, 235 n.5
Breton, André, 177
Buck-Morris, Susan, 13, 14
Bueys, Joseph, 181
Bürger, Peter, 6, 93, 128–40, 156, 163–65, 175

Cage, John, 150, 180–81
Capitalism, 17, 83, 86, 141, 144, 148–49
Catastrophe, 141
Causality, 42–44, 80, 110, 187. *See also*

245